THE LITERATURE OF PHOTOGRAPHY

THE LITERATURE OF PHOTOGRAPHY

Advisory Editors:

PETER C. BUNNELL
PRINCETON UNIVERSITY

ROBERT A. SOBIESZEK
INTERNATIONAL MUSEUM OF PHOTOGRAPHY
AT GEORGE EASTMAN HOUSE

THE ARTISTIC SIDE
OF PHOTOGRAPHY

IN THEORY AND PRACTICE

BY

A. J. ANDERSON

ARNO PRESS
A NEW YORK TIMES COMPANY

NEW YORK ★ 1973

Reprint Edition 1973 by Arno Press Inc.

Reprinted by permission of
Stanley Paul & Company Ltd.

Reprinted from a copy in
The George Eastman House Library

The Literature of Photography
ISBN for complete set: 0-405-04889-0
See last pages of this volume for titles.

Manufactured in the United States of America

————◆————

Library of Congress Cataloging in Publication Data

Anderson, Arthur James, 1863-
 The artistic side of photography.

 (The Literature of photography)
 Reprint of the 1910 ed.
 1. Photography. I. Title. II. Series.
TR145.A55 1973 770'.28 72-9179
ISBN 0-405-04890-4

THE ARTISTIC SIDE
OF PHOTOGRAPHY

THE ARTISTIC SIDE OF PHOTOGRAPHY

IN THEORY AND PRACTICE

BY

A. J. ANDERSON
Author of "The Romance of Fra Filippo Lippi"

LONDON
STANLEY PAUL & CO.
1 CLIFFORD'S INN

PREFACE

There has not been, my dear Monica, that progress in pictorial photography which one feels the right to expect; and yet, since human nature is human nature, this stagnation is exactly what one ought to expect : for what cook would serve up plain roast chicken when it might be converted into something modish à la Rostand? And what photographer could be content with a simple platino-type when he has the stock of the oil-and-colourman at his disposal?

Therefore, instead of starting where D. O. Hill left off some sixty years past, and going on to conquer the method of pure photography, the picture makers first employed themselves in the imitation of Victorian Academicians; then in the combination of portions of various negatives in one print; and lastly in manipulating effects by the oil or gum process that might have been attained with greater ease and certainty by stump or paint-brush. During this time the pursuit of plain, straightforward photography was principally neglected.

Now, thanks to the steadfastness of certain English purists and the influence of the American Photo Secession, there are signs of a return to the methods of D. O. Hill. This is surely the commencement of a real photographic advance towards honest Art.

5

Preface ♣

Unfortunately, there is a gap between the photographic writers of the older school and the purely practical or purely artistic writers of the present, and I am making a tentative effort to fill this gap until the new movement breeds its own literature.

You will find that I have noted down several of our conversations, and now publish them. I have done this baseness, partly because we seem to have reached our point in less time than it would take to write a chapter, and partly in the hope that they may serve as pleasant vehicles for the moral doctrines which we determined.

I pray you, as a type of sweetness and common sense, to accept the dedication of my book.

<div align="right">

A. J. ANDERSON.

</div>

April 9, 1910.

CONTENTS

7

Contents ♣

8

Contents

ILLUSTRATIONS

Having twelve photogravures and twelve half-tones at his disposal, the author has endeavoured to secure the best general result in the reproduction. In some cases a print would bear half-tone, or even reproduce better in half-tone ; in other cases a print could only be reproduced properly in photogravure. In some cases—especially when printed on rough platinotype—the photographs have lost in the reproduction ; in some cases the selected photographs have defied reproduction, and have been discarded.

LIST OF ILLUSTRATIONS

Illustrations ♣

As an illustration of the artistic possibilities of photography, the above list of photographs is altogether satisfactory ; but these photographs do not purpose to be illustrations of the text.

In illustrating a book there are three courses open : the writer may have special pictures made to illustrate the most important points in the text ; he may choose a certain number of pictures and write the text round them ; or he may ignore the pictures, write on, and leave the pictures to sing their own song in their own way.

Now, it is obvious that the author could not send a score of the leading photographers hunting round to illustrate certain passages in his MS. ; he did not wish to confine himself to a series of wordy and discursive criticisms ; so he has been forced to ignore most of the illustrations, and allow them to warble on unmolested.

After selecting what he personally considers the finest examples of pictorial photography, without regard to men or methods, the author is compelled to point out that all the photographs, except two, are straight prints from straight negatives, and that platino-type predominates.

Whilst thanking the various illustrators for their kindness and courtesy, the author acknowledges a special debt of gratitude to Mr. Alvin Langdon Coburn for his great assistance with both illustrations and text.

12

THE ARTISTIC SIDE OF PHOTOGRAPHY

A. THE MEDIUM OF PHOTOGRAPHY

CHAPTER I

IS PHOTOGRAPHY A FINE ART ?

To the Art Critics.

" You have set photography amongst the mechanical arts ! Truly, were photographers as readily equipped as you are to praise their own work in writing, I doubt whether it would endure the reproach of so vile a name."

I claim no originality for this protest. I have merely taken it from Leonardo da Vinci's note-book, substituting " photography " for " painting."

If da Vinci, smarting under the " reproach " of his sixteenth-century critics, wrote :

" You have set painting amongst the mechanical arts ! Truly, were painters as readily equipped as you are to praise their own work in writing, I doubt whether it would endure the reproach of so vile a name,"

modern photographers cannot grumble if modern critics follow similar methods.

The cream of the joke lies in the fact that da Vinci

The Artistic Side of Photography ♣

tells us that the old critics called painting " mechanical," because it was " done with the hand."

After all, photography is an " Art " which has made but little progress since the days of D. O. Hill, and photographers are only beginning to discover the flexibility of pure photography.

Possibly photography has failed to earn its status as a Fine Art, because so much of it has been " done with the hand."

CHAPTER II

I. AT the present time there is a restless feeling amongst artistic photographers, and, I think, a feeling of disappointment. Until a year or two ago pictorial photography appeared to be making steady progress ; then that progress seemed to stop, and the more artistic among the camera people had to ask themselves why progress had stopped. They may have explained to themselves publicly, as they explained during the London Photographic Salon of 1908, that photography was only growing more sound and sane, and that the day of startling eccentricities was over ; but they knew in their hearts that the movement had stopped. Then, at the Salon of 1909, the Committee hung a collection of the late D. O. Hill's photographs on one of the exhibition walls, and pictorial photographers owned openly to each other that pictorial photography had made no material progress since the year 1843, and that there were few of the modern pictures which equalled the work of Mr. Hill.

As a matter of fact, D. O. Hill seems to have taken up photography chiefly as an aid to his painting ; his work was unknown or forgotten until recent years, and consequently his influence has been unfelt : the artistic revival and progress of pictorial photography has been a revolt from the " critical definition " of

the optician, from the "full scale of gradations" of the chemist, and from the conventional art of the mid-Victorian period—a revolt which led the revolutionists into many excesses and endless pitfalls.

And yet, after all the struggles, strivings, and heart-burnings of the past twenty years, the more thorough pictorial photographers find themselves much where Mr. Hill left off.

II. Well, as I have said, pictorial photographers are feeling somewhat restless and somewhat unsettled; so much that has been proclaimed as the Pathway of Art—I mean so much in the discovery of methods and material—has led nowhere.

What has become of the set pieces with dressed-up models; of the combination printing in which mountains and mud-banks were successfully blended into one picture; of printing through a sheet of glass until the outlines of the image became blurred and bleary; or of enlarging so that the threads of the intervening bolting-silk were visible? Where are the "Rembrandt lightings," the "moonlight effects," and the low-toned noonday nocturnes? Has gum-bichromate proved to be the way of salvation, or oil-printing sounded the knell of sepia drawing?

So now the pictorial photographers find that, in spite of passing pangs of artistic progress which tempted their men to wear long locks and their women flowing gowns, they are only standing near where Hill left off; and, if they be thoughtful, they are beginning to review the situation.

If this be true—and it is true—the way in which photographers reconsider the artistic possibilities of photography is of the utmost importance.

III. It is seldom that equal powers of memory and

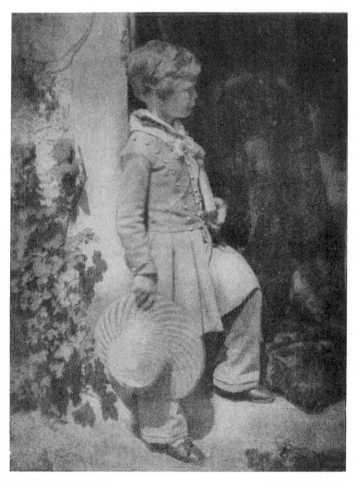

PORTRAIT OF A BOY. *By D. O. Hill.*

17

reason are found in one and the same person ; and, although either faculty may be developed to a great extent, the particular natural power is the one that is usually cultivated.

An accurate memory is the foundation on which pure history, languages, and dogmatic theology are built up ; the gift of reason is the rock on which mathematics, science, speculative theology, and the fine arts are founded. In fact, the creator (whether he devise a picture, a sewing-machine, or a new religion) must be better endowed with a sense of logic than with a memory for detail : it was the artist of the Renaissance, and not the scholar, who planned earthworks and created fortifications.

Now, I am not arguing for one moment that the artistic mind and the mathematical mind are one, for the mathematical mind will probably lack that quality of imagination which is essential in artistic expression.

What I am really arguing is that the artistic mind belongs to the class of mind which is naturally endowed with reason rather than with accuracy of memory ; and it is precisely this quality of reasoning—of thinking out things—that will help the photographer to reconsider the artistic possibilities of photography, and enable him to start afresh where D. O. Hill left off.

A moment's thought will show that although a fine memory will enable a man to learn facts with surprising facility, and enable him to declaim them from chair, platform, or pulpit ; yet no recollection of the irregular verbs, the formulæ of photography, or the details of the Mosaic law, will help him to write an original poem, or to compose an original picture.

Of course the artist may have a most excellent

19 B

memory; but there must be a deal of either logic or imagination mingled with it in order to supply the creative element and stamp the work with originality. And so we may roughly divide the artists into two classes : the idealist, who uses his memory as a foundation on which to erect a structure of convincing imagination ; and the realist, whose memory is subservient to his reason. If the imaginative artist should fail to use his reason, he becomes eccentric, sentimental, or improbable ; if the realistic artist should lack the sense of logic, he becomes an uninspired copyist, who copies Nature in a disagreeable and often faulty way.

IV. In all branches of pictorial art the quality of reason is essential, and in no branch is it so vitally essential as in photography ; for in pictorial photography the artist is taking the forces of light and chemistry and using them for artistic purposes, and consequently he must have a reasonable understanding of his materials and a reasoning grasp of the effects he intends to produce.

Some time ago I was shown a graceful study of a girl seated in a room, reading the morning paper. The reflection from the paper had thrown a pleasant white light on her chin and the front of her face, but the shadows on the side of her cheek were most unnaturally chalky.

"Hallo !" said I, "you have used a white reflector."

"A sheet on a towel-horse," he answered. "They advise one to, in so-and-so." He mentioned a popular photographic handbook.

Here was a clear case of memory without reason. Some unreasoning Goth of the dark days of photo-

graphy had invented the white reflector; the un-
reasoning writer of the handbook had remembered the
hint, and recommended the practice blindly; and
my unreasoning friend had adopted it without a
moment's consideration. If the room in which the
girl was portrayed had been an obviously whitewashed
cell, the lighting of the shadow might not have ap-
peared unnatural; but in an obviously ordinary
room, papered with obviously commonplace wall-paper,
there could have been no conceivable object which
would have cast such a white reflection into a pure
shadow. When I pointed out the error, my friend
saw it; but he ought to have reasoned out the lighting
for himself before ever he took the photograph.

Strange to say, I have just been shown the reflector
which D. O. Hill employed to cast light into the face-
shadows.

Now, in Hill's time, photography was hideously
slow: exposures had to be made in the brightest
lighting, and even then the shadows would come out
black and devoid of detail; so Hill set himself to
devise some means of relieving the shadows in a
natural way.

He must have thought of a white reflector—it is
impossible to imagine that he failed to think of any-
thing so handy and simple as a sheet flung over an
easel; but as his portraits were taken in a pure light,
he wanted his shadows relieved by pure light, and not
by white reflections; so he had a large concave mirror
made for the purpose of reflecting a sufficiency of pure
light into the shadows.

This may seem a small matter; but I happen to
have seen Hill's mirror, and the same principle applies
to all the practical part of artistic photography: it

must be approached through the reasoning part of the intellect.

V. Memory, uncontrolled by reason, has always been the curse of Art. I do not allude to memory of Nature, but the memory of artistic rules and precedents.

Of course every artist must learn all he can from those that have gone before; for if each man had to start anew, without profit from the experience of others, Art would not progress; but he must learn through reason, and not through memory; through convictions, and not through imitation. The mischief is that, whenever a great painter has appeared, his personal rules have been magnified into dogmas, his practices into precedents. Since every famous artist has mingled genius with individual mannerisms; and since the mannerisms can be easily committed to tradition and imitated, whilst the genius is inimitable, the legacy is not an enviable one.

Out of this legacy the English Academicians crystallised the "Rules of Composition" and the "Canons of Art." Their recipe was simple: Take Raphael's precedents and Reynolds's teachings; add a dash of Michael Angelo, a pinch of Titian, a sprinkling of Claude, and all the artificiality of the period; garnish with classical allusions, and varnish to taste. The general effect of this formula may be seen in the Academy Gallery at the Victoria and Albert Museum.

In this atmosphere, and amidst these surroundings, "pictorial photography" came into existence. And, partly because the first originators of pictorial photography seemed to have missed the influence of the pre-Raphaelites and Ruskin, of Wilde, Whistler, and the Impressionists; partly because the Royal Academy

was backed by public opinion ; partly because the method of photography lent itself to the imitation of existing Art—the pictorialists absorbed the rules and canons of the Victorian period. " Detail ? " The camera could elaborate minutiæ far better than Mr. Frith ! " Finish ? " Albumen and silver-print could take a polish equal to the finest painting ever varnished ! " Subject ? " The " tame models " of whom Mr. Robinson writes could dress and pose as artificially as any puppets of the painter's canvas ! " Composition ? " Retouching, sunning-down, and manipulation in printing could give a most canonical balance ! Is it strange that pictorial photography commenced on the wrong lines ?

VI.　Now, to tell an Englishman of the twentieth century to pose his figures like an Italian of the sixteenth and compose his landscapes like a Frenchman of the seventeenth century is foolish ; to tell a photographer to arrange his rapid exposures so that they resemble the gradually built-up compositions of the painter is more foolish ; but to tell a rational man to do all this, not by an appeal to his reason, but because it is decreed by the canons of Art, is the most foolish thing of all.

For Photography is a new Art, who must be clothed in a new garment of her own—a garment to be fashioned with much careful thought, and not in a garment that was fashioned for Painting.

If photography is to start on a path of artistic progress, every step must be guided by reason and personal conviction ; and since the artistic side of photography is only in the process of evolution, all reasoning must be regarded as tentative.

LEAF FROM MY NOTE-BOOK

The Inception of the Book

The modern method of education, by which girls
are taught scraps of science and logic and ethics,
and scraps of bibliography and bibliolatry and biblio-
logy for all I know to the contrary—and undoubtedly
scraps of bibble-babble—may not give them the
accomplishments of their grandmothers, but it cer-
tainly makes them companionable.

Monica is most companionable.

" Why has not photography made more progress ? "
asked Monica, throwing herself into my easy chair.
We had been to the Salon the day before and were full
of D. O. Hill's pictures.

" Because men won't think for themselves," I
answered. ' Only very strong men think out every-
thing fresh, and keep on improving. Strong men
begin by thinking for themselves, then they begin to
think of themselves and their past successes, and
lastly they imitate their earlier work ; the ordinary
man imitates either the strong man or the very strong
man. In photography an artist must think out every-
thing for himself."

" But surely every one must learn," suggested the
girl.

" Certainly," I assented ; " but as soon as a strong
man has felt his feet he takes only the advice that

strikes him as strictly logical, and consequently he assimilates all he learns, and it becomes part of him."

" Why don't you write a photography book ? "

Women have a disconcerting way of changing from one subject to another.

" Why should I preach pure photography and make a heap of enemies ? I've been a gum-bichromate man myself, and I know how strongly the gum-workers feel. Besides, it would be very difficult to blend Art, Chemistry, and Physics into an interesting book."

" You might make the book about reasoning out everything," said guileful Monica.

" The book would be a most interesting book to write," I temporised.

She gave a soft little laugh. " You will write the book, Mr. Anderson."

" I would rather sit on a hornets' nest ! " exclaimed I.

" You will write the book," laughed Monica.

Since a suggested book on pure pictorial photography had become " The Book " to both of us, I suppose Monica was prophesying a certainty.

CHAPTER III

THE ARTISTIC QUALITY OF THE MEDIUM

I. Now, all reasoning must start with some postulate ; and so long as this postulate can be shown to be absolutely reasonable, it will be accepted without argument by all who have common sense.

POSTULATE.—Each true medium of artistic expression—from oil-painting to silver-point, from wood-engraving to mezzotint—must have its own particular virtue.

Thus, when an artist wishes to depict a subject, he chooses a medium that will enable him to express himself to the best advantage : if he wishes to bring out the quality of force and richness of colouring he uses oil-paints ; if he wishes to bring out the delicate luminosity of his subject he employs water-colours : he would find wood-engraving suitable for strong effects in monochrome, and mezzotint unequalled in tone-rendering. Only a fool would think of using a process that is " nearly as good as " something else ; for the wise artist selects his medium in the belief that it will enable him to secure some special quality in his picture.

Again, if two methods gave exactly similar results, a sensible artist would choose the method that was most economical of labour and material ; and, since pictures are usually painted to be sold, common honesty would demand permanency in the medium.

26

II. So, if photography is to take a recognised place amongst the methods of artistic expression, it must have some essential quality that cannot be equalled by the employment of any other medium ; it must be sufficiently economical of both time and material to justify its adoption ; and it must give permanent results.

Besides, as there are several methods of making a photographic print which are essentially different, the printing method must comply with the above conditions.

Now, if the ordinary man were asked to mention the particular quality of photography, he would immediately answer : " The accurate drawing of detail." In fact, the word " photographic " is used by painters to describe a mechanical accuracy in the drawing of detail.

But the drawing of fine detail is not the quality of the medium, it is only the quality of one kind of photography ; for if a pinhole be pricked in a sheet of black paper and substituted for the lens, a delightful photograph may be taken, showing very soft detail— and this is as much photography as the work of the finest lens. Besides, although fine definition and accurate drawing may be very useful in the reproduction of paintings or in photographing architecture, they are often an insufferable nuisance in pictorial work, and much thought in focussing, enlarging, and printing is needed to abate the nuisance.

Granted that a drawing of fine detail may have an especial merit, as in Samuel Cooper's miniature painting, the drawing must show discrimination ; for the important parts must be drawn clearly, the unimportant parts either synchronised or suggested, and the unnecessary and irritating parts left out. The mechanical drawing of fine detail everywhere, the

27

unimportant being depicted with the same care and precision as the important, is (excuse me) a damnable quality in pictorial work.

Stop down an expensive anastigmatic lens, and everything is sharp ; use it at a large aperture, focussing the point of interest, and the streak of definition runs right across the picture from edge to edge ; employ a soft-focus lens or a pinhole, and all is equally soft. I have never met a man who did not yearn for a lens that would leave out what he wanted to leave out, and emphasise what he wished to emphasise ; and the long and the short of it is that photography must win its place amongst the Fine Arts, in spite of the detail-drawing of the lens.

III. But, besides drawing detail, the lens draws shading ; and since photography is in reality a method of working in tone, we must look for its artistic quality in the drawing of the delicate gradations of light and shade.

The foundation of " light-drawing " lies in the fact that neither the photographic lens nor the human eye sees ordinary objects, but only the light which they reflect. The layman does not realise this, but the modern artist makes it the first principle in his painting.

Take a woman dressed in white satin, as an example : her face has form and her dress has form, but these forms are not in themselves visible. It is true that the contour and quality of these forms may be determined by the sense of touch, especially when the investigator has the sensitive hands of the blind ; but they are in themselves invisible to the sense of sight. The form of a candle flame may be perceived by sight ; but the forms of the face and dress cannot be seen unless they be illuminated from some extraneous source of light ;

28

and then it is the light which they reflect that is visible
and not the objects themselves. (This sounds sophis-
tical, but it is really both sound and important, as the
next passage will show.)

Where the light strikes the surface of either dress
or face at such an angle that it is reflected directly
back towards the eye, a high light is created; and it
is obvious that the strength and nature of these high
lights will depend on the reflecting qualities of the
satin and skin.

Where the light strikes the surface at such an
angle that the bulk of it is reflected away from the
eye, a shading is created; and the intensity and depth
of this shading depends partly on the nature of the
surface, which may diffuse the light so that a portion
is reflected towards the eye, and partly on the strength
of the reflections from surrounding objects, which
will help to light up the shaded portion. It is evident
that the folds of the dress will be filled with light re-
flected from the surrounding satin; and consequently
the white satin will have softer shading than most of
the face. It is also evident that the shading under
the chin will be relieved by reflections from the satin.

Where the surface is shielded from the direct rays
of light, a shadow is created; and the intensity of this
shadow will depend on the amount of light which is
reflected into it from the surrounding objects.

Thus, since no one would look at the sun or any
brilliant source of light if he could help it, we see all
objects by the light which they reflect; and when the
strength and direction of the illuminating light is such
that we see objects in a multitude of high lights, shad-
ings, and shadows, these objects appear very beautiful.
When the lighting is flat and diffused, there is but little

shading and less shadow, and the objects seem uninteresting. Colour may be beautiful; but even the most brilliant scene appears uninteresting without shadows and shading.

Now, most shadows, especially in England, are filled with luminous diffused light and are exceedingly delicate ; and the gradation of the shadings are so delicate that no human words could describe them or human hand depict them ; and the different high lights vary in intensity. Probably mezzotint is the most perfect method of working in tone, and Raphael Smith was the most skilful of engravers ; but even the hand of Raphael Smith could not rub down the burr of a copper plate, so as to render all the gradations in his mezzotints.

Well, the lens will catch all the rays of light, just as they would reach the eye ; and it will focus every shade of gradation on the sensitive plate with even more delicacy than the shading could be focussed on the human retina ; and most of this delicacy can be secured in the negative ; and quite as much of it can be reproduced in the print as human vision is able to appreciate.

And so, unless it be denied that exceeding delicacy in tone-work is an artistic virtue, the medium of photography must be included amongst the methods of artistic expression ; and its particular quality may be defined as follows :

THE ARTISTIC QUALITY OF PHOTOGRAPHY LIES IN A
 DELICATE RENDERING OF THE GRADATION IN
 HIGH LIGHTS, SHADINGS, AND SHADOWS.

IV. It may be argued, with much show of reason and many airs of superiority, that the same objection

which has been urged against the drawing of definition can also be urged against the drawing of tones and shading—that it is mechanical; that its gradations must be placed where they are undesired, as well as where they are wanted ; but this is not so.

As far as the quality of tone-rendering is concerned, photography is an exceedingly plastic medium ; for within certain limitations, and without interfering with the purity of the tone-work, the gradations may be placed almost exactly where the photographer wants them. The scale of gradations may be condensed into a very few tones, or it may be expanded to its full limit ; the delicacy of the higher tones may be brought out whilst the shadows are simplified ; the depth and richness of the low tones may be accentuated, whilst the high tones are rendered in a few tints of grey ; the picture may be printed in either a high or low key. All this may be effected simply by exposure, development, and printing, without interfering with the purity of the medium.

Again, it may be urged that it is irrational to talk about the perfection of photographic tone-rendering and suggest its simplification, all in the same breath ; but the same argument might be applied to that delicate instrument the violin, or to that delicate medium the novel. The photographer may not wish to develop the gradations in every part of his subject, any more than the musician may wish to bring out the full tones of his violin in every passage of his music, or the novelist wish to bring out the fullness of word-painting in every incident of his novel : the subordination of tone in some parts serves to throw up the tone in others.

Once again, in speaking of the shading of light and

The Artistic Side of Photography ♣

the gradations of photography, one is apt to speak of the scale of gradations as though they were split up into semitones or demi-semitones, whereas they come in a sweep that is as even as the flowing of water or as a slur on the violin. In Mr. Cadby's portrait of a child, reproduced on page 33, much of the delicacy must be lost in the reproduction, but sufficient will probably remain to give some·idea of the quality of photography. It will be noticed that the shading gives a solidity to the flesh that is most convincing, and I know of no other method of working in a high key that would give a similar result : the simplification of the child's frock is purely photographic. Other illustrations give examples of photographic shadow-rendering.

V. It would be absurd to compare photography with any other artistic medium—just as absurd as it would be to compare one sex with the other, or one species with another, or prose with poetry, or oil-painting with water-colour—and why attempt an absurdity ? But photography has a certain quality in tone-rendering which lends itself to certain effects, and which cannot be obtained in any other medium. It is only by realising both the virtues and limitations of the medium that photographers can hope to do good work.

Probably in my desire to emphasise the virtue of photography, which is tone-drawing, I have exaggerated its weakness, which is the mechanical drawing of detail. Certainly this weakness can be minimised in some branches and turned into an actual virtue in others.

Let some genius invent a perfect lens that will draw detail Where he wants it, and How he wants it, and

32

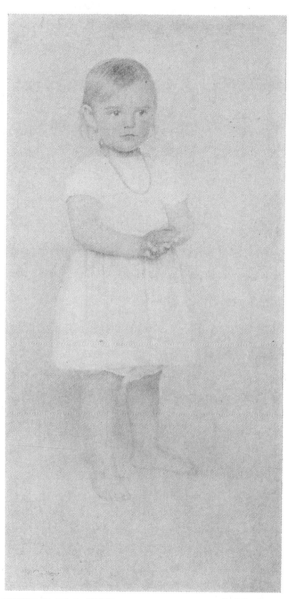

PORTRAIT OF A CHILD. *By Will Cadby.*

33

When he wants ; let him take a Fine Negative ; let him make a Fine Print ; let him call the artists and critics together and say :

"Sirs, I have discovered a Perfect Method of Working in Monochrome."

Then, if they be both connoisseurs and honest men, they will answer what they will answer.

LEAF FROM MY NOTE-BOOK

The Pianola versus *Billiards*

" They say," said Monica sadly, " that artistic photography is like playing the pianola ; and I don't like the pianola, Mr. Anderson."

" They do say it. I have heard even Evans say it ; but it isn't true." The girl's face brightened.

" If I had to make a print from a negative taken by some one else, and my work consisted only in softening some parts and emphasising others, then I should be like a pianola player. Pictorial photography is like billiards."

" Go on ! Please go on ! " urged Monica.

" One has to calculate the angles at which light rebounds from an object, just as one has to calculate the angles at billiards ; one has to calculate the rebound from soft or coloured objects, just as one has to calculate the absorption of energy and alteration of angle in the rebound from a soft cushion ; one has to get the exact strength in both exposure and development, just as one has to get the exact strength in a billiard stroke ; and one has to play for the break. A break commencing with exposure and ending with a perfect print from an enlarged negative is no small break, and each step must lead up to the next."

" Well played ! " whispered Monica.

" All this time the hand is governed by the eye and brain, just as in billiards ; but herein lies the differ-

36

ence : in making a billiard break, two players aim at exactly the same result—an addition to the score ; whilst in photography each artist aims at something entirely original. Good average pictorial photographers are about as common as good average billiard players ; but taking everything into consideration, is it strange that absolutely first-class men are rare ? "

" No, indeed," said Monica.

" As rare as a Roberts or a Stevenson ? "

CHAPTER IV

THE ARTISTIC USE OF THE MEDIUM

I. SINCE the last chapter commenced with a postulate that will bear revision and needs completion, it would be well to amend the original postulate and supply the complement :

POSTULATE I.—Each medium of artistic expression must have its particular quality.

POSTULATE II.—Art utilises the particular quality of the medium employed.

If each accepted art medium be an example of the survival of the fittest ; if each accepted art medium has survived simply and solely because it has some special quality that is suitable to the production of rich effects, or brilliant effects, or of effects in tone, the true artist will choose the particular medium that is most capable of giving the effect he is aiming at ; and, having chosen his medium, he will endeavour to bring out its particular qualities. It would be absurd to attempt to secure a water-colour effect with oils, partly because it would mean a neglect of the fine qualities of oil-paints, and partly because a water-colour effect could be obtained far better with water-colours. One does not cart manure in a carriage, nor does one go for a pleasure drive in a manure-cart, and only the lady novelist sends forth her hero to shoot partridges armed with a rifle.

Quite recently I met a marine painter who had

revived the old method of tempora painting (pigment mixed with egg instead of oil), because he thought that the medium would lend itself to the painting of lead-grey water ; and so it did.

II. We saw in the last chapter that the weakness of photography lay in the mechanical drawing of detail, whilst its virtue lay in the delicate rendering of the gradation in high light, shading, and shadow. The artistic use of the medium surely demands that its virtue should be utilised.

If the contrary held good—if the virtue of photography lay in the drawing of detail, and the weakness of photography lay in the tone-rendering, then the position of the worker in oil or gum-bichromate would be sound and reasonable ; but the photographer who adopts one of the controlled pigment-processes accepts the mechanical drawing of the lens, whilst he takes the magnificent tone-rendering of photography, and proceeds to manipulate it.

The gum-bichromate * print that is placed, face

* In "gum-bichromate," a sheet of paper is coated with a mixture of gum, bichromate, and some pigment—crayon powder, for instance. So soon as the coating becomes dry, the action of light renders the coating insoluble in water. The paper is printed under a negative until the shadows become more or less insoluble in water ; the high lights and half tones, which are shielded from the intensity of the light by the negative, remain more or less readily soluble in water. If the paper be placed in a dish of water, the superfluous pigment will gradually wash away and leave a picture in gummy pigment.

In the "oil process," a sheet of paper is coated with bichromatised gelatine. When printed under a negative, and damped, the shadows attract, whilst the high lights repel, printers' ink. The print is "developed" by dabs of a brush charged with printers' ink.

39

downward, in a dish of water and allowed to develop naturally, is as much pure photography as a carbon; but what gum worker would be content with such development? No! he turns on a jet of water to wash away the high lights, or he rubs the surface of the print with a pad of damp cotton-wool or a moistened paint-brush, so as to exercise "personal control." Taken in its purity, the gum-bichromate process is rather a flat and lifeless process, and no photographer would adopt it unless he intended to manipulate the print with a spray of water, brush, or cotton-wool. If the oil-print were printed mechanically, with an inked printers' roller, it would probably give results that were as natural as collotype; but the oil-printer takes a stiff little brush, charges it with printers' ink, and proceeds to ink up his print by "hopping" the brush on the surface of the gelatine. Considering that he has to ink the whole surface of his print evenly, to pick up the ink where he may happen to have dabbed it too thick, to get his effect whilst he maintains his values, and to do all this before the gelatine becomes too dry, what earthly chance have the poor unfortunate tones?

III. Now, there never was a more unsympathetic draftsman than the lens: each awkward curve in the subject is recorded, each ugly angle seems to be accentuated; and as to detail—a telegraph wire is drawn as a hard black line, and a telegraph pole or a notice board becomes the most prominent thing in the landscape. All the defects in outline (unless the gummist buries them in artificial patches of shadow), and much of the insistent detail, are reproduced by the pigment process, whilst each rub of the gum-worker's cotton-pad rubs away precious tones, and

each dab of the oilman's brush destroys the purity of the gradations.

And what is a controlled pigment print after all?

A controlled pigment print is something that has but little of the photographic virtue of tone and most of the photographic defects of drawing.

Again, what is a controlled pigment print?

It is something that might have been done better, and executed with far greater freedom, if the photographer had only taken the trouble of learning to draw, so that he could handle a paint-brush or crayon-stump with dexterity.

Let us consider the pigment print in its making: a man presses the rays of light into his service, and makes a negative that is full of delicacy of tone; then he takes this negative and proceeds to make a print from it, and he takes the print and proceeds to develop it into a picture, either building up the tones and values out of his head, or else washing out the delicate high lights by means of a wet paint-brush, water, and imagination.

He may have a rough proof before him as a guide; he may not. If the subject be a figure study, he does not return to his studio and re-pose his model and finish his picture from life, like a true artist. If the subject be a landscape, he does not carry his un-developed print into the open air and work from Nature: he works from a memory which is often days, and sometimes months old, and he has to begin and finish his print within, say, a quarter of an hour. If the photographer happens to have worked from a guide-print, the result is invariably quite different from the guide-print.

This controlled process is so uncontrollable that one

PORTRAIT OF MISS R——

By Alvin Langdon Coburn

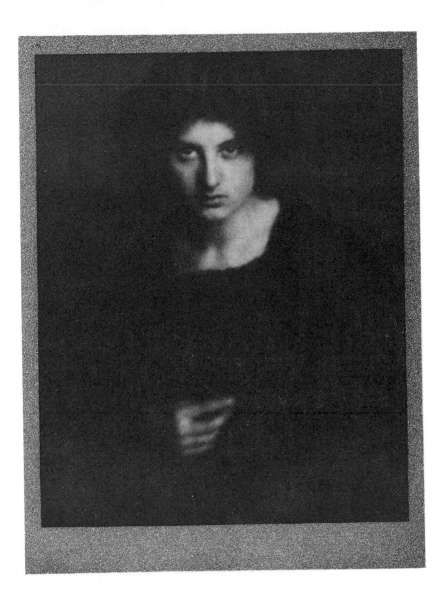

seldom sees two identical prints in oil ; and, with the exception of three or four continental gum-workers, no one can duplicate a gum-bichromate.

IV. If the sole virtue of photography lay in the accurate drawing of outline and detail, it could not be included among the methods of artistic expression ; for the draftsman can draw all but the most microscopic elaborations with equal accuracy, whilst he can soften ugly contours and omit useless details. Photography's one and only claim to be numbered among the recognised methods of artistic expression lies in the fact that it can force the rays of light to render gradation with greater delicacy than could be attained by human manipulation.

But when the worker in controlled pigment takes the development of tones into his clumsy hands—clumsy compared with the natural development of pure photography—he robs his medium of its essential and particular quality, without offering any compensating quality that will place his craft among the fine arts. Can either the gum-worker or the oil-printer claim that their methods give better tone-rendering than several of the older and recognised arts ? Can one imagine any sane artist giving up his brush or crayon to take up gum and oil, with all their limitations in drawing ?

V. And here follows a nice point in ethics : " Can the control-pigment print be termed a ' photograph ' ? " Should it not rather be called by some name that implies a superstructure of hand-made tone-work on a photographic foundation ? For, although it be photography up to a certain point, at the exact point where the vital quality comes in, the tone-work is rendered by the photographer's manipulation : it is

the action of the photographer's hand, and not the action of light, that creates the finish of gradation in both oil and gum-bichromate. The question is one of the utmost importance, and this for three reasons which closely affect the future of pictorial photography.

In the first place, when a member of the artistic world (a connoisseur, or artist, or critic) is shown a controlled pigment print, he may admire the picture, but he invariably feels (and usually says) that the effect might have been better attained in some other medium ; whereas, when he is shown a pure photograph by a first-class tonist, he discovers a distinction in the work that is beyond the skill of painter or engraver ; and, learning that this distinction in tone is the quality of pure photography, he realises that photography is a serious medium, with essential qualities of its own, and not a makeshift for those who cannot draw.

In the second place, an artistic person who takes up photography (and these are the very persons on whom the future of photography depends) is attracted by the prints which most resemble the crayons and engravings that he is used to ; and, since these are called " photographs," he is apt to overlook the true quality of the medium.

In the third place, controlled photography would take its proper rank and receive its proper recognition, if it were regarded as a separate craft, and not as photography that has been interfered with.

Besides, the controlled pigment process, whether in gum or oil, is a mixture of photography and manipulation, of the action of light and the action of the human hand ; it is of mixed origin, and has no more right to be called " photography " than the child of an English-

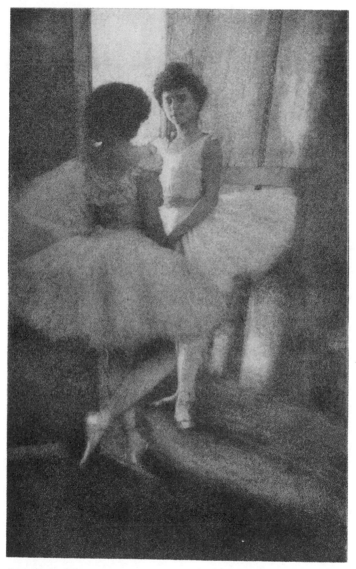

BALLET-GIRLS. *By R. Demachy*

man and Hindoo has to be called a European. Since controlled pigment is a complicated process, it should have a complicated name; since it is a mixed process, we need not hesitate to mix our languages; and *Photohomography* * is almost as descriptive as *Eurasian*.

VI. If only the term "photohomogram" were applied to a gum- or oil-print, the controlled pigment process would take its place among the lesser forms of artistic expression, and would become an admirable method for the man of leisure.

Some time ago an artist invented a new method of monochrome, which he called "monotype," and which had many of the qualities of gum-bichromate, with the exception of the photographic basis. A polished copper plate was coated with moist pigment; the high lights were rubbed clean and the middle tones lightened, until a picture was formed; from this a single impression could be taken on a sheet of paper. Very delightful pictures were made by this process; but there were two reasons why it never became a recognised medium: it was better to apply the pigment direct to the paper in the ordinary way; and since only one impression could be taken, no artist could make his living by monotype, and it was regarded as a dilettante method for men of leisure.

* In the dictionary of the future, we shall find :
Photonomography, *n.* the art of producing pictures by manual dexterity on a photographic basis.—*ns.* **Photohomograph, Photohomogram,** a picture so produced.—*n.* **Photohomo,** one who employs the process. (Gr. *phos, photos*, light, L. *homo*, a man, Gr. *graphein*, to draw.)

It is a good word, and no more a bastard than photogravure. Notice the crafty compliment to S. W. in Photohomogram ! *Photohomo* is also handy. (*Critic*: "Why not 'Photoman' ? " *Author* : "Why not ? ")

The Artistic Side of Photography ♣

In the hands of an exceedingly clever artist, like M. Demachy, gum-bichromate has an especial charm, and the artist can make suggestive sketches or landscapes of the Barbizon School at will. Artistic photography would be lost without Demachy; but there is only one Demachy. The oil method is inferior to photography in purity of tone, and inferior to mezzotint in richness and freedom of handling. Mr. Evans, as I write this, has made the practical suggestion that photohomographs should only be exhibited in photographic exhibitions as " Pictures by Photographers."

VII. Purists are only prigs and pedants under another name, and Art places no restriction on the artist. What a man chooses to do in his dark-room or studio is his private affair. It is the public appreciation and recognition of the qualities of a medium that matter.

After all, the artist is taking a portion of Nature that was never created for pictorial purposes, and making it into a picture. It may be necessary to strengthen a high light or darken a shadow, so as to " pull the picture together " and keep it within its picture frame. This may be effected by chemical means, without destroying the gradations, or damaging the purity of the tones. But if the photographer be a wise man and a true artist, he will work so as to bring out the full quality of his medium; for this is Art.

LEAF FROM MY NOTE-BOOK

Photogravure

" What do you think of photogravure ? " in-
quired Monica. " And how is it done ? " We had
been to Coburn's Exhibition of " London," and had
compared his photogravures of London with his
original photographs. Some of the photogravures
had seemed to show almost as much appearance of
control as oil-prints.

" To take the last first," I answered. " You know
what a carbon print is ? "

" A carbon print," replied Monica, putting her
hands behind her, " is a layer of gelatine full of carbon
dust stuck on a sheet of paper. Where the gelatine is
thin, the paper shows through and makes high lights ;
where the gelatine is thick, the carbon forms the black
shadows."

" Suppose you made the carbon print on a sheet of
polished copper, and placed it in a bath of acid ? "

" The acid would penetrate the high lights of the
gelatine where the gelatine was very thin, and eat
into the copper. As the shadows became stronger and
the gelatine thicker, the gelatine would protect the
copper more and more from the acid."

" Exactly ! But suppose, instead of making the
carbon print from the ordinary negative, you first made
a positive transparency, something like a rather dense,
flat lantern-slide, and printed the carbon from that ?

The Artistic Side of Photography ♣

The carbon print on your copper would be a nega-
tive print, and the acid would eat most strongly into
the shadows."

" Of course ! " assented Monica.

" If you were to photograph a line engraving, all the
little black lines would be eaten into the copper ; if
you cleaned off the gelatine, dabbed printers' ink on
the copper and wiped the surface of the copper clean,
the ink would be left in the lines ; and if a damp piece
of paper were pressed heavily on the copper, so that it
picked the ink out of the lines, you would get a re-
production of the engraving, only reversed from left
to right. But this would not answer with an ordinary
photograph. Why, Monica ? "

She thought a moment. " You would wipe the ink
out of the broad shadows, as well as off the high
lights."

" Exactly ! So the worker first makes a dust with
bitumen or resin powder, lets this dust settle on the
copper, and warms the plate until it sticks ; then he
makes the carbon print on the plate. In the acid
etching, the bitumen dust protects thousands of tiny
portions of the copper, and the shadows are protected
by tiny knobs of copper, which prevent the ink from
being wiped out of the shadows."

" And control ? "

" In a good negative the high lights are printable,
consequently the high lights in a photogravure may
be slightly etched. The professional worker brightens
the high lights by rubbing down the etched roughness
with a burnisher—he deepens the shadows by rolling
a wheel fitted with small, sharp spikes, over them.
But in so treating the plate he must destroy the delicate
gradations of the high lights, whilst he deepens the

shadows by pure hand-work. The true artist will control his effects in the proper chemical way whilst he is making the transparency and carbon print ; he can also do much by regulating the strength of the various acid etching-baths. This should retain the quality of the natural gradations."

"And the advantages of the process ? " inquired Monica.

"Having got your proof right, you can print off twenty copies before the copper shows wear ; or you can plate the copper with steel, and print off your thousands."

" It means that a perfect print by Mr. Coburn or Mr. Steichen may be cheap enough for people—even paupers like me—to buy."

" It means far more than this," I answered gravely. " The law of Life is, that no Art has become great until artists can live by their work : an amateur is always more or less of a dilettante. It means that pictorial photography will offer a livelihood, and that photography has, at last, the chance to establish itself as an Art."

B. THE HANDLING OF THE MEDIUM

CHAPTER V

THE SECRET OF EXPOSURE

I. As we have already decided in the previous chapters, the art of photography lies in rendering the gradations of light, shading, and shadow in their infinite delicacy.

The mechanical part of this rendering is done by the lens : thus, the brilliant rays of light reflected from a dewdrop are focussed on their proper spot in the picture, and appear on the focussing screen with all their brilliancy ; the feeble rays of light reflected from some shadow are focussed on their spot in the picture, and fall on the screen with a feeble gentleness. In this way the picture is mechanically reproduced on the focussing screen.

The lens is covered ; a sensitive plate (a sheet of glass, coated with a thin layer of gelatine containing minute particles of bromide of silver) is substituted for the focussing screen ; the lens is uncovered ; the picture is allowed to fall on the sensitive plate for a few moments ; the lens is again covered, and the exposure has been made.

Now, no one seems to know the exact effect that the light produces on the particles of silver ; and so, if I avoid scientific language and write in plain, non-scientific English, I must be pardoned.

The practical action of the light striking the sensitive film is very similar to the blow from a prize-fighter's fist. When the light strikes the film hard, it bruises deeply; when it strikes the film gently, the bruise is on the surface. This simile may be carried still further; for the light-bruise does not show at once, but grows black as soon as the plate is placed in the developer.

Again, a single sharp blow does not bruise the face deeply; but let a second blow fall on the same spot, and the blow seems to sink in, and the bruise becomes serious. In the same way, the evening light during an exposure of one second may not bruise the shadow portions of the film sufficiently; but let a second blow be struck by another exposure of one second, and the blow will sink in. In practice, such a blow is struck by one exposure of two seconds' duration.

In an under-exposure, the violent rays of light reflected from the dewdrop bruise the film; the gentle light reflected from a shadow fails to make a bruise and leave a mark.

In a correct exposure, the rays from the dewdrop bruise deeply, whilst the shadow-rays have time to keep on striking until they bruise the surface of the film.

In an over-exposure, the light batters away at the film, until it is heavily bruised all over.

II. Now, *the secret of good exposure*, as well as the secret of good development, lies in the fact that the film has appreciable thickness, and that the yellowish emulsion of the film has great light-stopping power.

The photographer who fails to realise this may do good ordinary photography, but unless he realises that the film has thickness, he can never bring out the full beauty of his high lights, nor develop the full richness

of his shadows. If the photographer wishes to understand his medium, if he wishes to expose and develop his plates like a rational artist and not like an automatic time-machine, he must work from this text :

The Film Has Thickness

Let us imagine that the film is half an inch thick ; or, still better, let us make an enlarged section of a negative by cutting it cleanly in half, and enlarging the edge where it has been cut : the enlargement would form a diagram something like this :

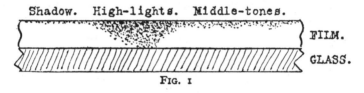

Shadow. High-lights. Middle-tones.

FILM.

GLASS.

Fig. 1

Let us forget for a moment the simile of the prize-fighter's fist, and picture the light as a bullet striking a piece of timber : the rays of light are our bullet ; the yellowish film of sensitive emulsion is the balk of oak timber.

The weak light reflected from the shadows would be like a spent bullet—it would bruise the surface of the film without penetrating. The moderately strong rays would be like a bullet propelled by a moderate charge of powder—they would lose momentum and force as they penetrated the film, and would stop within a short distance of the surface. The strong rays of light would pierce right through the film, just as a modern rifle bullet would pierce through the balk of timber.

Thus, in our diagram the shadow gradations are quite on the surface of the film ; the gradations of the

middle tones have penetrated to some little depth, and the gradations of the high lights—please notice this, it is very important—the gradations of the high lights are deep down in the film. It is very important, because the high lights have pierced through the surface of the film with the violence of a rifle bullet, bruising every particle of silver in their passage, and the delicate gradations of the high lights will be found deep down in the film, where the light has begun to lose its momentum.

The approximate truth of the foregoing diagram may be easily determined by a very simple experiment. Take two thinly coated sensitive plates ; put them together, film to film ; place them in a dark slide, taking care to wipe the back of the outer plate absolutely clean ; place the dark slide in the camera, and expose fully on some very contrasty subject ; then develop the two plates in the same dish. The plate that was nearest the lens will be found to contain all the shadows and half tones, but the high lights will have pierced right through this outer plate, reducing the silver particles to one even mass of blackness. The plate that was farthest from the lens will have been reached by none of the shadows and half tones, but it will have the most wonderfully delicate gradations in the high lights. This, of course, shows the importance of having thickly coated plates, otherwise the high lights will be apt to pierce so strongly through the film that their gradations will be lost. It also makes us consider whether the use of a double-coated plate—I mean a plate in which the outer layer of emulsion is very rapid, so as to catch the shadows, and the inner layer of emulsion slow, so as to stop and catch the high lights—is not the way to deal with all subjects that have strong contrasts.

The Artistic Side of Photography ♣

If the reader should wish to try a more simple experiment than the above, let him take a discarded negative and rub the surface of the film with globe-polish : the shadow details will quickly rub away, then the middle tones will rub away, and so on.

III. Of course, if only the ordinary type of photography be contemplated, that is to say, normal exposures, normal development, and prints like those produced by a good professional landscape photographer, there is no great importance in this chapter ; for the purchase of Mr. Watkins's Manual will enable the photographer to turn out the ordinary thing in the ordinary way, with the regularity of clockwork.

But I am assuming that my reader may wish to work with his understanding ; that he may wish to bring out the full richness of his shadows, or to accentuate the delicacy of his high lights ; that he may aim at a picture like one of the illustrations that grace this book. If such be his wish, and such his aim, then these diagrams are of great importance.

Suppose, for instance, that the artist should desire to render his subject in a high key, with soft, pearly high lights full of delicate gradations, with cool grey shadows showing but little detail. Suppose he should wish to sacrifice the shadow details in order to secure the full beauty of the high lights ; this diagram would show the type of exposure he should aim at :

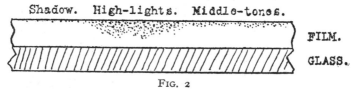

Fig. 2

The exposure should be short, so as not to allow

58

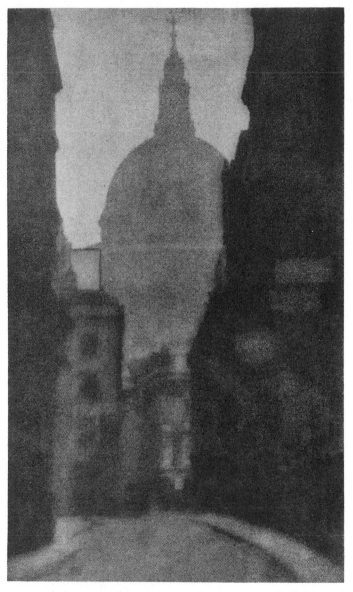

ST. PAUL'S. *By W. Benington.*

the violent high lights time to pound away at the surface of the film, to bruise the surface of the film and penetrate deeply into the film ; they must be kept on the surface of the film, so that they may be easily reached by the developer and quickly developed. Then, when the plate is properly developed, the high lights will have just sufficient density to print delicate gradations before the empty shadows are printed too dark.

IV. Again, suppose an artist should wish to depict an evening scene, in a low tone suggestive of evening ; and suppose he should wish (as would be right and proper) to secure full, rich gradations in the shadows, a very desirable diagram of exposure would be as follows :

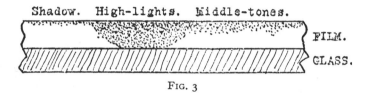

FIG. 3

Here the exposure should be very generous, for the faint light reflected from the evening shadows must be allowed plenty of time to impress itself on the film. If the exposure be too short, the shadow details will not be recorded, and consequently they cannot be developed.

Of course the question of developing these and other exposures will be considered in the next chapter. Also, there are many other variations of exposure ; but when the photographer has once grasped the principles of these, he can easily think out other variations for himself.

V. Whether the photographer wishes to shorten the exposure, so as to secure full details in strong high light, and lessen the rendering of shadow detail, or whether he wishes to prolong the exposure so as to catch every detail in the shadows, he must start with a knowledge of the correct normal exposure.

There are two methods of determining the correct normal exposure, and there is not much to choose between them. In the exposure meter a strip of sensitive paper is exposed to the light, and the exposure of the sensitive plate is determined by the speed with which the paper darkens ; in the exposure-table method the photographer has to determine whether the light is bright, cloudy, or dull, and calculate the correct exposure by means of certain simple tables : the choice between the Watkins or Wynn exposure meter and the Welcomes' pocket-book and " Exposure Record " is a question of personal taste.

It must always be remembered that a normal exposure gives the maximum gradation throughout the high lights, shadings, and shadows, and these gradations ought not to be tampered with unless there be due cause. The play of light and shade, the gradations of half tone and shadow are very beautiful; and to tamper wantonly with these things is to rob the medium of its particular quality. Of course there is no need to develop a fully exposed negative until it will print a full scale of gradation, ranging from pure white to dark black ; but a fully exposed plate may be developed into a negative that will give a print similar in quality to a refined mezzotint. A meaningless under-exposure is, after all, a very "cheap" form of Art.

Under-exposure must leave its mark, for it is im-

possible to develop detail that has not been impressed on the plate ; but the modern plate is thickly coated, and a generous exposure may be given with safety. The image on a reasonably over-exposed plate will take longer to print than one which has been exposed correctly, but the prints from the two negatives will be almost exactly the same. Therefore, if there should be any doubt as to the correct exposure, it is always well to err on the side of generosity.

But, as I have pointed out, there are exceptions to normal exposures—there is the high-keyed print, for example, with its delicate high lights, or the low-toned print, with its luminous shadows. The right rendering of a puff of steam, floating against the sky, would demand an exceedingly short exposure.

The artist's maxim is : " Expose for the tones that are most desired."

LEAF FROM MY NOTE-BOOK

An Exposure

September 1907.—This morning poor little Eileen
came to me in great trouble. " All the exposures of
all the photographs I took in the holidays are wrong,
Mr. Anderson ; and I did take such pains ! "

I tested the shutter—it is one of those pretty, plated
between-the-lens shutters that they fit to three-guinea
cameras—and not one of the speeds is correct. The
" one second " worked at three-quarters, the " quarter-
second " worked at about one-tenth ; the rest of the
speeds, from " one-twentieth " to " one-hundredth,"
all worked at exactly one-thirtieth of a second.

These cheap between-the-lens shutters play the
deuce with short exposures. They are never accurate,
and they spend most of the exposure in opening and
shutting : whilst they are opening or shutting, they
are cutting off some of the light. The roller-blind
shutter seems accurate, and so long as one allows for
the fact that it is covering part of the lens during most
of the exposure, and therefore gives an extra long
exposure, the roller-blind is not half bad. The focal-
plane is far and away the most reliable and efficient.

The dealer sold Eileen all sorts of elaborate appli-
ances for determining the correct exposure ; he sold
Eileen this lying shutter ; he sold poor Eileen !

CHAPTER VI

I. THE secret of development, like the secret of exposure, lies in the fact that the film has thickness.

In exposure, the thickness of the film prevents the light from penetrating too far into the gelatine ; in development, the thickness of the film prevents the developer from circulating freely through the depths of the film. As the delicate gradations of the high lights lie far down in the film, these must be reached and developed.

Now, most developers rapidly become worn out with the labour of blackening the light-struck silver ; and the moment a developer becomes worn out, it ceases to act. The silver particles which are near the surface of the gelatine are safe enough, for the bulk of the developer is flowing to and fro over them, and continually bringing fresh developer into contact with them ; but the silver particles which lie deep down in the film have no such generous supply. When the first dose of developer, which has been sucked down into the depths of the high lights, has become exhausted, the silver particles can attract fresh developer only as it circulates through the gelatine. The following diagram is self-explaining :

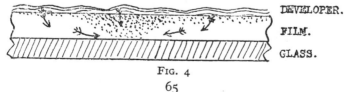

DEVELOPER.

FILM.

GLASS.

FIG. 4

The Artistic Side of Photography ♣

At first sight, it seems strange that the deeper gradations of the high lights ever develop properly ; but it must be remembered that the first dose of developer which reaches them is fresh ; and that, whilst the developer on the surface is becoming worn out, the deep gradations are drawing fresh supplies of unused developer from the surrounding film. But whether the gradations of the high lights draw their fresh developer from the chemicals in the dish, or whether they draw it from the chemicals in the surrounding film, or whether (as is most probable) they draw it from both sources, the developer takes time to circulate, and the gradations of the high lights take time to develop.

II. Now, we commenced the last chapter by comparing the action of the light on the film to the action of a prize-fighter's fist on the human face, and we can again apply the simile. Take a heavy blow, and a light blow ; the heavy bruise begins to blacken first ; the light bruise begins to blacken later in the day, acquires its colour quickly, and when it has discoloured slightly stops growing darker ; the heavy bruise goes on discolouring, long after the light bruise has ceased to darken further.

So it is in a sensitive film : the high lights, which have been struck violently, begin to develop first ; then the shadow details commence development, develop quickly, and stop development. The high lights continue to develop, long after the shadows have stopped, and continue to pile up density to almost any extent.

Thus we have three factors to consider in development, the relative importance of which depends on the nature of the result desired :

(*a*) The surface of the high lights—that is the coarse parts of the high lights which are on the surface of the film ; and on these depend the contrast and strength of the photograph.

(Some may say that the shadows give strength to a print ; but a moment's thought will show that the shadows only print dark because the high lights are dense, and that the depth of the shadows is determined by the time which the high lights take in the printing.)

(*b*) The shadows, which lie on the surface of the film, and on the gradation of these depends the richness of the photograph.

(*c*) The deep gradations of the high lights, which lie deep in the film, and on these depends the delicacy of the photograph.

(*d*) There are also the middle tones, but these, I think, must be left to take care of themselves ; and if the contrasts are right, the half tones may be trusted to turn out right.

Now (A) if we take a good ordinary negative and rub away the surface with globe-polish ; if we rub until we have quite rubbed away the shadow details and nearly rubbed away the middle tones, we shall also rub away the surface of the high lights. This part of the high lights that we have rubbed away is the coarse part, and if we could examine it we would find that it had an even tone of density, without any gradation.*
The function of this coarse part is to give strength to the high lights ; it has been too heavily bruised by the

* I do not claim that this (A) is scientifically accurate, only approximately and practically accurate. What more do you want ?

67

THE CRYSTAL GAZER

By Mrs. G. Kasebier

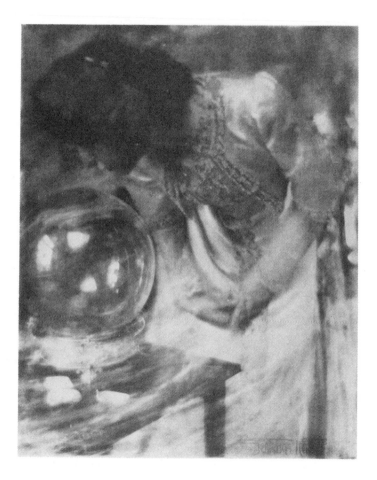

violence of the light to have any appreciable grada-
tion ; it has been so heavily bruised that, if the plate
be left in a strong developer, it will become vastly
dense. If this coarse part be over-developed it will
simply bury and kill the delicate gradations of the high
lights : it must be developed sufficiently to give
strength, without causing the high lights to print out
too white. It is an important part of the negative,
because it is the part that one keeps on developing
until one has secured the desired amount of contrast.

(B) So long as (that unnecessary and harmful
ingredient) bromide is not mixed with the developer,
the shadows, which are on the surface, will get a
constant change of developer, and should cause no
trouble.

(C) If it be desired to develop the delicate gradations
of the high lights, deep in the film, the developer must
have plenty of time to circulate through the film. A
diluted developer will reach and develop these grada-
tions before the coarse surface of the high lights
attains too much density. This will be considered
presently.

III. Next as to the developer. I shall assume that
pyro-soda be employed, partly because pyro gives a
fine printing quality to each particle of silver that it
develops ; partly because the shadows in a pyro nega-
tive do not lose density in the fixing bath ; partly
because one must assume a definite developer. I have
given a pyro formula in the last chapter for a developer
that stains neither film nor fingers.

Now, experience shows that a very weak developer,
say half a grain of pyro to the fluid ounce, takes very
much longer to develop a plate than one that is strong.
Reason argues that when the subject is flat, and

there are no honest high lights, when the image is quite close to the surface of the film, the developer is bound to reach the whole image, and the strength of the developer is of no material importance; but when there are fairly strong contrasts, and the gradations of the high lights are deep down in the film, a diluted developer gives its chemicals much longer to circulate through the film and develop the delicate gradations of the high lights. Some years ago I made a long series of experiments with developers of different strengths. The subject was a child in a white silk dress, and the value of the light during the different exposures was identical. In every case I found that the diluted developers gave the best gradation in the high lights.

This is an important point to bear in mind (in a negative as well as a positive sense), for there are cases where it is desirable to simplify the details of the high lights.

Bromide seems entirely unnecessary in all ordinary cases, and the use of bromide in the developer certainly holds back the shadows, and alters their value during the earlier stages of development. When the development is shortened in order to secure a very soft negative, bromide becomes a positive danger. However, bromide sometimes has its uses, as we shall see presently.

The last chapter contains full directions for the development of a negative with ordinary contrasts.

IV. So far, we have chiefly considered the development of the ordinary type of negative, with its fairly long scale of gradations; now let us consider the development of a negative in which the subject is rendered in either a high or low key. The same principle

of development still holds good—the film has thickness and the developer has to circulate through the film. As a rule, both high and low tone negatives should be rather thin ; the high tone negative will be printed lightly on the printing paper, whilst that in a low key will be printed deeply.

We will imagine that the subject is a landscape, towards evening, and that our artist wishes to depict the subject in a low, restful key. The high lights are not over-strong, and he has given a long exposure, so as to secure a full richness of detail in the shadows ; then he has to face the task of developing the shadows so as to bring out the full richness of detail.

These shadows are quite on the surface of the film, and a warm, strong developer rocked to and fro over them would develop the details with rapidity, before the rest of the negative attained much density. For reason says that these shadows are " surface bruises," and that once they begin to develop they will develop quickly ; and experience teaches that a strong, warm developer will set to work quickly, and that it will develop the shadows before the high lights have attained much density. It is true that the developer would not have much time to circulate through the film and develop the gradations of the high lights ; but our artist is aiming at the shadow-rendering, and must be prepared to sacrifice something of the high tones ; in fact, he regards the high lights merely as objects that will give contrast to the shadows. From the moment that the shadows have developed, the photographer begins to watch the high lights closely ; and the instant he considers that the contrast between high lights and shadows is sufficient, he stops development. The high lights will be rendered in masses of

grey, with only slight gradation, but the shadows should be very rich.

Again, let us take another type of picture in a low key. Imagine that the subject is another evening scene, but that the charm lies in the high lights. It is an evening scene, so it may be rendered aptly in a low key; but since the quality of attraction lies in the high tones, the high tones should be considered in both exposure and development. Reason will tell our artist that a short exposure is needed to render the high tones—the shadows, in this case, are of secondary importance. Reason tells him that if he uses a very weak developer, and aims at the thin negative required for low-tone printing, the developer will have plenty of time to reach and develop the gradations of the high lights: so he mixes a weak developer, and as soon as the contrasts please him, stops development.

I have spoken of sacrificing either shadows or high lights, just as though this " sacrifice " would make the picture imperfect ; but in many cases the simplification of details in one or other of the tones is the very thing needed to perfect the rendering of a subject. If the tones of the high lights in a picture are very beautiful, detail in the shadows may draw away the attention from the beauty of the light tones, whereas simple shadows may serve to emphasise their perfection.

V. Next let us consider the development of a negative in a high key. There is something luminous and pearly about the chief high light in the subject—I have again to make use of the word " pearly," because the shimmer of light from pearls is the only thing that will describe my meaning—and the artist is determined

to secure this quality. If the whole of the subject had been flooded with light, a simple orthochromatic exposure might have met the case; but in this instance there is a heavy foreground, which the artist wishes to bring into tone with the rest of the picture.

He would start by giving a short exposure, so as not to drive the high lights too deeply into the film. He would prepare a weak developer, say half a grain of pyro to the ounce, and he would use only just sufficient developer to cover the plate. Now see what would happen—the film would start with sucking in a full charge of absolutely fresh developer; the developer on the surface would soon become worn out (for there would be but little of it), whilst the high lights would continue to draw a fresh supply of chemicals from the surrounding film of gelatine. A diagram may be useful.

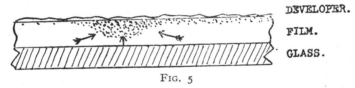

DEVELOPER.

FILM.

GLASS.

FIG. 5

If the image should seem lacking in contrast when developed, the worn-out developer should be poured away, and development finished with a fresh solution.

However, in a high-tone picture the accent need not always rest on the lightest tones. For example, suppose our artist should wish to photograph a girl in a white dress against a white background: he would naturally aim at bringing out the value of the flesh tones, whilst he would be content with "sketching in" the folds of the drapery. A full exposure would impress the tones of the face on the sensitive film;

a full development in a strong developer would secure these flesh tones ; whilst the dress would develop such density, that only the shadows in the folds would print out. Of course the resulting negative would be dense and require patience in the printing, but the result should be very delicate.

VI. Some years ago I had an experience which throws a sidelight on development. For a long time I had been trying to secure a really interesting photograph of a steeplechase, and towards the end of a meeting I had the luck to make an exposure which promised well. When I came to develop the plates, I found to my disgust that I had carelessly filled my slides with slow orthochromatic plates, instead of extra rapid ones. I tried to coax out those wretched negatives in every way I could think of, but without success. Finally I grew desperate, and when I came to my important exposure—it was the picture of a bay horse, ridden by a jockey with white jacket, white breeches, and a light blue cap—I tried a desperate remedy.

Now, as I argued, a warm and strong developer forces development, whilst strong bromide stops development and checks chemical fog ; also, I wanted to develop the bay horse on the surface of the film, and I did not care a rap about the jockey's jacket and breeches. So I mixed a hugely strong pyro-soda, with tons of soda in it ; heated the developer almost up to the melting-point of the gelatine ; added plenty of bromide, to prevent the chemical fog which such a developer would be likely to produce, and set to work.

First I soaked the plate in a ten-per-cent. solution of bromide, until the film was full of the chemical ; then I washed the surface of the film under the tap, so as to

remove the restrainer from the surface ; then I poured on the hot developer. Naturally, the bromide in the film stopped the development of the high lights, and only the surface was developed ; but the plate developed quickly into a nice clean negative ; and although there were no gradations in the jockey's clothes, the horse came out capitally.

Inversely, if an exposed plate contained a very contrasty subject, and the photographer wished to secure the gradations of the high lights, he might place his plate in the developer for a few seconds, until the gelatine swelled and absorbed the developer ; then he might place the negative in a dish of clean water, rocking the dish, so as to wash the developer out of the surface of the high lights, whilst the developer in the film continued its work ; finally he would return the plate to the developer, until development was completed. I have never tried this method, but it sounds reasonable.

VII. The secret of both exposure and development lies in the fact that the film has thickness ; that the shadows and high lights lie at different depths in the film ; that the developer washes to and fro over the shadows, whilst it has to circulate through the gelatine in order to reach the gradations of the high lights— the rest is only a matter of deduction and reasoning.

My diagrams must not be taken as scientifically correct ; they are only meant to illustrate my meaning.

LEAF FROM MY NOTE-BOOK

The Development of a Subject

" Mr. Anderson," began Monica, " in the beginning
of our "—blessings on the " our " !—" book, you
wrote that the quality of photography lay in the
delicate rendering of the gradations in high light,
shading, and shadow ; now you speak of simplifying
the gradations of the shadows by under-exposure.
Is this quite consistent ? "

" We had some most excellent fish with some most
excellent sauce, and some most excellent Chablis for
dinner last night. I simplified the fish by leaving out
the sauce, so that I might the more fully enjoy the
wine."

" That sounds greedy," sniffed the girl, " and not
very convincing. Please develop your argument, Mr.
Anderson."

" I have always said," I continued, " that a beautiful
dress needs a beautiful figure. You have a beautiful
figure, and you wore a most beautiful dress last
Thursday : the effect was magnificent. But——"

" Yes——? " said she.

" Now take your face as the high lights, and your
dress as the shadows ; the details of last Thursday's
dress took off attention from your face. I much
prefer you with simple ' shadows,' like the washing-
gown you are wearing, so that my attention may not
be distracted from your face. You are very beautiful,
Monica ! "

" Mr. Anderson ! " she cried, half angry.

" I was only developing the argument," explained I.

CHAPTER VII

FOR some reasons, a chapter on orthochromatic photography ought to be inserted here ; for other, and more weighty reasons, the chapter ought to fall towards the end of the book.

In theory, the ordinary sensitive plate is insensitive to those colours which affect the human eyesight most strongly : red, yellow, and yellowish-green affect the ordinary plate no more than if they were black. On the other hand, the ordinary photographic plate is exceedingly sensitive to the darker violet-blues, colours like indigo, which are almost invisible to normal eyesight ; and it is also very sensitive to those rays which we term " ultra-violet," rays that are absolutely invisible to human vision.

This is theory. In practice, nearly all objects reflect such a large quantity of white light (this white light includes violet, indigo, and the other chemically active rays) that a well-exposed photograph, taken on an ordinary plate, is not usually unsatisfactory. As a matter of fact, many of the finest photographs that have ever been exhibited have been taken on ordinary plates. To preach orthochromatic methods as the sole way of salvation, is to damn the work of the late D. O. Hill.

The more I see of the artistic side of photography, the more am I inclined to think that it is based on

what is known as " ordinary photography "—that is to say, the employment of the ordinary plate, or of the orthochromatic plate without the colour screen. The photographer who takes up chromatic photography in its full purity, with a plate bathed in isocyanin and a correct colour filter, must surrender much of the power that enables him to work in either a high or low key ; and, with the exception of selecting his subject and choosing his station-point, his work must be more or less mechanical. But a knowledge of the principles of rendering colour into monochrome is necessary, and a full or partial use of chromatic methods is often most desirable.

I have done my best to face this most difficult question in Chapter XXII.

CHAPTER VIII

THE PRINT

I. WHEN a painter wishes to produce rich and strong effects of colour, he uses oil-paint as his medium. In practically all other cases, whether the artist be working in colour or monochrome, he selects some medium which gives an absolutely dead surface.

The question of lustre or shininess in a monochrome picture is only a matter of taste ; but since all great artists, in all ages, have avoided lustre in monochrome, we can hardly deny that good taste dislikes shininess. Of course we independent Englishmen have every right to use print-out paper, and squeegee our prints until their surface is as bright as a dish-cover ; we have every right to follow the example of those nineteenth century barbarians who varnished their precious mezzotints ; we have every right to range ourselves with those vulgar souls who delight in brilliant chromolithographs ; and we have every right to class ourselves with savages in their love of things which shine, glisten, and glitter. But artistic minds must feel that "lustre or shininess is always, in monochrome, a defect." I have substituted the word "monochrome" for Ruskin's "painting."

Any one who has held up a transparency before a white reflector will have realised how luminous a really good transparency is. A wash drawing, a mezzotint, or a platinotype is only a transparency

combined with a reflector, the image being the transparency and the white paper the reflector : the light shines through the transparency and is reflected back again through the transparency. Any shininess in a print must reflect back some of the light, before it has pierced the surface of the image. A moment's thought will show the difference between the mock luminosity of a varnished or glazed shadow, and the true luminosity of a platinotype shadow which is lit by feeble rays of light from the white paper behind it.

II. There are two printing papers which seem admirably fitted for pure photography, papers which give permanent prints, and which render the most delicate gradations of the negative—carbon and platinotype. The former gives an image in charcoal or pigment, held in a thin coating of gelatine ; the latter, an image in pure platinum, which becomes part of the paper.

The pictorial difference between carbon and platinotype is, that the former must have a certain lustre, due to the gelatine ; whilst the latter has a surface which is as dead as the surface of a mezzotint. I do not say that this lustre in carbon is more than a necessary defect ; in fact, a carbon print must have juicy shadows, if it is to avoid all suspicion of flatness ; but I do say that this quality, which demands that carbon work should be hung so that it does not reflect the light, is troublesome.

Platinotype, on the other hand, draws its richness from the rendering of the most delicate gradations, and derives its luminosity from the light reflected by the white paper behind the image.

It is rather astonishing to notice how the number of platinotypes at the leading exhibitions is decreasing.

But then, vanity is a strong factor in the artistic character, and the photographer naturally likes to feel that he has done something more than the printing of a print in the simple process of platinotype. He wants the " ipse fecit " writ large over his picture.

On the other hand, it is consoling to realise that many of the greatest among the English and American schools are faithful to platinotype ; and it is consoling to foresee that as soon as pure photography has regained its position—this time on artistic instead of techincal grounds—platinotype will receive due recognition.

III. Platinotype is at once the easiest and the most difficult of methods. It is the easiest, because the making of the print is easy ; it is the most difficult, because it repeats the faults of the negative with exact accuracy.

The two bogies which have kept many from adopting platinotype are the bogies of damp and " floating." Personally, although I have used platinotype for years, I can remember only one failure through damp, and that was due to the temporary use of an attic with the moisture running down the walls. I have experienced no difficulty in floating my prints, because I do not float them.

It is quite a sufficient protection against dampness if the paper be kept in a calcium tube, with the lump of carbide which was packed with the paper transferred to the tube. It is totally unnecessary to dry the negative before placing the paper in the printing frame ; and the sheet of rubber need only be placed behind the paper when the frame is placed out of doors on a damp day.

Then as to floating the paper, face downward, on

REBECCA

By Frank Eugene

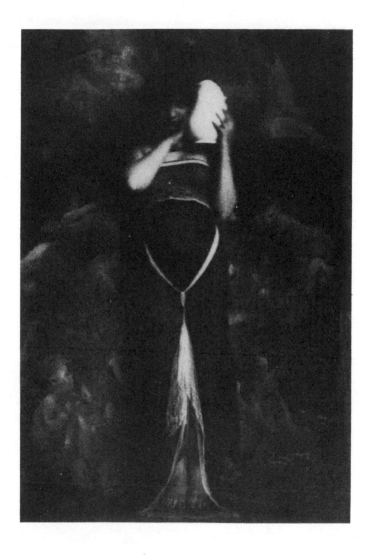

the developer, and running a serious risk of air bubbles and development marks—why not lay the print, face upwards, in a clean developing dish and pour the developer over it, as though it were a negative ? Theoretically, the developer may wash away some of the platinum, but unless the fluid be very hot this does not seem to make any practical difference.

Of course an enlargement in platinotype requires an excellent enlarged negative, since there is no shininess to gloss over defects in the shadows, and defects in the high lights cannot be scraped away like those in carbon ; but this technical challenge should only be an incentive to the photographer, and urge him to show that he is a workman and no duffer.

IV. I hold no brief for platinotype. The only drawback to carbon is its lustre.

LEAF FROM MY NOTE-BOOK

Is the Lustre of Oil Painting a Defect?

Of course it is ! It is as much a defect as the heat of my reading-lamp, or the smell of smoke which hangs round my study, or the moisture on Monica's forehead after a rousing game of tennis.

But I cannot get my light without heat, nor my smoking without smell ; neither can Monica enjoy her tennis without dewdrops. It simply comes to this : one can't have one's game without burning the candle ; and—Is the game worth the candle ?

Looking at the lustre of oil-painting as a defect, the question is, whether the richness of colour in oils is worth the shininess ; because, sad to say, one can't get the full richness of pure colour in solid painting without the lustre. It is not the surface lustre that gives the richness, it is the oily mass of paint beneath.

Take a sheet of white paper and paint it with thin washes of water colour. The light strikes the white surface of the paper, and is reflected back through the thin layer of colour. But take a canvas and paint it with thick brush-strokes of dead, solid colour ; and the effect is exceeding chalky.

The light strikes a dead mass of colour, green for choice ; and Heaven only knows how the light rays get worried and broken up. But make the pigment oily and lustrous, and the light is reflected back from

88

the oily mass of pigment through the outer surface of colour.

If the lustre of oil is a defect, the shininess of varnish is an evil; but, unfortunately, varnish is needed to protect the pigment from the air, so it becomes a necessary evil after all.

The varnish on Botticelli's " Birth of Venus " at the Ufizzi Gallery destroys much of the picture's delicate beauty; but without the protecting varnish it is doubtful whether any beauty would still be visible.

C. SOME ARTISTIC PRINCIPLES OF PHOTOGRAPHY

CHAPTER IX

PERSPECTIVE AND THE LENS

I. EVERY one must have seen the freak photograph of a man lying down, with his feet towards the camera, and have noticed that the feet appear double the natural size. This is not the fault of photography, but the fault of the ordinary camera manufacturer, who invariably fits a lens of far too short a focal length for the plate it is intended to cover. If the camera had only been fitted with a lens of double the focal length, the feet of the reclining man would have appeared a natural size.

Since a practical example is worth several pages of argument, I reproduce copies of two photographs which I myself took—one with an ordinary five-inch "quarter-plate" lens, and the other with a lens of about fourteen inches in focal length.

Again, every one must have noticed that the ordinary landscape view is entirely misleading, and gives a very false idea of the place which it is intended to depict. If we know the locality, we at once realise that the distant hills look half their proper height, and consequently appear dwarfed and insignificant, whilst the country seems far too large and flat. This is also due

The ill-proportioned figure of a horse in the left-hand bottom illustration is due to the use of a short-focus lens. The second illustration, in which the horse appears natural, is due to the use of a fairly long-focus lens.

The small photograph of the two boys was taken with a 10-inch lens on part of a quarter-plate, and only embraces a view-angle of about 4 degrees.

FIG. 6. Angle of 4°.

5 inch ¼-plate lens. FIG. 7. 14 inch ¼-plate lens.

91

to the use of a lens of insufficient focal length. If the lens had been double the focal length of the one employed, the hills would have been drawn twice as large, and they would have appeared the same size as those which we remembered.

Perspective is the drawing of solid objects, situated at different distances from the eye, on a flat surface— as, for example, the drawing of the nearest and more distant parts of a building on a sheet of paper. For practical purposes, we may take a window-pane as the picture surface, and, closing one eye, draw the outline of a distant tree on the glass with a brush dipped in pigment. The farther the eye is placed away from the glass, the larger will be the outline ; and a tree that would be drawn three inches high when the eye is one foot from the window-pane, will be drawn six inches high when the eye is placed two feet from the window-pane.

Now, this last paragraph is most important, because the whole theory of having the right lens fitted to the right camera depends on it. When I say that ninety-nine out of every hundred lenses that are sold are far too short in focal length for the plates which they are listed to cover—far too short in focal length to give a natural and artistic perspective—I am not overstating my case. So I must ask any one who intends to take up photography, or even any one who is simply interested in photography, to arm himself with a paint-brush, some thick sepia or lamp black, a sheet of glass measuring about eight by six inches, and to make some experiments in drawing perspective on the sheet of glass.

(*a*) First, let him take his stand in a meadow, choosing a station-point that will give him a pleasant

picture through the glass ; and, holding the glass exactly twenty inches from his eye, let him outline some prominent objects in the landscape. He will get a perspective similar to fig. 8.

(*b*) Then, without moving his station-point, let him hold the glass exactly ten inches from his eye, and outline the same objects. There will be more of the subject included on the glass, and all the objects will be half the size of those in fig. 8 ; but the relative

FIG. 8 FIG. 9

proportions of the objects in fig. 9 will be similar to those in fig. 8, and consequently the perspective will be the same.

This is part of the theory of perspective. The perspective depends on the station-point, and whether the objects be drawn on the larger or smaller scale, the perspective remains the same. But in practical picture-making this theory falls to the ground, as we will see from the following :

(*c*) Again taking the six-by-eight sheet of glass, let the student hold it at exactly ten inches from his

eye, and try to compose a pleasing picture through the glass. He will immediately move closer to the tree in the foreground, so as to get it a fair size in his picture, and this tree will be drawn much the same size as the tree in fig. 8, whilst the distance will come small, like the distance in fig. 9. And, since we are inclined to fix the scale of proportions by the objects in the foreground, the distance will appear dwarfed.

I am drawing the perspective of a picture on a sheet of glass, and I need a figure in the foreground. Monica is kind, and poses for me. I want my foreground figure to be a reasonable size ; and whether I hold the sheet of glass ten, or twenty, or thirty inches from my eye, I shall choose my station-point so that the image of Monica comes a reasonable size. This is only reasonable, and every one else would act in the same way. Confound the distance !

FIG. 10

Of course this idea of drawing the perspective of a picture on a sheet of glass is only theoretical ; but since it is an established part of the theory of drawing, and since it fits in very admirably with the theory of photography, I make use of it.

In photography the lens takes the place of the human eye, and the perspective is determined by the station-point of the lens ; the sensitive plate takes the place of the sheet of glass on which our student drew his perspective, and the scale to which the subject

is drawn is determined by the distance between the centre of the lens and the sensitive plate. The following diagram should make all this clear :

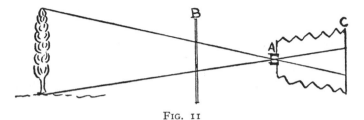

FIG. 11

When a lens is focussed on some very distant object, the distance which separates the optical centre of the lens from the focussing screen is called " the focal length " ; thus, a five-inch lens is one which must be placed five inches from the focussing screen (or sensitive plate), in order to bring distant objects into sharp focus. A five-inch lens would, of course, photograph objects to a certain scale and in a certain perspective. It will be seen from the foregoing diagram that if the eye were substituted for the lens, and the different objects outlined on a sheet of glass held five inches from the eye, the perspective, proportions, and size of these objects would be in all points similar to the scale in the photograph.

II. The focal length of a lens that is usually sold as a " quarter-plate lens " is five inches, or rather less : that is to say, the size of the different objects is depicted as though they were outlined on a sheet of glass, measuring four by three inches, held five inches from the eye. This brings us back to our previous experiments in outlining perspective on a sheet of glass for the perspective drawn on a sheet of glass, measuring four by three inches, and held five inches from the

eye, is in all points similar to that drawn on a sheet of glass measuring eight inches by six, and held ten inches from the eye. We saw that this perspective was violent and unsatisfactory, and that a perspective similar to that given by a ten-inch lens on a quarter-plate was more desirable.

Let us compare the use of a five-inch lens and a ten-inch lens, fitted to the same quarter-plate camera. A photograph is taken with the ten-inch lens, and then, without shifting the camera, the five-inch lens is substituted and a second photograph taken. Since the station-point has been the same in both exposures, the perspective of the objects which are included in the two photographs will be similar ; but the five-inch lens will have depicted the objects half the size of those taken with the ten-inch lens, and it will also have included much more foreground and much more of the landscape on either side of the picture.

In actual practice, however, no one with a spark of artistic feeling would choose the same station-point for an exposure with a five-inch lens as he would choose for an exposure with a ten-inch lens ; for he would wish to get a figure, or some other object, a certain size in the foreground of his quarter-plate picture, and he would place the five-inch lens close to that object. Consequently, the foreground would be about the same size in both pictures, but the distance taken with the five-inch lens would be only half the size of that taken with the ten-inch lens.

The actual impression which is produced by the employment of a short-focus lens—and I should call a five-inch lens " a short-focus lens " for pictorial work—varies, but it is always misleading. When the distant objects are of unknown size, such as hills or rivers,

they appear lower or smaller in the photograph than they appear in Nature ; when they are of known size, such as cattle, men, or cottages, the photograph gives the impression that these objects are much more distant than they are in reality. Thus, a pond becomes magnified into a lake, the interior of a small workshop is enlarged into a factory ; in fact, many wine-merchants have their wine cellars photographed with a wide-angle lens, so that they may appear of imposing dimensions in their catalogues. Again, a horse that is one hundred yards from the camera appears as though it were two hundred yards distant, and so on. Once again, the side of a building photographed in perspective, especially when the building is close to the camera, appears to recede too violently, as may be seen from the first block in the following diagram.

On the other hand, a very long focus lens does not give sufficient perspective, and there is not a sufficient diminution in size as the different objects retire from the camera.

Possibly the following diagram, showing a square block of stone photographed with a short-focus, medium-focus, and very long focus lens, may give some idea of the comparative rendering of perspective by such lenses.

The fault in a lens of abnormally long focal length, such as a telephoto lens, lies in the fact that such a lens does not photograph the subject as it is seen by the unaided human eye, but as it would be seen through a telescope. Mr. Ernest Marriage exhibited a photograph of a bull-fight, which was reproduced in *The Amateur Photographer* of September 28, 1909, at the R. P. S. of the same year. This picture gives a good idea of the perspective depicted by a very long focus lens. All

the figures appear of much the same size, and the pailing against which they lean does not seem to retire.

A few years ago one of the leading painters was making some studies of artillerymen at gun practice.

SHORT FOCUS MEDIUM FOCUS

He worked from his bedroom window, aided by a pair of strong binoculars.

"What on earth is wrong with my sketches?" he asked a friend. "Why," laughed his brother artist, "your foreground begins in the middle distance." With a lens of great focal length, the foreground of the picture has to be taken from the middle distance of the landscape, so as to get the "foreground" objects sufficiently small to fit into the picture, and

LONG FOCUS

consequently the distance is apt to appear right on the top of the foreground.

In short, just as the painter's perspective is founded on the station-point of the artist's eye and the metaphorical piece of glass on which he is supposed to draw his subject, so the photographer's perspective is

founded on the fact that the lens corresponds to the artist's station-point, and the focussing screen to the sheet of glass on which the perspective is presumably drawn.

III. Before proceeding to discuss the most convenient focal length of the lens, I must make use of our sheet of glass to enforce another point in perspective. By so doing, I shall save myself the drawing of several troublesome diagrams, and my reader some wearisome arguments.

Try drawing a vertical object—a house or pillar, for example—with the sheet of glass held out of the perpendicular, and notice the quaint distortion that ensues. If the glass be held slanting away from the student, the top of the pillar will be drawn too big, and if it be held slanting towards him, it will be drawn too small. The sheet of glass must be held strictly perpendicular. Exactly the same holds good with the camera : in photographing a vertical object, the focussing screen must be strictly perpendicular.

Again, try drawing a house in perspective, and instead of holding the sheet of glass parallel with the near side of the house, hold it at a slight angle. The lines on the side of the house which is drawn in perspective will naturally converge towards the vanishing point, but the lines on the near side of the house will also converge towards a second vanishing point, which is very confusing. Under similar conditions, the focussing screen of the camera should be kept parallel with the near side of the house. The object of a cross front on a camera is to shift such a subject towards the side of the focussing screen, if necessary, whilst the camera-back is still kept parallel with one side of a rectangular object.

CHAPTER X

AN AGREEABLE PERSPECTIVE

I. I DO not in the least apologise for the fact that
I am devoting two chapters to the question of photo-
graphic perspective. The use of a four-and-three-
quarter-inch lens on a quarter-plate and of a seven-
inch lens on a half-plate has become so common that
the evil cannot be met in a few paragraphs. Be-
sides, although it is comparatively easy to show
that lenses of very short or very long focal length
are unsuited to artistic photography, it is not so easy
to determine the best focal length for a lens which
is intended to be used in general pictorial work.

In determining the most desirable focal length for
a lens, there are two different lines of argument that
may be adopted. The first method assumes that
every picture has a natural " viewing distance " ; that
is to say, that a picture of a certain size would, natur-
ally, be inspected from a certain distance ; that a
picture is, theoretically, the window through which
we look, or the sheet of glass on which the student
drew his perspective ; and that, consequently, a lens
having a focal length that is similar to the viewing
distance will give a similar perspective. A diagram
on page 102 makes this clear.

This rule is perfectly sound, so far as it goes ; and

if it only lead to the adoption of long-focus lenses for that class of softly defined, well accentuated, impressionist work, which is intended to be viewed from a distance, it would serve a very useful purpose. Again, this rule might well be adopted in the taking of portfolio prints, which are intended to be inspected at close quarters; and the employment of a ten- or twelve-inch lens on the smaller pictures, and an eighteen-inch lens on the larger pictures, would be a good rule of thumb.

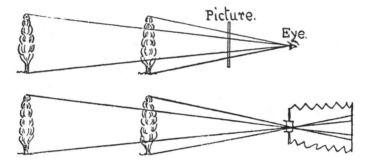

But, unfortunately, the "natural-viewing-distance" rule lacks elasticity, involves the use of a whole battery of lenses, and has other practical disadvantages.

II. The alternative rule, which is the one commonly adopted by painters, is both scientific and elastic. This second rule is based on what is termed "the natural-view angle," and assumes that only so much of the landscape will be included in the picture as can be conveniently seen by the human eye without turning the head.

When admiring a view, the head is kept still, whilst the eyes rove from point to point: this inspection, unconsciously, determines the perspective and the relative size of the different objects. Then the head

is probably moved on the neck, and a fresh angle of the landscape taken in. The head is not swung round with an even move-

FIG. 12

ment, but it moves in a series of jerks and takes in a series of view-angles, each one of which determines the relative size of the different objects; so, even though the whole of a panorama be embraced, the impression of the different objects is much the same as it is when only a single view-angle is inspected. The amount of a subject that can be easily seen without moving the head includes an angle of about twenty-five degrees.

There is yet another natural view-angle that must be considered. When the eyes are fixed on one object of great interest, such as the sun rising out of the sea, they do not revolve in their sockets, and only an angle of about two degrees is embraced: consequently, the

FIG. 13

object appears of great size and great importance. This is the reason why the moon looks so large, and this is why artists invariably paint it large.

As the sun rises out of the sea, the eyes do not rove, and the vision only embraces an angle of some two degrees; then, as the sun springs clear of the horizon, and

the sunbeams play on the ripples, the eye begins to rove a little—probably taking in an angle of nearly five degrees. Lastly, when the sun is high in the heavens, the eye embraces an angle of about twenty-five degrees. Figs. 12 and 13 give some idea of the apparent size of the sun rising out of the sea, and the sun when it has just risen over Dartmoor.

The first is roughly sketched to scale, as though it were taken with a thirty-inch lens ; the second is actually drawn from a photograph taken with a fourteen-inch lens.

A sketch-map plan, showing the different view-angles, may be useful :

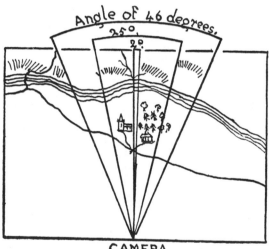

CAMERA.

The very wide angle of forty-six degrees is that which is included by the ordinary commercial lens ; the angle of twenty-five degrees is that which is included by the

human sight, and by the photographic lens that is recommended for artistic purposes ; the angle of two degrees is the narrowest angle of fixed vision. The dainty little photograph at the commencement of the last chapter included a view-angle of about four degrees.

III. In formulating definite tables of view-angles for pictorial photography, I do not wish to be taken too literally : when, for instance, I recommend a ten-inch lens, an eight-and-a-half-inch lens will not seriously affect the perspective. To commence with a table for those who like to use an assortment of lenses with the same camera, and assuming that this camera is a quarter-plate :

Quarter-plate Camera	*Focal-length of Lens.*
Natural view-angle 	10 inches.
Angle of concentrated interest ..	15 to 20 inches.
Absolutely concentrated interest ..	36 to 50 inches.

Of course, the lens of fifty-inches in focal length would be a telephoto lens, and the twenty-inch lens might well belong to the same class.

But this is a cumbersome way of setting to work. It is far more practical to employ one good lens of a decent focal length ; and when the subject is of concentrated interest, to make the exposure with a view to the subsequent enlargement of a portion of the film. Taking the employment of a ten-inch lens on a quarter-plate as the counsel of perfection ; a seven-and-a-half-inch lens on a plate measuring three-and-a-quarter by three-and-a-quarter as the counsel of convenience ; and a five-inch lens on a small portion of the film as

NEW YORK CENTRAL YARD

By Alfred Stieglitz

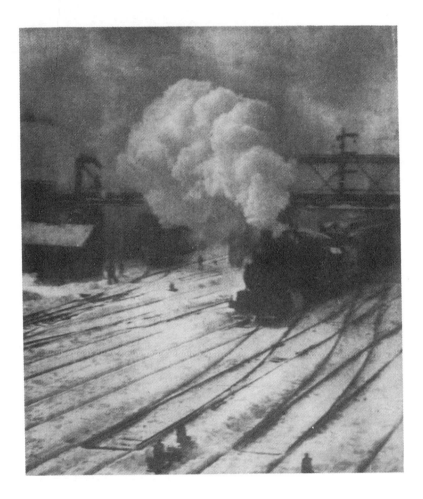

the necessity of unavoidable poverty, the table would work out, roughly, as follows :

Subjects, or Views in which the Interest is	Portions of the Film to be enlarged.		
	With 10-in. lens.	With 7½-in. lens.	With 5-in. lens.
General	4 in. ×3 in.	3 in. ×2 in.	2 in. ×1½ in.
Concentrated	2¾ ,, ×2 ,,	2 ,, ×1½ ,,	1⅜ ,, ×1 ,,
Very concentrated	2 ,, ×1½ ,,	1½ ,, ×1 ,,	1 ,, × ¾ ,,
Sunsets, etc.	⅜ ,, × ¼ ,,	¼ ,, ×	

For many years I have used the first column, with a ten-inch lens on a quarter-plate reflex camera, and have found it quite reliable. The reflex is certainly a great advantage with a lens of fairly long focus, as it allows the subject to be both focussed and composed on the focussing screen up to the moment of exposure ; and the convenience of seeing the image placed right way up is certainly a great help in the composition.

When using the last column with a five-inch lens, the subject should be chosen and the composition arranged by means of a view-finder. A simple and most efficient view-finder can be made by cutting a rectangle, four inches by three inches, in a thin piece of mahogany, and attaching a measuring string, with knots tied at ten, fifteen, and twenty inches from the wood. In use, one of these knots is held against the cheek-bone, and the view selected through the rectangle : the finder on the camera is only used to centre the view.

I advocate this finder, because the perspective given by a five-inch lens, on even a portion of the plate measuring two by two and a half inches, will not appear quite satisfactory until the picture is enlarged

up to three by four inches. When the image has been enlarged two diameters, the result will be exactly as though the picture had been taken direct with a ten-inch lens. This small portion of the image may be safely enlarged up to sixteen by twelve.

LEAF FROM MY NOTE-BOOK

Opticians and Perspective

November 18, 1907.—This afternoon I bought a second-hand copy of M. Carey Lea's "Manual of Photography," dated June 1871, and at once turned up "Photographic Perspective."

"As we see objects best at ten or twelve inches from the eye, this would appear to be the least focal length for a lens," writes Mr. Lea. "Still, as the eye does not discriminate closely in these matters, and is very tolerant within limits, lenses of all focal lengths, from seven to fifteen or sixteen inches, may be employed with advantage."

In June 1902 I wrote of five-inch lenses: "The photographer does not select his subject because it is beautiful, but because it will make a good photograph. A pond poses as a lake, and a row of distant mountains is dwarfed to nothing."

In June 1871 Mr. Lea wrote of five-inch lenses: "They may make pretty pictures, but these are wholly incorrect, as many must have noticed. A garden becomes a park. The farther part of a house is represented on so much smaller a scale than the nearer part, that the eye, accustomed to correct representations, is deceived, and imagines the further part, by reason of its smallness, to be much farther away than it is."

As I had never seen Mr. Lea's book when I wrote

the above, and imagined that I was writing something absolutely new, the coincidence of opinion is interesting.

Well, Mr. Lea fought his battle for lenses of a pictorial focal length more than thirty-six years ago ; then the opticians made four-and-three-quarter and five-inch lenses of great perfection, and listed them as quarter-plate lenses ; and now all the camera makers fit five-inch lenses to all quarter-plate cameras ; and I have had to start single-handed, to fight the battle of pictorial perspective all over again.

Only the other day I ordered a new quarter-plate camera with a ten-inch lens.

" But we always fit five-inch lenses to these cameras, sir," protested the shopman.

" I require a ten-inch lens," I reiterated wearily.

" Perhaps you require it for some special purpose," suggested the shopman, brightening.

" Yes, for pictorial photography."

" But we always fit—— "

Then the shopman paused and looked at me with pitying eyes. I was clearly a lunatic.

CHAPTER XI

COMPOSITION

I. One of the best cooks I ever met with had a formula. " I mix by random, and add my flavouring accordingly." A board-school cook would have worked from a recipe book, and would have weighed and measured the constituents of her dish ; a hygienic cook would have combined her proteids and albumenoids in scientific proportions ; but this inspired cook, although she founded her proportions on a very extensive experience, tested her dish in the making, dashed in a touch of this or that flavouring, until each dish which she served became a veritable creation.

And so with composition. It is not a thing of formulæ and recipes ; it is not founded on science. Good composition is an impulse.

An architect must plan the composition of his building in advance, partly because he has to secure scientific stability, and partly because he has to depend on contractors and masons for its construction ; but an artist or a poet or a novelist, although he has probably some rough scheme of construction in his brain to work from, mends, alters, and elaborates this scheme as his work develops. I always imagine that Whistler, in painting Carlyle's portrait, felt that the wall was rather bare and empty, and therefore roughed in a picture hanging on the wall. At any rate, this is the way that composition is actually worked out.

The Artistic Side of Photography 🪷

The Protestant will tell one that the Reformation was a revolt from corruptions which grew up during the Renaissance ; the Catholic will assert that Henry the Eighth introduced the Reformation into England because he wished to divorce Catherine and marry Anne. Both these statements are true, and both are false ; for it is impossible to dissect the development of history, the evolution of a novel, or the composition of a picture, with balance and justice. Motives are generally mixed, usually spontaneous, and always constructive : the course of the action of to-day is the result of what happened yesterday.

When we consider that composition is the assembling and arrangement of several things, so as to make one thing out of them ; when we realise that the composition of a book grows with the writing, and the composition of a picture with the painting, we must see that it is hopeless to formulate any workable rules of composition, and that good composition can only be achieved by the cultivation of that creative faculty which is born out of the artist's desire to express himself in a reasonable, well balanced and pleasing manner.

Ruskin never wrote anything that was more illuminating than the following :

" If a man can compose at all, he can compose at once, or rather he must compose in spite of himself. And this is the reason of that silence which I have kept in most of my works on the subject of Composition. Many critics, especially the architects, have found fault with me for not ' teaching people how to arrange masses ' ; for not ' attributing sufficient importance to composition.' Alas ! I attribute far more importance to it than they do—so much im-

portance, that I should just as soon think of sitting down to teach a man how to write a Divina Commedia or *King Lear*, as how to ' compose,' in the true sense, a single building or picture. The marvellous stupidity of this age of lecturers is, that they do not see that what they call ' principles of composition ' are mere principles of common sense in everything, as well as in pictures and buildings. A picture is to have a principal light ? Yes ; and so a dinner is to have a principal dish, and an oration a principal point, and an air of music a principal note, and every man a principal object. A picture is to have harmony of relation among its parts ? Yes ; and so is a speech well uttered, and an action well ordered, and a company well chosen, and a ragout well mixed. Composition ! As if a man were not composing every moment of his life, well or ill, and would not do it instinctively in his picture as well as elsewhere, if he could. Composition of this lower and common kind is of exactly the same importance in a picture that it is in anything else—no more. It is well that a man should say what he has to say in good order and sequence, but the main thing is to say it truly."

Now, this is a fine, true passage, from beginning to end, until we come to the last clause of the concluding sentence ; and then we miss all mention of the two saving qualities which must govern truthfulness, in Art as well as in Life, and especially in the art of photography. For, after all, Truth is only a naked maiden who must be clothed with reserve, lest she should be vulgar ; and she is only a thoughtless chatterbox who must be endowed with restraint, lest she should babble aimlessly.

When we read a clever novel, or look at a fine

THE WATER CARRIER

By Alvin Langdon Coburn

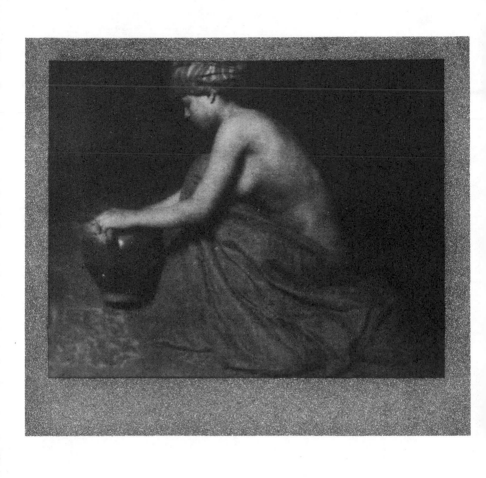

picture, we do not feel the composition ; we only feel
that the story has been well told, or that the picture
has been well designed—perhaps we do not feel even
so much as this, only that the picture is satisfactory.
But since the aim of composition is to satisfy, we may
be certain that any work of art which satisfies a
cultivated person is well composed.

The actual method of composition differs with the
individual, and there are probably nearly as many
methods as there are individuals. A man with a calm,
foreseeing mind may plan each chapter of his novel,
or draw in every detail of his picture before he com-
mences the actual work. A man with an impulsive
temperament may elaborate as he goes on ; but, in
either case, the artist is morally certain to rewrite some
of the chapters of his novel or touch up some portions
of his picture after its first completion. Ninety-nine
times out of a hundred, the artist arranges his materials
chiefly by instinct, and only learns the subtle inward-
ness of his composition from his critics. " Composi-
tion " is an after-thought.

Now, we commenced with the assertion that good
composition is an impulse—that is to say, the effect
of an impelling force acting on the mind. It may be
a sudden impulse, a protracted impulse, or a series of
impulses ; but it can never be derived from either
formulæ, science, or system. And yet, an impulse is
usually the result of something that has been learned,
or of something that has been experienced, or else of
some instinct that has been inherited from the last four
generations of ancestors. A man proposes to a girl
who attracts him ; she accepts, and his immediate
impulse prompts him to kiss her. At first sight, any-
one would say that this was a spontaneous impulse,

inspired by Nature ; but it is nothing of the sort.
The man only kisses the girl because he has reason to
believe that the osculation will give him that sense of
intimacy he desires. If he had proposed to the girl
in a theatre, his impulse would have prompted him
to move his hand until it touched hers. If the couple
had been South Sea Islanders, their impulse would
have been towards the rubbing of noses. In fact,
save in the case of the greater impulses, such as eating
and drinking, an impulse is seldom purely individual,
but is based on information, experience, or heredity.
Modern naturalists tell us that even the wildest animals
do not fear man until they have been instructed by
their mothers. Information may seem to have been
forgotten, experience may be tucked away at the back
of the brain ; but these two things form the chief source
of impulse, even though the impulse may appear abso-
lutely new. Individuality mostly lies in the personal
use of knowledge, originality in the blending of know-
ledge, experience and heredity into something new,
or in carrying knowledge one step farther.

Since this be so, the more an artist cultivates his
mind, the more does he store up that knowledge which
begets impulse ; the more he cultivates the sense of
proportion, the sounder and more evenly balanced
will his impulse become ; the more he cultivates a
feeling after beauty, the greater will be his impulse
towards beauty.

The mere fact that the majority of artists, both
European and Japanese, have delighted in a certain
form of composition, in which the main lines sweep
diagonally from corner to corner, to be countered by
opposing lines of secondary importance, does not rob
this design of originality : for if originality excludes

those beauties and forms of beauty which have been enjoyed and depicted by others, then the landscape photographer who would be truly original should model his garden into a strictly unique landscape, and confine his photography to his own demesne.

I have been forced to insist on my point by the propaganda of a certain modern school—and even photographers are not altogether free from this trend of thought—which confounds individuality with ignorance, and originality with something that is abnormal.

II. Photographic composition falls into two distinct classes : arrangement and selection. The former class includes portraiture, still life, and such subjects as can be arranged by the photographer himself ; and in this class the composition of the photographer is almost, or quite, as much a personal matter as the composition of the painter. The latter class comprises landscape, seascape, architecture, and, I think, genre work ; in this class the composition is mainly the selection of an artistic arrangement by an artistic mind. But, so far as the artistic merit is concerned, I cannot think that selection is inferior to arrangement.

An artist selects a sympathetic model, and tells her to pose herself whilst he prepares his palette. He finds the pose absolutely ideal, and paints the girl exactly as she has flung herself—every single item of the arrangement happens to fall right, and the artist paints the subject exactly as it stands : there is no arrangement in the composition, only selection or appreciation. A lesser or meaner man would have altered the pose slightly, so that he might lay claim to the composition ; but the true artist who aims at perfection paints perfection when he finds it.

The Artistic Side of Photography ♣

Possibly the composition in Velasquez's " Venus "
may have been selective. Possibly he let " Venus "
throw herself on her couch, and painted the girl exactly
as she had flung herself, adding the be-ribboned Cupid
to carry out the idea of the subject. Certainly the
figure of Venus herself is photographic to the last
degree ; photographic in the apparently selective
nature of the composition ; photographic in the realism;
photographic in the reflection of light from living flesh ;
photographic in the definition, which is the definition
of a long-focus lens, plus the blur which the model's
breathing would cause during a long exposure ; photo-
graphic in the truthfulness, tempered with reserve
and simplicity. Possibly the great charm of this
" Venus " lies in the photographic nature of the
rendering, and the restfulness of selective composition.

Le Sidaner is Le Sidaner. He is also (at least so
The Times tells us) photographic in the composition
of his later pictures.

In his Hampton Court series, which was painted in
1907 and exhibited at the Goupil Gallery in the follow-
ing spring, he has painted the palace as it is and the
gardens as he found them, without twisting and twirling
things about in order to obtain academic composition.
He found the gardens, with their beds and borders,
sufficiently beautiful to please him ; he found the old
courts, with their mellow red brickwork, sufficiently
artistic to satisfy him : so he chose out such portions
as were characteristic and complete in themselves,
set up his easel, and painted them.

He painted one corner of the garden with the autumn
dew lying so thick that the grass looked a smoke-white,
and again the same corner with every flower standing
clear in the evening light ; he painted the courts with

the reflection of the setting sun on the windows. In each picture Le Sidaner set himself some problem of light ; in each picture he achieved a luminosity that no other painter has approached.

Now, when *The Times* critic (I understand that the real critic of the paper was away) calls Le Sidaner's composition " photographic," he is verbally correct ; when he points out a certain lack of rhythm, swing, and emphasis, he is visually correct ; but when he speaks of these qualities as defects in Le Sidaner's paintings, he is altogether unreasonable. Paint Hampton Court with rhythm, swing, and emphasis, and it would cease to be Hampton Court as we know it.

The truth is, that conventional Art has educated herself up to the rhythm, swing, and emphasis of a Raphael, a Correggio, a Titian, even as the Frenchman has educated himself to absinthe. Those who can appreciate the Italian pre-Raphaelites and certain of the Moderns, have learnt to appreciate something that is more natural. The insistent ripple of the brook, the monotonous hum of the bees, and the steady flop of the summer wavelets are not faults, nor is life danced to eternal waltz music—which, being interpreted, means that quiet, selective composition may be very delightful.

LEAF FROM MY NOTE-BOOK

A Casuistry

He was young, long-haired, and clad with loose green homespun and divine self-assurance : I met him in the train.

" Photography can never be a Fine Art," he said. " The photographer must take what is before him. There can be no personality, no construction, no creation."

" But if the real artist—the painter "—I glanced at a bundle of canvases which was propped on the seat beside him—" were to find a perfect landscape— perfect in every respect——"

" Such things don't happen."

" But if he did find a perfect landscape ? "

" Of course he'd paint it. He'd be an ass to alter it." This was the true artist in him peeping out.

" Now, suppose a real artist—a painter "—you see I was leading him on craftily—" bought a patch of ground with a fine distance behind it ; suppose he digged and delved, and planted and irrigated, and toiled and sweated, until this piece of ground was a veritable paradise, and then painted it truthfully ? "

The young man nodded his head.

" You see," I continued, " the painter could study every kind of light, and each object in the same light."

" Not half bad," he murmured.

" Then your idea of the ideal artist is—a landscape-gardener who photographs," I concluded.

CHAPTER XII

COMPOSITION IN PHOTOGRAPHY

I. As we have seen, there are two types of photographic composition—arrangement and selection. The former, which is mainly confined to portraiture and still life, gives the artist considerable latitude ; the latter, save in the choice of a station-point and the addition of an occasional figure, limits the artist to the selection of a suitable subject under the best possible conditions of lighting and atmosphere.

And yet both these types of composition have a common origin in the impulse that inspires them ; and if we begin to differentiate between the respective merits of arrangement and selection, and esteem arrangement, which is built up on many impulses, more than selection with its single impulse, we must ultimately arrive at very awkward conclusions.

The true artist composes by impulse, and not from text-book or diagram : one pose is taken because it accentuates the grace of a graceful figure, another because it adds dignity to a model who is naturally dignified ; this object is included to fill an ugly blank, that is eliminated because it is superfluous ; this view is chosen because it fits the picture space pleasantly, that is rejected because, although it is beautiful in the landscape, it arranges awkwardly in the picture.

II. Unfortunately, the very nature of composition

125

renders it impossible to be taught. " It is impossible to give you rules that will enable you to compose," writes Ruskin. " If it were possible to compose pictures by rule, Titian and Veronese would be ordinary men."

But it has been left for a very clever Japanese to point out why there can be no formulated rules of composition : " A painting, which is a universe in itself, must conform to the laws that govern all existence. Composition is like the creation of the world, holding in itself the constructive laws that gave it life." That is to say, the constructive laws of each picture are self-contained, and the rules which govern the composition of one picture cannot be applied to the construction of another picture.

Fortunately, however, although composition cannot be taught, it can be learnt ; and it can be learnt just as everything else is learnt—swimming, writing, plumbing, cricket—by practice. After all, book learning is of but little value, except for examinations ; theory is of but little use, until it is applied ; but the moment a man begins to practise any art or craft himself, from that moment he begins to pick up knowledge and form his own theories. Thus, to the student of composition, every good picture he sees, every graceful object he meets with, and all the good advice he can secure begin to have an educative value.

And yet, although there can be no rules for pictorial composition, there are certain common-sense principles that may be applied to all composition, from the planning of a life to the painting of a picture or the taking of a photograph. These principles are founded on common experience and simple logic, and they may be applied, with equal justice, to the novellinos of the

fifteenth century or the novels of the twentieth, to woodcuts from Japan or paintings from Chelsea.

III. May I start with the premise that all Art implies expression, and that unless the artist has some theme which he wishes to express, his work is foredoomed to failure ? I am willing to make my premise as wide as possible, and allow that the theme may be either intellectual or material, that it may be the graceful arrangement of lines so as to form a decorative design, or merely a topographical photograph of the cottage in which Alfred burnt the cakes. Surely this is a premise that is sufficiently obvious and sufficiently inclusive to be accepted without question ; and yet it will exclude quite nine-tenths of the photographs that are taken—perhaps more.

" This will make a picture ! " mutters Photographicus, setting up his camera and unfolding his focussing cloth.

But why will it make a picture, dear Mr. Photographicus ? What is the theme of your picture ? You know perfectly well that you will only think of the " subject " of your picture when you are comfortably seated in your arm-chair, with the print before you and a whisky-and-soda beside you, and that if you were perfectly honest with yourself you would entitle your picture : " Something that I Thought Looked Like a Picture " —hardly a sufficient theme, is it ? There can be no composition in such a print.

" But there is composition ! " protests Photographicus : " selective composition."

No ! my dear sir. There may be something in your ready-made picture that reminds you of the composition diagrams in " Little Archie's First Steps Pictureward " ; but this is not composition in any

understandable sense of the word. There can be no composition unless there be some theme around which to build up or arrange the composition. For Art is the expression of a theme, and composition is the constructive part of expression : eliminate the theme, and you eliminate the possibility of composition.

Art commences with some definite theme—call it the " plot " in a novel, or the " subject " in a picture. Art then proceeds to develop this theme, to accentuate the important parts and subordinate those which are unimportant, to arrange, to weld, to blend, to balance, until the different incidents in the novel, or the different objects in the picture form one harmonious whole— this is the composition. All those points which the text-books call the " elements " or " principles " of composition are only the common-sense ways of developing the theme, and any very intelligent savage would adopt similar methods.

Take " the law of principality," for example. Would not our brilliant savage emphasise the point of any story he was telling ? Would not he tell his story with " continuity " ? Does not he lend grace to his poetry and music by " repetition " ? I doubt whether the early artists of the Renaissance had any very definite " rules of composition," and yet much of their composition was most excellent. In more recent times, when composition became a thing of rules and precedent, the set and formulated nature of the academic composition robbed pictures of much of their conviction. Could any one call Sir Joshua Reynolds's painting of " Three Ladies Adorning a Term of Hymen," which is hung in the National Gallery under another and inferior title, either natural or sincere ? Does not this picture, from the composition,

down to the anglicising of the Latin *terminus*, give an admirable idea of the best Art of A.D. 1774 ? Expression, and not composition, is the end and aim of Art ; and the moment that composition becomes the end, instead of only a means to an end, from that moment Art becomes artificial.

IV. Taking the picture as the expression of a theme, and the composition as its arrangement or construction

FIG. 14

or development, let us see how the composition works out in actual practice.

A photographer is walking beside a lake, and becomes attracted by the graceful curves of the rushes which border its margin, so he resolves to take " Rushes " as the theme of his picture. He walks along the bank until he finds a particularly fine and graceful cluster of rushes, with a dead branch floating just beyond ; for he feels that the contrast between the angular twigs and the lithe rush stems will serve to accentuate the

latter. Now, rushes do not grow in isolated clumps, so the photographer places the principal clump rather towards one side of his focussing screen, and includes several other clumps. This serves to convey an impression of truthfulness, whilst the subordinate groups repeat the main subject with variations, just as the theme is repeated with variations in both music and poetry. Next comes the question of the background ; and what could make a better background for water plants than water ? So the photographer extends the camera stand, tilts the camera downwards until the rushes are rightly placed, until the distant bank of the lake comes quite to the top of the picture, and swings back the focussing screen until the definition pleases him. Such a composition might be very satisfactory, and the photographer would never have thought of it unless he had started with the theme of " rushes."

It is this plan of starting with the theme that is so important in composition, and the artist naturally picks out the keynote of his theme as the point round which to arrange the different objects in his picture. Thus, in a genre subject, the man who is telling a story, or the girl who is reading a letter, would be the centre around which to group the other figures ; in " The Orchard," an old apple-tree might well form the chief object ; in " November Sunshine," the composition might be built round a ray of light slanting down through the November mist.

Lastly, let us consider the composition of an actual photograph, Mr. Arbuthnot's " Cliff Path," and try to discover why the composition is so excellent. First we notice the crafty way in which the artist has contrived to give an impression of giddy height to his pathway, not by placing the track high up in his

THE CLIFF PATH. *By M. Arbuthnot.*

picture, but by placing it low down, suggesting the sea far below, and leaving the spectator's imagination to fill in the rest. The actual path is depicted just as though the onlooker were about to walk along it, and this is the impression he receives :

" Oh yes ! the path is wide enough and safe enough, in all conscience ; and yet I cannot help a feeling of vertigo. The slope of the cliff threatens to roll me over the edge of the path, and I shall fall miles— perhaps on the rocks ; perhaps into the sea.

" It is all very well for those two females—they have no imagination ! All the same, the woman takes care to place the girl inside.

" What a magnificent cloud ! It seems to counter the slope of the cliff so as to beguile me on with a false sense of security. And is not that gleam of sunshine on the sea, coming from Heaven knows where, weird !

" However, I must be walking on, simply because I have not the moral courage to turn back—but I never enjoyed a walk less."

I think Mr. Arbuthnot's picture says all this, and I believe this is why the composition is so good. The artist has not followed any conventional scheme of design, but has used the composition simply and solely to work out his theme.

V. As I remarked just now, there are certain common-sense principles of composition that may be applied to all forms of artistic expression. Stripped of their terminology and reduced to plain language, these principles are both simple and logical.

Just as a book should be complete in itself, with no dull chapters, no awkward breaks, and with the theme or story leading up to the crisis ; so should the picture be welded into one concrete whole, with no awkward

vacant spaces, and with the chief point of interest properly accentuated.

Of course, it is not easy to take a small portion of a landscape and arrange it on the focussing screen so that it forms a complete and self-contained picture, with nothing that tempts the eye beyond the frame ; but if it be remembered that it is the theme, and not subordinate objects and unimportant details, which must be presented whole and unimpared, the difficulty is considerably reduced. Thus, in portraiture it does not matter if part of the hat be cut off, so long as the face is well placed in the picture. Again, the word " completeness " may be used in two widely differing senses : it may mean that the subject should be complete " down to the last button," or it may mean that the picture conveys one definite impression, whilst it is left to the onlooker to carry this impression to its natural mental conclusion.

If completeness be the first essential of composition, then unity of purpose is certainly the second. For if some minor point in the construction be made too important, or if the theme be told in a disjointed manner, the composition at once loses force. Therefore we find two qualities in all good composition, whether in writing, music, or painting—" principality " and " continuity."

" Principality " simply assumes that every theme has its chief point, round which the composition is arranged, and that this point should be honestly, and in reality, the principal point or object in the picture. If the principal point be the centre of the composition, if this pathway leads towards it, and the contour of that hill slopes towards it, and so on, the principality will be established ; but just as it is often desirable to

strengthen the chief chapter of a novel, making it a trifle more vivid than the rest of the book, so it is often necessary to emphasise the chief object in a picture. This may be done naturally, by placing the chief object in the sharpest focus or by throwing it into contrast with some patch of a contrasting tone, or it may be effected by artificially strengthening some high light or deepening some shadow.

" Continuity " insists on the even flow of the theme, and marks off the novel and picture from the collection of short stories and thumb-nail sketches. Different clumps of trees are united, partly by the lines of the landscape, and partly by giving principality to one of the clumps ; different groups of figures are joined by a common interest, a common movement, or a common motive. " Radiation," or the convergence of the lines of the landscape, the slope of the hills, the tend of the pathways towards the point of interest, helps to give continuity to a picture.

So far we have considered what may be called " the construction of composition." Now let us glance at its refinement. " Repetition " is one of the most graceful things in both Art and Nature. The repetition of one clump of trees by another, of one group of figures by another, of one line by another, all give a feeling of pleasure ; but there is a vast difference between repetition and reiteration, and there should always be enough variation in artistic repetition to avoid monotony— unless, of course, monotony be the subject of the theme. Graceful curves are also pleasant in a picture ; but awkward curves, like those in an ordinary English vase, are very ugly, whilst graceful curves, like those in ancient Grecian pottery, are beautiful. The " curvatures " of individual objects in Nature are always

graceful, but the curves of the contours of a landscape may be vile. The "harmony," or fitness of the different objects included in the picture, is essential. Harmony of tone demands its separate chapter.

Lastly, there is the general pattern or design of the picture to be considered. The first thing we notice in a picture, before we come close enough to take in the details, is the design; and since a first impression counts for much, the design is of great importance. Roughly speaking, there are two classes of pictures; there is the decorative class, in which everything depends on the arrangement of the colour scheme, or on the graceful flowing together of lines; and there is the subject class, in which the expression of the theme is the chief object. It follows that, although in strictly decorative pictures the theme may be sacrificed to the design (or rather the design may become the theme), in subject pictures the design must be subservient to the theme. When the picture starts with the design instead of the theme, and the composition is built up on the design, the composition is bound to become artificial—we have already seen this result in Reynolds's painting of the Three Ladies Adorning the Boundary Statue of Marriage. But, although the design should never be the foundation of photographic composition it should not be overlooked; for when the photographer realises that the masses and contours in a photograph form a pattern, an ugly or awkward design will be instinctively avoided, and one that is satisfactory chosen.

VI. But let us get a breath of fresh air after all this studio talk, remembering only that we have a theme to express.

For, after all that has been written and read, after

all that has been said and done, the fact remains that
composition is only the skilful expression of a theme ;
and the skilful and logical expression of a theme is the
source from which the principles of composition are
derived.

LEAF FROM MY NOTE-BOOK

Decorative Design

" The function of decorative work is to decorate," I remarked.

Monica smiled, for my assertion sounded obvious.

" Colour decorates," I continued. " An arrangement of lines may decorate. But tone work has never appealed to decorative artists ; and of all the methods of working in tone that can be imagined, photography is least suited to decoration."

" But there are decorative photographs," protested Monica—" very decorative photographs ! Why, you pointed some out to me at the Salon ! "

" Have I ever pointed out a photograph that was half so decorative as the coloured Japanese print that I bought last week ?—I mean the shilling one. Have you ever seen a photograph that was half so decorative as Rackham's work ? "

" No-o," said Monica.

" With infinite patience, a camera-man may find a decorative scheme in Nature that comes almost right ; once or twice in a lifetime he may find one that is altogether right ; but even then it is hardly likely to fit any especial place, or fit in with any particular scheme of decoration. A decorative painter will draw a better picture straight off, and one that will exactly fill the desired space, besides fitting in with the rest of the decoration."

Monica nodded her head.

"You see," continued I, warming up to my subject, "truth to Nature is not essential in decoration; in fact, decoration is usually a conventional adaptation of Nature; so the photographer cannot score there. Truth to the delicate rendering of gradation is not essential in decoration; so the photographer cannot score there. On the other hand, colour is often absolutely essential, and a bold outline, such as that which is given by wood engraving, is usually necessary when the decoration is in monochrome."

"Then you think—— ? "

"That to ignore the real spirit of the medium of photography, which is——"

"The rendering of the infinitely delicate gradations of the high lights, shadings, and shadows," laughed Monica impudently.

" — in order to try and do what the draftsman could do far better——"

" — is weaving ropes of sand, eating Dead Sea apples, and—— Come and play tennis, Mr. Anderson ? "

So we went.

D. WORKING IN TONE

CHAPTER XIII

TONE AND KEY

I. A PHOTOGRAPHIC journalist once told me that he avoided the word " tone," because people would mix up " tone " with " tones " and " toning." Of course " toning " is a chemical process, " tones " is another term for gradations in photography, whilst " tone " means harmony and refinement.

The best definition of tone that has ever been given appeared in *The Amateur Photographer*, under the name of Mr. Anthony Guest ; and he explained that we use " tone " in its right sense when we speak of the tone of a school being good.

The subject has little or nothing to do with the tone of a picture ; the colour of a monochrome has nothing to do with the tone, as long as the colour is neither crude nor vulgar ; tone simply depends on the rendering of the gradations of light and shade.

An artistic photograph must have qualities similar to those of an ideal gentleman : it must be strong in character, without being assertive ; it must be refined, without being vague or uncertain ; it must have no violent contrasts, no spottiness of light and shade, and above all, no suspicion of muddiness or fogginess.

140

There is one other quality that tone demands, and I do not know exactly how to describe this quality. We all know the type of man who has " lots in him " ; he may be very quiet and reserved, but this quietness must not spring from an empty brain ; he may be positively brilliant, but this sparkle must be the outcrop of a still more brilliant intellect. Tone must not give us the feeling that it is superficial.

A picture in which the tone is fine will form a restful spot on any wall, whatever the subject may be ; for the eye delights to rest on the refinement of tone, even though the thoughts may be busy elsewhere, just as the ear is charmed with soft and pleasant music whilst the brain may be deep in some abstruse subject.

Much of the photography which filled the exhibition walls some ten or fifteen years ago lacked tone. The finish of this work was perfect, and yet it gave one the impression that the photographer had exhausted every gradation that his plate would give, whilst the definition was an advertisement of the quality of his lens. Then came the swing of the pendulum, and many of the elect revelled in muddy tones, in fade-away, anæmic lightness, in fuzziness and incoherency, in that dizzy double printing which the interposition of a sheet of glass between the negative and printing-paper entails. It was the first photographic striving after tone ; but instead of emulating the tone of Raphael Smith and the other great mezzotint engravers, instead of studying their proof prints in the British Museum, these photographers evolved some new idea of tone out of their inner consciousness. Thank Heaven, this phase is practically over : it was very detestable whilst it lasted.

Strength and virility are absolutely essential in

pictorial art; but this strength does not mean the strength of hardness so much as the strength of the

> . . . sash
> Which, softness' self, is yet the stuff
> To hold fast where a steel chain snaps.

A very soft and delicate picture may have all the strength of a silken sash ; and we notice this quality in Mr. Cadby's portrait of a child.

A very clean, workmanlike negative, followed by a very clean, workmanlike print, goes far towards establishing strength in a soft-toned picture ; whilst any suspicion of a chemical or mechanical fog in a high-toned print, or any taint of muddiness in a low-toned print, renders the picture weak and undecided.

II. This leads on to the subject of " Key," for tone and key are intimately connected. And, I think, that this fact should always be remembered when speaking of pictorial work. Art is a paradox, as full of contradictions as a fair and natural woman ; more-over, Art is one great whole, which refuses to be dis-sected and expressed in art jargon. The moment one attempts to define and tabulate the various points in art, from that moment one is involved in repetition and cross-indexing.

A piano has over seven octaves of notes ; but unless " The Battle of Prague " set as a trio is being per-formed, with the " cries of the wounded " thrown in, it is improbable that the whole of these octaves will ever be used in one piece of music.

My greengrocer's daughter delights in playing fireworks all over the keyboard ; my piano-tuner, after he has finished his labour, relapses into a harmonious melody which seems to display every note on the

instrument ; and the highly technical photographer brings out every tone within the compass of his plate. But a refined soul will not desire to touch every note of the piano or every gradation of the sensitive film.

Just as in Nature the lightest tone is usually several shades short of white, and the darkest tone some degrees short of black, so, in what may be termed ordinary photography, the highest and lowest possible tones are seldom employed. But the artistic photographer will often feel moved to curtail his range of gradations much further than this.

I can remember, in 1903, that Mr. and Miss Warburg showed two delightful pictures of shimmery, summery sea. These pictures were, rightly, keyed very high, only a few of the lighter and softer tones being employed. Contrariwise, an evening scene may often move the artist to use a very few dark tones ; and so long as the artist remembers that even twilight is luminous, this print in a low key may be both truthful and enjoyable.

The contraction of a scale of gradations which strikes some predominant note into quite a few tones in the high, low, or middle key is satisfactory, so long as the work is well and artistically done. But I think there must be some predominant note around which to contract the tones.

One of the most delightful of modern hymn-tunes was composed on three notes by an organist of Christ Church, St. Leonards : the hymn was an evening hymn, and the predominant note of this music was the lowest of the three. Mr. Cadby elaborates his essays on children in the same simple manner, and strikes a predominant note in the child's flesh-value, which is usually the lowest note in his theme : this is why his work is so strong.

A PORTRAIT

By George H. Seeley

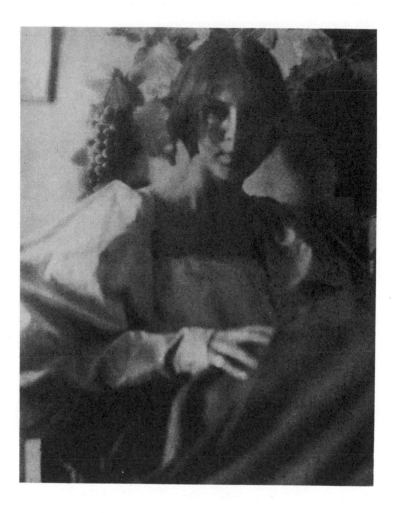

This predominant note may be the highest, lowest, or betwixt and between ; but I think there must be some predominant note to justify the contraction of tones—some accent to give point and emphasis to the whole. Perhaps the lack of a predominant note is the reason why the general run of photographs, which have been simplified into a few tones, are so eminently unsatisfactory.

When one considers that the quality of photography lies in the rendering of the delicate gradations of light, shading, and shadow ; when one considers that the ordinary negative renders these gradations in a marvellous way ; when one considers that the beauty of an ordinary subject, done into a photograph, lies in the full, rich harmony of light, shade, and shadow, one can see the absurdity of rendering such a subject in only a few tones of drab colour : it is like taking a piece of music composed for a full orchestra and playing it on either a violin or a double-bass.

On the other hand, when the photographer wishes to bring out the full virtue of some particular quality in his picture, the particular virtue of some delicate quality in high light, or the gradation of flesh-tones, or the richness of some shadow, he is quite right in simplifying the rest of his tones and bringing them close to his predominant note. Such an action does not weaken the picture ; it simply draws the attention away from the less important notes and concentrates it on the chief note.

Again, the key of a picture should fit in with, and emphasise the subject. Take a girl gathering roses, for example : the predominant note should be struck by the tones of the girl's face, or the tones of her hands, or the tones of her sun-bonnet, or the tint of

147

the rose she is gathering ; and the rest may be keyed around it.

But to expose, print, and develop so that the whole is conveyed in a few tones, without any predominant tone or accent, is to render the picture dull, drab, and featureless.

Thank Heaven, this last style of work is dying down ; but some of it still exists, and every year one or other of the leading photographers seems to be temporarily drawn into its meshes.

Possibly the surest test as to whether the gradations of a delicate picture have been properly built up, and that strength which is essential to tone secured, is to study the carrying power of the picture. The definition may be of the softest, the gradations few in number ; but if the picture closes up and comes together as one steps back from it, if it becomes clear and distinct as one moves away, the gradations will have been properly founded and the tone will be assured.

Each year, several of the pictures that are exhibited at the Royal and the Salon lack this particular quality, and refuse to close up as one stands away from them : they are fuzzy at close quarters, they remain fuzzy when inspected at a distance. This defect is especially noticeable in some of the large heads. May I respect- fully suggest to the selection committees of the two exhibitions, that if a picture refuses to close up there must be something inherently and vitally wrong with the construction of gradations, and that such a picture should be rejected without further question ?

And here I must attempt to win the toleration of those who belong to the old school of technical photo- graphy, and who have a strong aversion towards

diffused focus and a contracted scale of gradations. A large photograph is not meant to be inspected at close quarters ; and so long as the picture closes up and looks clear and coherent at a distance, it cannot rightly be stigmatised as " fuzzy."

In the same way, a picture with fine, clean gradations in a high key, or rich, clean gradations in a low key, demands great technical skill, and should appeal to the brain of the technician, even though he may dislike such work ; but a picture that is either muddy or full of chemical fog, may be justly termed " muzzy." By pointing out these real defects to the would-be pictorialist, the man who personally delights in a " full scale of gradations " and f/32 will become a valuable ally to honest pictorial photography.

For the common defect in low-toned photographs is dinginess or muddiness or murkiness, all of which are the enemies of truth and sincerity. As long as an evening scene can possibly be photographed, so long will there be sufficient diffused light to render the subject luminous.

He who is unfortunate enough to have a dingy print, framed and hung on his wall, would be wise to substitute a piece of rich velvet, and place the photograph gently in the dust-bin. The velvet will have some beauty, whilst the print is an ugly lie.

LEAF FROM MY NOTE-BOOK

Tone

Julia is so refined that she plays Beethoven's
" Moonlight Sonata " almost without expression.

" Expression," argues Julia, " is a vulgar appeal to
the emotions ; whereas the development of the theme
should, in itself, appeal to the intellect." Therefore
she ignores the pedals, and plays the whole without
emphasis.

Possibly her intellect may supply to herself what
her music appears to lack ; but then it can only supply
the lacking quality to her own brain, and she is playing
to a whole roomful of other persons.

She is a polished musician, but her playing sounds
to me featureless. She seems to play without soul,
and yet she professes to all be soul, all culture, all
refinement—perhaps her soul is only calm and passion-
less ; so she tones down a sonata which is full of
shimmer, storm, and passion, to suit her unimpassioned
soul.

There are some, among the pictorial photographers,
whose idea of tone approaches monotone. Possibly
they may take the Parable of Julia to heart.

CHAPTER XIV

VALUES

I. IF my memory serves me aright, many photographers used to confine the term " values " to orthochromatic photography, and employ this term to describe the right rendering of colours into monochrome. For example, they would speak of " the value of red " when they wished to suggest that red should be depicted in a lighter tint than dead black ; they would speak of " the value of blue " when they wished to insist that blue could not be justly rendered by blank, white paper. Of course this was perfectly right, so far as it went ; but since the colour that we see depends partly on the actual colour of the object, partly on the amount of atmosphere which intervenes between the object and the eye, and partly on the reflections from surrounding objects, the term should be used in a wider and more complete sense. Besides, there are other questions, as well as colour-rendering, that are included under " values."

Let us first consider the question of ordinary values on a clear day, when there is no perceptible atmosphere to complicate matters. The subject is an open landscape, with one strong shadow in the foreground, and the photographer wishes to take a good, technical photograph having a long range of gradations.

The old-fashioned technical photographer would have aimed at what he called " the perfect negative "

—clear glass in the shadow and density in the high light, a negative that would have printed the shadow an intense black, and the highest light a pure white ; but a simple test will show how faulty such a rendering would be. Let the photographer place a piece of black velvet in the shadow and a piece of white linen in the sunshine ; the folds of the velvet will appear far darker than anything in the natural shadow, and they might justly be depicted as black ; the high lights on the linen will appear far lighter than any object in the landscape, and these might well be depicted as white : that is to say, the darkest shadow in a normal landscape, accurately photographed, is several tones lighter than black, and the highest light falls short of a pure white. Between these two extremes, which set the scale and compass of the gradations, every object should be rendered in its proper tint : young green leaves, for instance, would come lighter than a blue sky ; August oak-trees would come very dark.

In technical photography of the highest class, which is simply holding up a mirror to Nature, the use of a panchromatic plate and colour-screen will ensure a truthful rendering of values, so long as the highest light and darkest shadow are correct. The highest light in a landscape falls short of white, and nearly always shows gradations ; the darkest shadow (unless it be a deep cave) is never black, and invariably shows details. This is the test of correct exposure and development, and the key to correct technical values.

II. The true value of the shadows depends almost as much on the amount of detail that is depicted as on the exact depth of the tint to which they are developed and printed.

What is the essence of shadows in moonlight, for

instance ? They seldom appear dark, seldom darker than a bluish grey, but they reveal absolutely no detail : surely part of their value lies in the fact that they have only an outline, filled in with an even wash of tone.

On the other hand, daylight shadows, at least daylight shadows in England, are never empty. To under-expose a shadow and rob it of its detail is like removing the detail from the surface of a florin : the colour may be perfectly correct, but the value is gone. This, however, must only be taken to apply to English shadows, into which the atmosphere diffuses and throws the sunshine : countries that have a perfectly dry atmosphere and brilliant sunlight may well have dead-black shadows. Thus, when I wrote a criticism of Mr. Coburn's Spanish bull-fight, some three years ago : " Again, in ' El Torso,' delightful in its sunshine, are not the shadows round the arena too inky black and devoid of all reflected light ? " I overlooked the fact that the Spanish sunshine, with no clouds to diffuse it, and no atmospheric moisture to reflect it, must have failed to illuminate the shadows. I asked Coburn about this same picture, only the other day ; and he replied that, so far as he recollected, he had tried to photograph the scene exactly as it struck him.

If I blundered in my criticism of Mr. Coburn's picture—and blunder I did—what must be said of the lady who illustrated an article on Switzerland with moonlight photographs which had been so over-exposed that every detail was visible in the shadows, and then complained that properly exposed moonlight photographs looked exactly like flat pictures of day-light subjects ? What can we think of those technical gentlemen who tell us that exposures in Italy, Egypt,

A LANDSCAPE

By Clarence H. White.

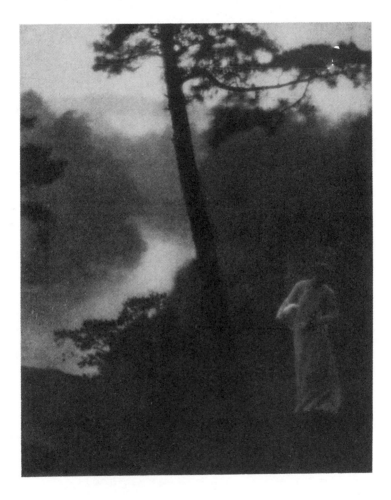

and India should be much longer than the exposures determined by the tables, so as to obtain " full detail in the shadows " ? We can only conclude that these people work by some sort of photographic precedent, instead of by visual impression ; and that they aim at a certain uniformity in the rendering of every subject under every condition (" with full detail in the shadows "), instead of striving to record the values of each separate subject truthfully.

III. The shadows of moonlight scenes lack all detail, and yet these shadows never appear very dark. The shadows cast by a strong electric light show an equal absence of detail, and yet these shadows appear very dark indeed. A moonlight subject might well be rendered in a few tones of a bluish grey ; a subject under an arc light might be depicted in hard black-and-white ; and if this latter were printed on a yellow-tinted paper, it would almost equal a colour drawing. In neither subject are the shadows illuminated by diffused light ; but the contrasts in moonlight are soft, whereas the contrasts given by arc light are very harsh indeed. This brings us to the fact that although shadow details have something to do with the question of values in photography, the heart of the matter lies in the contrasts.

In proof of this, we have only to take one of those abominable under-exposures, with the sun behind some clouds, which photographers are accustomed to pass off as " moonlight effects," and compare it with a real photograph of moonlight—such photographs can be taken—or else with some actual scene illuminated by moonlight. The shadows in the fraud may be as empty as those cast by the moon, but the contrasts in the under-exposure are wrong from beginning to end,

and therefore the values are wrong and the effect untruthful. The camera will lie, and the difficulty is to prevent the camera from lying and rendering the values falsely ; but the camera will never lie to order.

Here we find three distinct scales of values—moonlight, electric light, and under-exposed daylight—all of which are devoid of shadow details, each of which gives different contrasts, and each of which produces a different impression : therefore we are forced to acknowledge the importance of contrast in fixing the scale of values.

IV. The values of a technical photograph, which aims at holding up the mirror to Nature, is a simple and straightforward matter. Provided a panchromatic plate be used, and a colour-screen be employed so as to correct the colour-values, and provided truthful tone and truthful detail be secured in the highest light and the darkest shadow, the rest of the values will fit in correctly and automatically. But from the moment we shift the scale of tones upward, so as to render the subject in a high key, or from the moment we shift the scale downward, so as to render the subject in a low key—from that moment the question of values becomes a problem. This problem is more a problem of contrasts than one of shadow detail.

To-morrow, I have promised to photograph Monica. I forgot to discuss her dress, and I have not the slightest idea whether she will appear in white, black, or puce. If she should appear in white, I am prepared to sacrifice the high lights on the silk, satin, or bombasine (I do not profess to know what bombasine is, but it sounds attractive), and regulate my exposure so as to secure the flesh-tones ; if she should appear in black, I am ready to ignore the shadow details of the serge,

taffeta, or *crêpe de soie*, and devote myself to the render-
ing of Monica's face ; if she should appear in puce—I
do not know what puce is, so the matter is beyond me.

Seriously, in whatever manner Monica may see fit
to clothe herself, I shall devote myself to the task of
catching her expression, and of imprinting it on the
film by a suitable exposure—the details of her dress are
of no importance, so long as the general tint of the
dress establishes the value of the flesh-tones. Is my
meaning quite clear ?

The rendering of my subject's face (and for the
matter of that, the rendering of her hands) is of supreme
importance, and I shall want the general tone of her
face to suggest flesh colour. I do not care a rap
whether the " pearly high lights " on her dress are
depicted, or their gradations defined. I do not care a
hang about the rich shadows of her black dress ; but
I do want Monica's flesh-tints to have the value of flesh-
tints, and I depend on the contrasts between the dress
and the face to establish the value of these flesh-tints.
So I shall ignore the texture and details of the dress,
and develop the plate until there is sufficient contrast
between the dress and the face to establish the value
of the flesh-tones of the latter.

Unlike the technical photograph of the landscape,
with which we started, the values in this portrait will
depend almost entirely on the contrast between the
darkest tone in the black dress and the tint of the
face, or the lightest tone in the white dress and the
tint of the face, and not in the rendering of detail in
the highest tone or darkest shadow, unless, of course,
the lightest tone should chance to be one of the high
lights on the face. The reason of this difference seems
to be that the landscape professed to give truthful

values throughout the picture, and the shadows and high lights were of equal importance and equal interest with the rest of the subject ; whereas, in the portrait the interest would be concentrated on the face.

If the landscape had been so planned that the interest lay in the lighter tones, if the key had been so arranged that the lighter tones were paramount, then the spectator's eye would not have been focussed on the shadows ; and whilst the tint of the shadows would have played their part in establishing the values, the detail of the shadows would not have been of much importance.

V. Since we must have some basis to start from, we will assume that the transcript from Nature, the fine technical landscape photograph, is the normal method of rendering values : for artistic purposes, the scale of gradations may either be shifted upwards into a high key, or moved downwards into a low key, and the values will have to be adjusted accordingly.

In photography, especially with an ordinary plate, the best possible rendering of the light tones of a subject calls for a considerably shorter exposure than the best possible rendering of the shadows, and *vice versâ*—of course I allude to a subject in which the contrasts are fairly strong. This is not untrue to human vision ; for when the eye has been studying bright high lights, it takes some moments to readjust the pupil so that it may take in the shadows. But whilst the eye is gazing at the high lights, it is also conscious of some adjacent shadow, or of the silhouette of some tree-trunk that chances to cross the field of vision ; and although it does not take in the details of these darker objects, they help to determine the values of the lighter tones.

So, when the photographer makes a short exposure, with the intention of securing the full gradations in a luminous distance, and subsequently rendering them in a high key ; although he will, of necessity, be robbing the foreground shadows of their detail, he is not acting contrary to his visual impression. But if the photographer should develop his plate until the contrasts become very strong, until the foreground prints a deep black, whilst the distance is depicted in light tones, he will destroy the values ; if, on the other hand, he should only develop a printable density in the high lights, so that the deepest shadow will have printed to a darkish grey by the time the rest of the print is finished, he will probably have secured the values. The reason of this is patent :

When the photographer received his impression of the subject, his eyes were focussed on the distance, and their pupils were stopped down so as to take in the distance ; he also received a vague impression of the foreground, but his eyes were not focussed on the foreground, nor were their pupils sufficiently distended to see the shadow details, therefore he received only an indefinite impression, which could not possibly be expressed in strong black.

A similar course of reasoning shows that if a subject, in which the beauty lies in the richness of the shadows, be rendered in a low key, both exposure and development should bring out the full richness of the shadows, whilst the high lights should be kept soft and subservient. The function of the high lights, in this case, is simply and solely to give a value to the shadows ; and if the high lights are allowed to become too insistent, they challenge attention, and destroy, rather than establish, the value of the shadows.

The Artistic Side of Photography ♣

VI. In securing the monochrome values of different colours, the panchromatic plate, exposed behind a suitable colour-screen, will give tints that are technically accurate ; but it is almost impossible to translate some colours into suggestive colour-values.

I was walking across Wimbledon Bridge, yesterday. The L.S.W. platelayers were repairing the permanent way, and had hung a strip of red flagging above one of the lines. The wet rails, with the light shining down from behind them, were far brighter than the red flagging, and the engine running past was much darker; and yet this strip of red, lacking both high light and shadow, was far and away the most vivid object in the scene. How could the value of this red have been translated into monochrome ?

Those who have studied Nature know that the foliage in spring is much lighter than foliage in autumn, that September oak-trees are exceeding dark, and that an Italian blue sky is darker than much of the landscape ; but, when one attempts to photograph a regiment of French soldiers clad in bright red coats and bright blue breeches, how is one to secure the respective colour-values of the red and blue ?

Mr. Antony Guest informs us that the contrasts of light and shade on red are much crisper and stronger than they are on the equivalent tint of blue, and that this differentiation will give a suggestion of the respective colour-values—a statement which is absolutely correct. But how is one to secure this effect by photography ? Mr. Guest may be able to tell us. I cannot.

And yet, after all, the colours that are most often met with in Nature are sober blue, green in its various tints, and brilliant yellow, all of which are more or less

easy to translate into monochrome. In addition to this, Dame Nature comes to the photographer's aid, and tones down her colours with mist and atmosphere : in London, she often reduces everything into very delicate shades of monochrome, a bounty which is not sufficiently realised and appreciated by Londoners.

VII. As the different objects in a landscape are situated farther and farther away from the eye, they lose their intensity of colour and their contrasts become softened. This principle used to be treated under the title of " aerial perspective," but it is rightly part of " values " ; for if values are to have any reality the effect of atmosphere cannot be ignored.

Atmosphere must not be confused with mist, for on days which lack all traces of mist there is still atmosphere, and this atmosphere contains sufficient invisible particles of dust and moisture to alter both contrast and local colourings when they are situated at some distance from the eye.

Leonardo da Vinci noted down : " Objects being at a distance from the eye . . . ; and when this is the case, there must of necessity be a considerable quantity of atmosphere between the eye and the object, and this atmosphere interferes with the distinctness of the form of the objects, and, consequently, the minute details of these bodies become indistinguishable and unrecognisable." And again : " Shadows become lost in the far distance, because the vast expanse of luminous atmosphere which lies between the eye and the objects," etc., etc.

I have been forced to end my quotation " etc., etc.," because at this point da Vinci runs off the line, mixing up atmosphere with the smallness of the figure and looking through the eye of a needle in a way that I

cannot quite follow. But is not the Tuscan refreshingly modern in his artistic reasoning ?

And yet, at the risk of digression, I must protest that where Art is based on both Nature and logic there can be no question of modernity. The Ancient Greeks were more modern than the sculptors of the Renaissance ; * Botticelli was slightly more modern than Walter Crane ; Masaccio was infinitely more modern than Reynolds or Poynter ; and Filippo Lippi was as modern as the Newlyn School of Photography. It is only when the artist ceases to be natural that he becomes stamped with the time-mark of a school or period.

The first enemy of atmospheric values is a certain inborn prejudice which insists that a black cow is black, and that a whitewashed cottage is white, even though the " vast expanse of luminous atmosphere which lies between the eye and the object " should have reduced the colour of both cow and cottage to an appearance of neutral grey ; the second enemy of atmospheric values is a lens of a comparatively short focal length. And yet, since photography is inclined to exaggerate the effect of atmosphere, rather than to minimise it, we must place the blame on the lens and regard the photographer as an accessory after the fact.

The photographer is photographing a landscape,

* It is interesting to note that in a recent book of mine describing the life of a Tuscan artist of the Renaissance, I borrowed the dialogues on art so largely from da Vinci that I feared the accusation of plagiarism. But no ! One of the leading papers complained : " The fifteenth-century Tuscans are made to speak the studio jargon of the twentieth century." From art to amativeness, the ideas of the early Renaissance seem absurdly " modern."

and he desires the image of a tree in the middle distance to be half an inch high—his composition demands that this tree should be depicted in a half-inch image : one of a quarter-inch would be altogether too small. If he be using a ten-inch lens he will place his camera two hundred yards from the tree, if he be using a five-inch lens he will place the camera one hundred yards from the tree, and will consequently lose half the atmosphere.

VIII. Lastly, if the photographer really studies the question of values, he will instinctively turn to indoor subjects, faces in shadow, faces against the light, and so on ; and he will find that the values in such subjects depend almost as much on the amount of detail that is visible as on the strength and contrast of light and shade. This brings us back to our original conclusion that truthfulness in the rendering of shadow details plays a very important part in photographic values.

LEAF FROM MY NOTE-BOOK

The Study of Values

Some years ago, when I had more leisure to devote to my camera, I always used to carry the proofs of my latest photographs in my breast pocket. Whenever I found one of my subjects under conditions of lighting and atmosphere that were similar to those in the photograph, I would compare the different values in the proof with the values in Nature. This seems to me to be the only reasonable way of learning values.

Some days ago, when I had finished my afternoon's work and was walking into Wimbledon with Monica, I remarked on the beauty of the wet roadway in the growing dusk.

" Isn't the road looking jolly ? " said I.

" Yes," answered she.

" And doesn't everything work out nicely into about three tones of neutral grey ? " suggested I.

" I never noticed it," laughed she. " I suppose you notice it because you are writing the photography book."

Naturally I repudiated the idea ; but, all the same, I doubt whether any one would think of studying values unless he had a definite purpose in view.

A keen photographer will learn more from the direct study of Nature in a week than he could learn from years of studio work. The study of values is a very interesting subject.

CHAPTER XV

EMPHASIS

I. WE have already seen that it is both reasonable and artistic to have some principal character or object in every work of art. We must now consider the question of emphasising this principal object in a natural manner.

But before considering the question, we must remember that a landscape is not created in a series of little pictures, each complete in itself, each waiting to be photographed. We must remember that the eye is apt to wander over the surface of an ordinary photographic view, seeking rest and finding none. And we must also remember that the photographer has to select a portion of the landscape and make it into one satisfactory picture, complete in itself.

We will assume that our photographer has sufficient artistic instinct to realise the need of a principal object for the eye to rest on, a point of focus which will pull the picture together ; and that he either moves his camera about until some important object falls into the right position in his picture scheme, or else he places some figures where they will serve best. The subject may look right enough to the human eye ; but when the plate is developed, and the print printed, the artist probably finds that his principal object has lost its importance.

There are two reasons why this is so. In the first

place, the human eyesight is stereoscopic, and in the original view the principal object stood out from its background ; whereas the print must lack this stereoscopic sense of relief. In the second place, although the principal object in the original view had only just sufficient principality to attract the eye, yet, from the moment the eye was focussed upon it, all else was out of focus ; whereas in the print every object on the same plane is defined with equal sharpness.

Now, as I said, this photographer is an artistic man, so he proceeds to strengthen some high light on the chosen object in his print, or deepen its shadow ; and this has the effect of catching the eye and establishing the principality of the principal object.

It might be urged that the photographer was tampering with the purity of his medium ; it might be urged that he was upsetting values and altering the gradations of light, shading, and shadow ; but I do not think that this accusation would be correct.

The natural view-angle of the human eye, *when it is at rest*, is exceedingly narrow, and when the eye is fixed on the principal object in the landscape it is doubtful whether it sees more than an angle of $2\frac{1}{2}$ degrees clearly ; in other words, the eye does not see much more than the principal object. When it is realised that the view-angle of the ordinary camera set includes a view-angle of about forty-six degrees, the exceedingly narrow angle of acute human vision will be realised.

Besides this, the eye is not a mechanical instrument —it is the servant of the brain ; and if the brain be interested in the principal object the eye will not be conscious of much else.

And, consequently, when the eye is fixed on the

principal object in a landscape, the high lights and
shadows of that object acquire an importance which
makes them appear stronger than they really are ;
and the details of the object are seen with a clearness
which makes them seem predominant.

I do not suppose that the ordinary painter follows

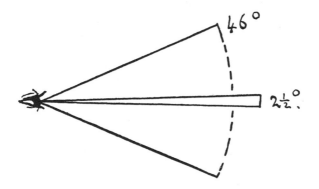

this particular course of reasoning when he places
the strongest high lights and darkest shadow close to
his principal object, and paints the principal object
a little clearer and a little stronger than the rest of the
picture ; it is far more probable that he simply paints
things as he sees them. But, nevertheless, he has been
trained to feel that the emphasis of the chief object
will create a resting-place for the eye, prevent it from
wandering outside the picture-frame, and establish a
feeling of unity in the picture.

With regard to the degree of emphasis. If the
accent should happen to be a Devon cow in the land-
scape, or a dark fishing-boat in the seascape, the accent
will be quite strong enough—probably too strong—
and the same may be said of a white-frocked girl or
a yacht with white sails ; but eternal red cows and

white-robed girls would become very monotonous, and the principal object will often have no more contrast or emphasis than the rest of the subject. In this case, the high light or shadow of the chief object may rightly be strengthened.

This strengthening of a high light or shadow should be affected with caution and restraint. The slightest deepening of a shadow, or the slightest raising of a high light, makes a marvellous difference in the effect, and the artist should aim at securing principality without advertising the fact, or showing how it was done.

It must also be noticed that the strongest high light in a picture need not be really lighter in tint than other high lights. A light patch of tone takes its value far more from an adjoining shadow than from a comparison with other light patches of tone. The patch A is exactly the same tint as B, but A looks lighter.

A B

FIG. 15

In the same way, a strong high light establishes the principality of a neighbouring shadow, although this shadow may not be darker than other shadows in the picture.

II. If only one or two prints are needed—and few amateurs require more than this—accents may be intensified in the printing ; if many prints are required,

a positive transparency should be made, and the shadows retouched. From this a new negative is made, and the high light retouched. I do not think a knife should be used on the shadows, because the first thing knifing does is to scrape away the shadow details : high lights may be lowered by means of knifing, since the gradations remain untouched.

It is a simple thing to print a shadow deeper than it comes in the negative, and it is equally easy to print the high light lighter.

The negative is placed in one corner of the printing-frame, and an unfixed proof is taken on P.O.P. ; the proof is laid on a sheet of glass, the shadow cut out with a sharp knife, and the marks of the printing-frame rebate trimmed off. This will form the mask for deepening the shadows, and is placed aside for the present.

Then the negative is held against the window, with the film side next the window pane, and the high light is covered with thick, light-red water-colour—this masks the high lights.

Next the negative is placed in the same corner of the printing-frame as it was to start with, so as to obtain register, and the platinotype is inserted. The mask is laid on the printing-frame,* and the shadow is printed for a few minutes in diffused light—diffused light will prevent hard edges in the shadows : only a slight extra printing of the shadow is necessary. If the negative takes twenty minutes to print, an extra four minutes should secure principality for the shadow.

* If the mask does not fit in easily, a trifle may be trimmed off the top and side opposite the registration corner. If it refuses to lie flat, a sheet of cardboard, with a hole opposite the shadow, may be laid on it.

The mask is then removed, and the printing is continued for another three or four minutes, so as to accentuate the high light ; the red paint is removed with a damp cloth and the glass polished. The printing is then continued until it is finished, and the print is developed.

It is well to try the effect of deepening the shadow on a proof platinotype before commencing to print. A touch of thin, moist-colour lamp-black, applied with a nearly dry paint brush, will show the exact effect. Experience will teach the photographer to secure a similar effect by printing.

III. The importance of an accent cannot be overestimated.

In order to press home this point, I have taken Mr. Arbuthnot's Chodzko portrait, and have had two half-tone blocks made, one a reproduction of the original and the other minus the accent of the black tie. Without the black tie, the portrait lacks strength and the picture is badly balanced. It will be noticed how the accent gives importance to the face, and so enables the figure to balance the large expanse of background.

In photographing a spray or group of white flowers it is generally necessary to accentuate one of the flowers. This may be done partly by focussing, and partly by the management of light and shade during the whole or part of the exposure. Here again an accent is true, because the human eye, although it takes in the general arrangement of the flowers, is usually attracted by one blossom. But in a genre study the arrangement of the figures may secure principality without any special accent of light and shade. A girl is reading a letter, while her lover is watching her face : the onlooker will naturally follow the man's example, and

Notice the black tie.

Without the accent.

his eyes will rest on the girl's face in an attempt to discover whether the news is good or bad. A fisherman is telling a story, and the rest of the men are looking at him or smiling at one another : the onlooker naturally seeks the face of the story-teller, and principality is established.

IV. This brings us to the logical conclusion that the heightening of light or shadow on the principal object is subjective. The more interesting the object is, the more will it attract the eye ; and the more it attracts the eye, the less need will there be of artificial accents : but when the object is not very interesting, accents are essential.

If the portrait of A. J. V. Chodzko, for example, had been placed on the picture surface in a more conventional manner, the black tie would have been needless ; for Mr. Chodzko's face is quite interesting enough to attract and hold the eye, whilst the white shirt-front and black coat are sufficient to establish the truth of the flesh-values. But since the placing of the figure is unconventional, the black tie is required to give extra importance to the face, and enable it to balance the expanse of background.

The next step in our reasoning seems to imply that in composing the portrait of a person with an interesting face, the face itself will be a sufficient accent ; whereas if the sitter's countenance be uninteresting, accents are needed to assist the composition. I have never heard this idea formulated, but yet it seems sensible ; but please note that I have written " an interesting face " and not " a pretty face," for many pretty faces are quite uninteresting.

We are far too apt to consider the optic nerve apart from the brain, whereas they work together ; and a

mental feeling of interest in the chief object of a picture may be far stronger than the mere visual excitement produced by a light or dark accent. May the gods give us all the sense of proportion !

LEAF FROM MY NOTE-BOOK

Emphasis

Last night I dined with some people who live in Cadogan Square, and I met an Italian girl who has just come from Italy.

She was of the fair type, this little Contessa, with hair as soft and silky as that of the Goth who founded her family ; but God had taken the hair of this little Contessa, and kissed it with the sun until it shone like spun sunbeams. The same sun which had touched her hair had kissed her cheek ; and he had kissed it so gently that it was tanned, and yet as sweet as peach-skin.

Lastly, her voice was rich and soft, and her face was alive with animation.

" Who else was there ? " you ask.

" For the life of me, I can't tell you ! But wait a moment ! There were several smart Society women and half a dozen assorted men."

" What did they wear ? What did they talk about ? And was the dinner good ? "

" The little Contessa wore soft white silk and pearls ; but she was the other side of the table, four seats up, and I could not hear what she said."

" And after dinner ? "

" My Contessa sang an Italian song : her singing voice was as pretty as her speaking voice."

" And the rest of the people ? "

" I don't remember." When the interest is concentrated on one person, the rest pass unnoticed.

E. THE CHOICE AND TREATMENT OF THE SUBJECT

CHAPTER XVI

THE INFLUENCE OF JAPANESE ART

I. IN the spring of 1907 Messrs. Graves, of Pall
Mall, held an exhibition of Japanese paintings. With
the exception of this exhibition, a very occasional
picture in some picture dealer's window, and a few
half-tone reproductions of paintings in *The Studio*,
English people have but little chance of studying
the higher Japanese art. One had hoped that the
Japanese exhibition held at the White City during
1910 would have been representative; but, alas!
one's hopes have only led to disappointment.

The need of some representative exhibition cannot
be overrated; because, although Japanese art has
had much influence on Occidental artists, it has so
far been the wrong type of art, whereas we require to
learn something of the right type of Japanese Art.*

It is true that some of the Western artists have
been influenced by the higher artistry of the Eastern

* June 20, 1910. A fine exhibition of Chinese and
Japanese paintings has just been opened in the Print and
Drawing Gallery of the British Museum. These paintings,
which are the property of the nation, and include the Anderson
and Wegener Collections, give a very good idea of Oriental
pictorial art, from the fourth to the nineteenth centuries.

painters ; but the huge majority, from the time of James McNeil Whistler down to the latest school of decorative photographers, have derived their inspiration from the colour-printers, whom the Japanese do not even recognise as artists.

I am casting no aspersion on the discrimination and æsthetic feeling of the larger class of Western artists ; I am only stating the fact that they are intimate with the colour-prints, whilst they appear to be unacquainted with the Eastern paintings. Whistler had that instinctive good taste which made him absorb only the virtues of the Japanese wood-engravings, but many of the rest have been badly trapped by the faults of these prints.

The social difference between the Japanese wood-engraver and the painter was similar to that which separates the ordinary house-decorator from the R.A. : the artistic difference was nearly as great as that which divided the eighteenth-century political cartoonist from Burne Jones or Holman Hunt. For the Japanese painter was a man of lofty ideals, who painted noble pictures ; whereas the colour-printer was usually an artisan of low ideals, who would stoop to depict the wayside, the tea-house, the strolling actor and the courtesan. The painter had intense refinement, whilst the wood-engraver was sometimes indescribably vulgar.

Of course the design and colour of the older colour-prints are usually exquisite, and the workmanship perfection ; but then, instinctive composition, natural colour-sense, and delicate manipulation are the birth-right of even the tea-house girl : on the other hand, the selection and treatment of subject are generally paltry. In a word, there is much the same difference between the paintings of the true Japanese artist and

179

the colour-prints of the wood-engraver as there is
between the writings of Lafcadio Hearne and those of
Mr. Douglas Sladen. The greatest of the engravers,
in their noblest achievements, only belonged to the
school which appealed to the lower classes : " The
Mirror of the Passing World."

Kakasu Okakura, who is one of the chief living
authorities on Japanese art, tells us that the present
art movement has taken for its keynote, " Life True
to Self "; or, as we might express the phrase, " The
Personal Interpretation of Life and Nature."

" According to this school, freedom is the greatest
privilege of the artist, but freedom always in the
sense of evolutional self-development. Art is neither
the ideal nor the real. Imitation, whether of Nature,
of the old masters, or, above all, of self, is suicidal to
the realisation of individuality, which rejoices always
to play an original part . . . in the grand drama of
life, of man, and of nature." This passage will bear
reading over several times, and might well be com-
mitted to memory.

Again, he gives amongst the fitting subjects for
artistic expression—" Fragments of nature in her
decorative aspect, clouds black with sleeping thunder,
the mighty silence of pine-forests, the ethereal purity
of the lotus rising out of darkened waters, the breath
of star-like plum flowers, or the waning light of some
great splendour."

All this is very different from the usual subjects and
schemes of the colour-printers ; and so, when we find
a man photographing a cart-wheel, with cattle showing
through it in the distance, or the fore part of a cow
cropping grass (the Japanese would probably have
depicted the hind end of the cow, with a quiet chuckle),

we know that he has been trapped by the failings of the wood-engravers.

What I have said about the colour-printers sounds harsh ; but I am trying to give the Japanese opinion of these men, rather than my own. Sometimes one finds a print that is altogether worthy ; but, as a rule, one finds a comic bird, an absurd beast, or a humorous man introduced into otherwise beautiful landscapes. Such practices may have pleased the common people, but they disgusted the cultivated classes, and the engravers were regarded as devoid of dignity and self-respect.

II. On the face of it, the idea that the impression of a wood-block, or series of wood-blocks, could ever be a fitting inspiration for those working in tone, is absurd. If one searched through every art medium, one could not find two methods more essentially unlike than those of wood-engraving and photography. And, since most of these engravings are printed in several arbitrary colours, decorative rather than natural, their influence on certain photographers becomes altogether inexplicable.

A reproduction of one of these colour-prints loses quite three-quarters of its charm, if the picture be translated into monochrome ; but when some subject which appears similar to the subject of one of the wood-engravings is selected and photographed, both in monochrome and in tone, there is little left except the quality of eccentricity.

The technique of the Japanese paintings, on the other hand, is probably nearer to good photography than any other method of artistic expression. The colouring of such Japanese paintings as I have seen is very reserved, and easily translated into the grada-

tions of monochrome ; the definition of detail is strongly reminiscent of the definition of a photographic lens, working at a large aperture ; there is an accentuation of a little clear detail at the point of interest, combined with great simplicity in the rest of the picture ; and the decorative qualities are more refined, more natural, and less assertive than those of the colour-prints.

But it is not chiefly the actual, visible qualities of a fine Japanese painting that makes it preach such a pungent lesson to the photographer—it is rather the underlying spirit which strikes home : for the artist's picture is but the outward and visible sign of an inward and spiritual meaning ; and this particular quality is, I am afraid, lacking in nearly all photographs. The photographer usually seems to be aiming at values, or tone, or composition, or decorative design ; and he very seldom attempts to reach the spirit of his subject.

The Western photographer takes a few flowers ; he arranges them tastefully in a vase, and gives a correct orthochromatic exposure. " Paint this spray of bamboo worthily," thinks the Eastern artist, " for it is life." Each brush-stroke has its moment of life and death ; all together assist to interpret an idea which is life within life—hence the difference between Western and Eastern art.

It is a strange fact that the English writers have caught the spirit of Nature with more illumination than the English artists :

> But forth one wavelet, then another, curled,
> Till the whole sunrise, not to be suppressed,
> Rose, reddened, and its seething breast
Flickered in bounds, grew cold, then overflowed the world.
> BROWNING.

Then came the Rains with a roar, and the *rukh* was blotted out in fetch after fetch of warm mist, and the broad leaves drummed the night through under the big drops ; and there was a noise of running water, and of juicy green stuff crackling where the wind struck it; and the lightning wove patterns behind the dense matting of the foliage, till the sun broke loose again, and the *rukh* stood with hot flanks smoking to the newly washed sky.—KIPLING.

But, perhaps, Pippa's song as she passes is the most Japanese of all English literature. I do not quote it, since it must be read as part of the original play, and not as a mere extract.

It is an equally strange fact that the French etcher Legros has caught the true spirit of his landscapes with more feeling than most of the painters, and all the photographers.

When the Baroness Orczy described the moon as " honey-coloured " she was superficially clever, and truthfully incorrect. The spirit of the moon and its moonshine is coldness, whereas " honey-coloured " suggests mellow warmth. Art should aim at the underlying spirit of the subject, and not only at the superficial appearance. And so the ideal of Japanese art is the spirit of a worthy subject, depicted with accent, simplicity, and refinement.

III. In all our attempts to benefit by the art of the Japanese, we are met with their formulated keynote, " Life True to Self ! " and also with the statement that imitation is suicidal to the realisation of individuality.

The imitation of Japanese methods is consequently forbidden, for the adoption of Oriental design can never be true to the Occidental temperament ; but we can learn the great lesson, that Art is noble and

JAPANESE LANDSCAPE

By Holland Day

demands a noble theme ; and that to make life live in our pictures should be the chief end and aim of Art.

There seems to be also a second lesson—an artist is strongest when he is reserved, and his Art strongest when it is refined.

LEAF FROM MY NOTE-BOOK

Japanese Paintings

The following was written after a visit to the exhibition of Japanese paintings in Messrs. Graves's gallery, and may prove interesting. It was published in *The Amateur Photographer* of March 5, 1907.

" These Japanese impressionists seem to receive impressions that are entirely different from those which stamp themselves on Western minds. They seem to see things differently from the way Europeans see things ; and, strange to say, they see things more as the camera sees them. Roughly speaking, they seem to seize on some object (or perhaps a group of objects) and focus it sharply, leaving all else out of focus and softly and imperfectly defined ; and, though I cannot recollect examples amongst the pictures at Messrs. Graves, the Japanese seem to receive ·a much more rapid impression of moving objects than we Europeans.

" I should say that the chief difference between the Eastern and Western methods is this : Europeans assimilate a subject slowly, allowing the eye to wander from object to object ; and although they concentrate most attention on the most interesting object, yet they obtain a fairly definite impression of the whole. The Japanese appear to fix their attention on the point of interest, and consequently only receive an indefinite

impression of the rest of the subject ; hence, in their pictures there is generally one object, or one plane, which is drawn with a masterly suggestion of detail combined with simplicity, and the rest is blended into broad masses of suggestive colouring. The colour, as well as the drawing of the principal object, is clear ; but the colours in the other planes are just those harmonious masses that one would be half-conscious of in the distance, if one were looking at some object in the foreground.

" The picture of the ducks, No. 26, if it is still on view, is exactly the impression one would receive if one fixed one's eyes on the ducks, and, without altering the focus of one's eyes, drank in a general impression of the water and sandbank. In the two pictures of ships, 21 and 28, the ships are clearly defined, and the rest merely suggested with broad simplicity. In the other pictures, the principal object is either clearly or strongly depicted, and the rest left soft and suggestive ; item, the moon and figures in No. 9 ; item, the trees and grass in the foreground of Nos. 21 and 24. And all these pictures give a strong sense of atmosphere, and produce a strong feeling of pleasure.

" In moving objects, the Japanese eyes see things quicker than ours do, and consequently these artists depict phases of motion, instead of giving a general impression of motion, like European painters. I believe that the Japanese custom of painting flying birds with their wings at the bottom of the stroke, pointing downwards, was only discovered to be true to Nature by the Western critics, when instantaneous photography came into vogue.

" These considerations raise many trains of thought. May not the Japanese teach us to see things in a new

and more artistic light ? And, just as we learnt from
the European impressionists to discard such hideous
conventions as the universal painting of trees and
foliage in various shades of brown, and see and paint
colour ; so may not we learn from the Japanese im-
pressionists that we are not untrue to Nature, as seen
by the human eye, when we depict our object of
interest clear and strong, and leave the rest all blended
into soft and undefined masses ?

" And in our photography, might it not be that the
flat field of our anastigmat is sometimes false and
artificial, and the small circle of clear definition given
by the Petzval, and other early lenses, sometimes true
to what we see ? And might not f/3 be sometimes
true to truth in outdoor work ? "

Nov. 8, 1909. The keynote of Japanese art—
" Truth to Self, and No Imitation," must not be lost
sight of.

CHAPTER XVII

THE SUBJECT IN PHOTOGRAPHY

I. THERE are two distinct parts in all forms of expression :

(*a*) The Subject ;

(*b*) The Expression of the Subject.

That is to say, there is the theme, and the treatment, development, and expression of that theme.

Amongst unrefined but clever persons, there is a tendency to think more of the subject than of the treatment ; a novel, with a clever plot and forceable character-drawing, will command a large sale amongst the general public, even though the literary style may be faulty, and a picture with a taking subject will pass muster, even though it be deficient in other artistic qualites. Amongst the refined, I think that the tendency is to value treatment more than subject ; a badly expressed book is at once placed out of court, even though the plot, or theme, shows considerable ingenuity ; inferior workmanship will at once damn a picture, even though the choice of subject be original. Amongst the over-refined, treatment is everything, and subject only a secondary consideration.

Amongst the best class of professional artists, writers, and musicians, I have generally found that the private leaning is towards a very high estimate of good expression. " Any intelligent man," say they, " can think out an interesting subject ; but it requires a Bernard

The Artistic Side of Photography ♣

Shaw to write a play without plot, and a Chesterton to weave an interesting article round 'The Hind Leg of a Mosquito.'" But, fortunately for the sanity of Art, the wealthy amateur is almost invariably a dilettante; and since the professional has to consider the selling of his books or pictures, he has to select a subject which is sufficiently interesting to satisfy the public.

But to leave the personal feelings of these different people on one side, and regard the matter from an impartial standpoint: a picture is the expression of some theme; an artistic picture includes good composition or construction, correct values or truthfulness, and tone or refinement. Is it reasonable to waste all the artistry involved in the composition, values, and tone on the expression of an unworthy theme? Is it not reasonable to insist that the subject must have sufficient interest or importance to be worth expressing?

This argument sounds absurdly obvious; but those pictorial photographers who are wrapped up in the artistic—as opposed to the chemical and optical—technique of their work, appear apt to overlook it.

II. Now, it must be remembered that pictorial photography was commenced by mid-Victorians, that the mid-Victorian photographers were strongly influenced by the painters, and that the mid-Victorian painters were as keen about interest of subject as Thackeray, Scott, or Dickens. A visit to the South Kensington Museum is essential to those who would grasp the origin of both the Royal and (strange though it sounds) the Salon.

I do not think I am exaggerating when I say that the early pictorialists amongst the photographers were entirely influenced by contemporary art, as exhibited

in the Royal Academy, and that their subjects were very similar to those selected by the painters. When Whistler was delighting the very elect with his nocturnes, symphonies, and essays in values, the photographers would have been amongst those who considered that he was flinging a paint-pot in the face of the British public.

Gradually the influence of the æsthetic movement spread to the Salon, and this was followed by the influence of the French and American schools. The academic composition of the Robinson school gave place to decorative schemes borrowed from the Japanese wood-engravers ; subject pictures were superseded by nocturnes, studies of tone and essays in values ; until now the selection of subject seems to have taken quite a secondary place amongst pictorialists.

Mr. Arthur Marshall, himself a constant exhibitor at both the R.P.S. and Salon, stated recently : " Place an empty barrel on the garden wall, with a geranium beside it ; photograph it against the sky, but under-expose it, and when the picture appears on the walls of our leading exhibitions—for it could hardly be refused—some persons will say that it has ' a bold conception of line,' others that ' the masses are well balanced,' others, again, that ' it has striking decorative qualities.' "

Leaving all exaggeration on one side, there certainly is a tendency amongst " advanced photographers " to neglect the choice of an interesting subject, and trust to an attractive pattern in the design of their composition, or a sophisticated restraint in tone, to give a pictorial merit to their photography. Fifteen years ago subject was everything to the photographer ;

now, the pendulum has swung too far in the other direction.

III. If one wished to be read off to sleep, one would choose a reader with a nicely modulated voice, and a book that was well written, without being too interesting ; if one were dining with a pleasant companion, one would prefer music that was soft and melodious, but which lacked the strong development of a theme ; if one were papering one's study, one would either select a paper of a single tint, or else a decorative design that was not too pronounced. But if one were picking out a novel to read, music to listen to, or a picture to look at, one would require interest.

The present fashion in pictorial photography may be soft, it may be toneful, it may be pleasant, but it is not very interesting ; the conception of line, the balancing of masses, and the decorative qualities may all show considerable artistic technique, but these things, in themselves, can hardly be considered intellectual. Even the most scholarly expression is apt to pall when it expresses nothing in particular. This is not to belittle the present refinement of technique, but merely to suggest that the true function of artistic expression is to express some worthy theme.

The honest, brutal truth is that many of the pictures exhibited at the Salon of 1909 were not pictures, in the true sense of the word, but merely studies in artistic technique.

Now, studies in tone, in values, in composition, may be the necessary steps that lead up to the mastery of the photographic medium, and very interesting to the photographer and those who are engaged in the same process of evolution ; but to exhibit such work publicly, asking the general public to pay at the rate of one

shilling a head for the privilege of admission, is hardly likely to popularise pictorial photography. Consequently, when and whilst the other London picture exhibitions were crowded, the Salon of 1909 was usually empty. The educated public does not want to see our studies in artistic expression, it wants to see these studies worked out into the expression of some artistic theme.

When studies are experimental, and open up new ideas in the technique of art, they are worthy of public notice. Some of Whistler's work was experimental, and sufficiently interesting from the bold novelty of its values ; much of the American Photo-Secession work has been experimental, and sufficiently interesting in the study of photographic values to make the subject matter of secondary consideration. In the same way, a great deal of the Salon work of recent years has partaken of the nature of illuminative experiments in tone, key, composition, and decoration.

But now the time has come when experimental studies should be kept at home and not exhibited in public ; and this for two reasons. In the first place, experimental work has served its purpose, and lost its originality, so, unless an experiment is absolutely new, it has ceased to have a legitimate claim on public notice ; in the second place, studies in the artistic technique of photography are becoming a habit, they are setting a fashion for the lesser pictorialists, and subject is fast losing its proper place in the scheme of pictorial photography.

The American school has almost passed through the technical stage, and is entering on a stage of subject-work which is honestly pictorial ; that is to say, the Americans have mastered the A B C of their craft,

and are commencing to make subject-pictures of importance. This may be news to many of my English readers, but since I have had the luck to see much of the latest Photo-Secession work, I am speaking from knowledge.

Just as the Photo-Secession led the way in the study of values, so it is leading the way in the study of subject. The type of American work that many of us Englishmen laughed at some five years ago as eccentric is the type of work that we are doing now : whilst the Americans are passing from study to picturecraft, many of the English school are wrapped up in studies that are reminiscent of those exhibited by students of a school of art. To give an example, Mr. Coburn has left the girder-bridge phase behind, and has published a collection of very fine subject-pictures of London : the Salon of 1909 was noticeable for its many essays on views seen through girder bridges.

IV. I spoke just now of studies becoming the fashion, and subject losing its proper place in the scheme of artistic photography. This is a fact, and no fancy : there is a distinct " No-Subject school." I do not mean that it is a school, in the ordinary sense of the word, but rather a sentiment in favour of treatment as opposed to subject. In a way, the No-Subject school is like the Mafia of Sicily, an intangible something that is without leader, members, or organisation, and consequently equally difficult to attack ; and yet, if one were to place half a dozen of the younger and more progressive of the leading pictorial photographers on the hanging committee of an exhibition, although they themselves would employ just sufficient subject in their pictures to carry the treatment, they would be inimical to interesting subject-matter in other

exhibits. I do not pretend to know why these men dislike subject in pictorial photography. I do not pretend to know whether it is due to some obscure code of ethics, or to a suspicion that "subject" spells sentimentality; but they are certainly opposed to any picture that would interest ordinary persons, whilst they desire and admire the delicious curves of the presentment of phantom pines in a puddle.

Perhaps the artistic ethics of the No-Subject school may be derived from an admixture of Photo-Secession and Hokusai. If this be so, these ethics are drawn from the Americans in their experimental stage, and from Hokusai with all the dash, humour, and interest left out.

V. The obvious difference between painting and monochrome is, that monochrome lacks the interest of colour. What music is to an opera, colour is to a painting; what plot is to a drama, subject is to a monochrome. Strip a grand opera of its music, have the parts acted instead of sung, and its charm is gone; strip a painting of its colour, convert it into monochrome, and it loses the peculiar quality of a painting, without acquiring the peculiar qualities which would have inspired a picture that was intended to be worked out in a single colour.

Men of the paint-brush, pencil, and etching-needle realise the importance of subject in monochrome, and consequently make their sepia sketches, drawings, and etchings more interesting in the subject than most of their colour-paintings.

Instead of boldly facing the limitations of monochrome, the modern photographer appears to have trained himself to disregard or ignore colour; or, rather, he seems to have trained himself to see colour

as though it were monochrome, and to see his photographs as though monochrome were similar to colour. Thus, when he looks at gorse and heather, he has educated himself to see the yellows and purples as he would see them in an orthochromatic photograph ; and when he looks at his rendering of these subjects, he metaphorically sees the colours of gorse and heather in the monochrome of his photograph.

To those who do not realise the adaptability of the human mind, the above paragraph may sound absurd ; but I believe that people may train themselves up to any artificial standard. For instance, heraldry signifies colour by the direction in which the lines are drawn ; and if I were to draw a soldier thus, it is probable that a trained herald would see red in the vertical lines of the tunic, and blue in the horizontal lines of the trousers. If I were to draw fowls with the sex mark above them, I believe that a naturalist would see one as a cock and the other as a hen. It is probable that many photographers imagine that they see colour-interest in their prints which is really non-existent.

Some of the paintings of Dartmoor which depict the ordinary atmospheric conditions are exceedingly attractive. The golden gorse in the foreground, with

the purple ling behind it, are sufficiently beautiful to delight the eye. But this same subject in monochrome is dull, unless the photographer secure some moorland sheep to give interest to the foreground, or some ponies or cattle in the middle distance. The same fact holds good with many landscapes.

VI. Under ordinary conditions, Dartmoor is dull when translated into monochrome.

But wait ! A very soft, faint mist sweeps over the moor, changing the distance into delicate shades of monochrome, softening the middle distance, and throwing the foreground into bald contrast. This is the photographer's chance, for Nature has taken the predominance of colour and substituted the virtue of tone. The sheep and cattle are no longer needed, for there is sufficient interest in the beauty of atmosphere.

And so, if the photographer can once more grasp the essential limitation and essential virtues of his medium, he will commence to choose subjects that are suitable to the camera. Colour-interest is beyond the limitation of photography ; but the rendering of light, shading, and shadow is the very essence of the medium.

The contrasts and balance of light and shade, sunshine and shadow, come within the scope of the medium, so long as colour does not form an important feature in the subject ; the soft tones of the very early morning, and the subdued colouring of evening are too little sought after ; the gradations of mists are a godsend, and London is painted in something that approaches tone on at least two hundred days in a twelvemonth. But bright diffused light, towards the middle of a clear summer's day—the very time when the ordinary man

is busy with his camera—should be left to the colour-painter.

Etchers, from Rembrandt to Brangwyn, have utilised the human figure to add interest to their pictures ; but modern photographers are apt either to shirk the difficulty of including figures, or to despise this appeal to the public. There is no doubt that figures have great pictorial value, so long as they are kept from becoming too obtrusive, and provided they are treated in such a manner that they form part and parcel of the subject.

Mr. Keighley handles his figures in a wonderfully artistic way ; they are always in keeping with the surroundings, always unselfconscious, and always so defined that they add interest to the picture without attracting too much attention. In his " Adieu," which illustrates this chapter, the figures are so well placed and depicted that it is difficult to believe that the picture was the work of the camera. I heard whispers about the " sentimentality " of " Adieu " ; but the person who cannot enjoy such wholesome and natural sentiment must be a decadent ; and he who fails to see the robustness which the strenuous pose of the woman gives to this sentiment must be a Chump.

The first essential in the introduction of figures into a subject is that they must be indigenous ; the milk-maid must be a daughter of the soil, and not Cousin Dora clothed with sun-bonnet and milk-pails. Dora gathering flowers in the garden will be well enough, but the camera will not stand Dora play-acting. The second essential is the definition or, rather, lack of definition—an overdefined milk-maid is apt to kill the rest of the subject.

VII. There are two great temptations that beset

the photographer in his choice of subject. The first is imitation, the second lack of specialisation.

Every artist has a tendency to be influenced by some one whose work he admires ; and so long as the influence does not degenerate into imitation the tendency is not harmful. But the moment the artist begins to feel his own feet, from that moment (if he be a true artist) he commences to choose his own subjects for himself, and strike out in his own line. The choice of this line is most important.

Unfortunately, the facility with which the camera draws anything and everything, without the necessity of study, tempts the photographer to take any subject that happens to please his fancy ; and so he wanders from portraiture to architecture, taking landscapes, seascapes, and genre pictures in between.

The camera can draw any subject with relentless accuracy ; and if the photographer be sufficiently versed in the technical side of his medium, he can render the superficial qualities of values and texture ; but he cannot hope to get down to the spirit of his subject without long and intimate study. Therefore the photographer who would become a true artist must learn to know and love his subject as thoroughly as a painter.

Gradually, out of the intimate study of the subject, there forms the inspiration for a picture : patience and perseverance do the rest. I do not mean that the inspiration is not sometimes immediate ; but this good fortune is the reward of patient study.

And, above all things, the photographer should realise that he will best interpret that form of nature with which he is in sympathy.

LEAF FROM MY NOTE-BOOK

Progress in Art

November 3, 1909.—Art is like life : each fresh start that a man makes involves a return to his natural self. This fresh start does not mean a beginning over again with the past forgotten, but a recommencement aided by the light of acquired experience.

A man grows blasé and world-worn ; he returns to the natural life that can be still found in the wilder parts of Norway, but he neither clothes himself in skins, nor does he arm himself with a bow and arrow —he dresses in good homespun and takes an express rifle and a split-cane rod.

November 4.—Art is like life : all real progress involves personal returns to Nature ; otherwise, A would form his own views of Nature, B would take A's views of Nature, and C would take B's views of A's views of Nature ; by the time that Z took Y's views of X's views of W's views of V's views, etc., etc., A's original views of Nature would have been distorted out of all belief.

When our world-weary man seeks the natural life, he does not start primed with Mr. Miles's theory of nut dietary, nor does he carry a library of little books on hygienics and eugenics and all the other " ics " : he goes to Nature for salmon, venison, and good fresh air.

November 5.—Ancient Greek Art drew its inspiration from Nature ; Giotto learned all he could from the

Byzantines, and returned to Nature; but from the sixteenth century, when men began to adopt the old Greek idea of Nature, Art gradually grew imitative and artificial.

November 6.—Instead of going straight to Nature, the ordinary pictorial photographer appears to take the latest fashionable interpretation of Nature, and carry the artificiality one step farther. This is one idea of " progress."

Monet painted things as he saw them, in the open air. His pupil, Le Sidaner, learnt all that the Master could teach him, and then went and painted things as he saw them, in the open air. This is another idea of progress.

Herr Sprechen has photographed the bow of a coal barge, Mr. Artichoke photographs the stern of a mud dredge; mein Herr has somewhat silhouetted the bow of his coal barge, Mr. Artichoke under-exposes the mud dredge until all detail is lost.

> If Sprechen was quite right to let
> His barge work out in silhouette;
> Then Artichoke has gone one better—
> His silhouette is silhouetter.

Behold True Progress ! Prosit ! !

CHAPTER XVIII

AN ESSAY ON NATURE

I. It is often stated that a picture should be an essay on Nature rather than a transcript from Nature. In fact, this statement is made so often, whilst its precept is so seldom brought to a photographic maturity, that one is tempted to doubt whether the majority of photographers fully realise the actual quality of a pictorial essay.

A pictorial essay is an appeal to the intellect through the senses; so are most story pictures, problem pictures, and dramatic pictures. But, whereas the story and drama appeal to the more emotional side of the intellect and the problem clamours for solution, the essay is intended to suggest some train of thought or bring out some special aspect of Nature.

Again, when an essay is worked out too far and elaborated too fully, it ceases to be an essay and becomes a treatise. A treatise is an essay worked out to its logical conclusion, and marked " Finis "; an essay is usually concluded in the mind of the person who reads it.

The transcript from Nature is objective, treating of what is real, visible, and tangible, depicting what is actually before the camera for all to see; the essay is subjective, an attempt to picture certain of the artist's thoughts or feelings about Nature. Therefore, since the essay is subjective, rather than objective, the

photographer should commence his "essay" with the idea of showing some aspect or attribute or quality of his subject, rather than with the idea of photographing the actual subject itself. For instance, the photographer intends to take what Ruskin used to call "a moonlight," and he has fixed on his view and station-point. If he took an ordinary photograph, simply showing the subject lit by the moon, he could hardly hope to achieve more than a transcript; but if he aimed at catching the shimmer, or glamour, or coldness, or shadows of moonlight, he might accomplish an essay.

Of course this does not mean that the essayist should entitle his picture "The Shimmer of Moonlight," or "The Coldness of Moonlight": such a title would savour too much of the ancient practice of writing "This is a cow," "This is a dog," underneath the different objects in a painting. But if the photographer would commence his picture with the idea of bringing out the coldness of the moon, as opposed to the warmth of the sun, he might suggest one of the qualities which is inseparable from true moonlight. When Mr. Coburn gave us "The Haunted House," in 1903, the essay lay chiefly in the title; when he gave us "Trafalgar Square," in 1909, the essay lay in the picture.

II. The essay is certainly a very high form of pictorial photography, for it not only demands a sympathetic understanding of Nature, combined with an imagination that sees more than the obvious, but it also requires a complete mastery over the materials. A man who could give an impression of a landscape before rain, when the eddying wind turns up the silver lining of the black poplar leaves, and the labourer

LONDON BRIDGE

By Alvin Langdon Coburn

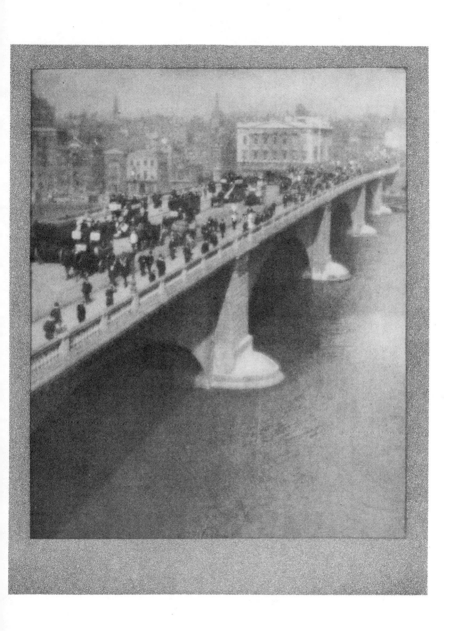

mutters : " It's blowin' up for rain, sure enough,"
would certainly have won his spurs in the technique,
as well as in the expression of his art.

Think of the possibilities of a real snowstorm against
a slate-coloured sky, as a pictorial essay on December ;
think of the cold, cheerful glitter of November sun-
shine on hoar-frost, of the heat of midsummer when
the cattle are resting in the shade and the heat-waves
flickering over the meadows ; think of the possibilities
of the coming thunderstorm, of the thunder-rain
bounding up in spray off the pavement, of the heavy
autumn dews on the water-meadows ; think of the
essays on human life that might be caught in the
Strand, in the City, in Piccadilly, each different in
character, each full of the spirit of the locality. Think
of all this, and then think of the men who spend
themselves on landscapes seen through girder bridges,
or on the decorative curves of the fountains in our
public squares. The country is almost an unread
book to the essayist : Coburn has not exhausted the
possibilities of London, nor has Mortimer said the
last word on stormy seas.

III. I do not mean that the pictorial photographer
should confine himself to essays on Life and Nature.
The gods forbid ! Many who can do most delightful
work in other branches are not naturally fitted for
essay work ; and, besides, we mortals do not always
crave for an appeal to our intellects. When I have
finished this chapter, I shall pick up the lightest novel
I can get hold of, and rest my brain ; when I can spare
an evening off, I shall not go to Bernard Shaw's latest
play, but to the lightest musical comedy that is being
acted. People who neglect the lighter side of life become
earnest, and people who once become earnest are a

curse to themselves and an unmitigated nuisance to
their friends.

To digress. At the present time there is a great
opening for a pictorial photographer with a dainty
sense of humour. I have seen many photographic
burlesques ; but with the exception of Mrs. Cadby's
chickens, and Mr. Ward Muir's back view of Sylvia
entering her sty, I can recall no examples of true
humour.

IV. But to return to the essayist. If I may venture
on some practical advice, I should recommend the
would-be essayist to follow my example, and keep a
note-book. When the idea for an essay occurs, or he
sees some phase of Nature which appeals to him
personally, he should enter full particulars, even down
to the proposed exposure. This practice not only
keeps him in mind of all the essay subjects he has
planned and thought out, but it also gives him a memo.
of the proposed lighting of the subject, possibly the
best direction for the wind (no small matter when either
smoke or water happens to be included in the com-
position), and it saves the time which is involved in
working out technical details.

It is not often that all the details of a proposed
essay come absolutely right ; but if the photographer
has several possible essays in his mind, there is a chance
that the conditions of light, atmosphere, and subject
may enable him to secure one or other of them.

This suggested note-book should not be too serious.
The difference between the earnest man and the man
who is in earnest lies in the fact that the latter—
however seriously he may take his work—does not
take himself too seriously.

I append some extracts from my note-book, as an

illustration of what I mean. These notes will serve to keep me in mind of the subject when next I am in Tuscany ; and the very frivolity of their nature will prevent my approaching the subject with a too strongly preconceived idea, which is no small matter when several years intervene between the first conception of a picture and its expression.

LEAF FROM MY NOTE-BOOK

The Girls of Prato

April 8, 1908.—And aren't they jolly, these girls of
Prato !—fair as the sunshine, and as saucy as you
please ! A group of working girls has just passed my
café. Two pairs of blue eyes glanced back, and two
pairs of red lips flashed out laughter at the droll
Englishman writing in his note-book. I wish I had
brought my reflex, instead of a hand camera ; but next
time I come here I shall be prepared for revenge.

Second entry. Same date.—Has any one ever com-
pared girls' hair to a field of ripe barley, when the wind
blows across it ? The fair type of Tuscan has exactly
the same sheen in her hair.

April 9.—Let me picture one of these fair Tuscan
girls, with a sunlit barley-field in the background :

> The sun, that rose at dawn
> To ripen the barley and colour the corn,
> Has kissed her locks.
> The sky, or the sea,
> Or the gentianella of Lombardy,
> Lies in her eyes.
> The peach, and each lily that grows
> Have joined to borrow a hint from the rose
> To texture her cheeks.
> And, although
> She's as fresh as the air
> Which passed o'er the barley
> And tinted her hair,
> She's as warm—and all—
> As the juicy fruit on a sunny wall.

This idea may come in useful some day.

CHAPTER XIX

SYMPATHY

I. THE race-mark of the English people is an excess of sentimentality, combined with a lack of sympathy.

The beggar who goes round singing emotional hymns gathers a rich harvest; the self-respecting workman who can find no work sees his children starve: he sees his dead baby bundled into a hand-bag and carried off by the parish undertaker, and is then summoned for the non-payment of rates.*

The aforesaid beggar sings his hymns in such a way, and with such a disregard for time, that he could never have learnt them in any place of worship—they are patter; lazy, drawling, begging patter—and yet I have often watched the mendicant gather alms from eleven or twelve houses out of thirty-six. The man who goes round singing " Home, Sweet Home," and " The Better Land " draws nearly as well, but the fine old fellow who comes along the street singing " The Death of Nelson " and " Hearts of Oak " is lucky if he gets a halfpenny.

If we could only once realise how we, as a people, are swayed by any appeal to the emotions, we might realise what a race of Jellybys we have become. We throb over the perpetration of atrocities in the Congo,

* This came out in the hearing of a summons for non-payment of rates at Willesden, November 1909.

we shriek at the execution of a Barcelona anarchist, and the cry of " Chinese Slavery " is enough to decide an election ; we subscribe liberally towards Homes for Stray Dogs or " Our Dumb Friends' League," whilst we let our poor almost starve on the Embankment ; but then, our destitute suffer hopelessly and silently ; and as they neither whine like dogs, nor show their ribs like horses, they make no strong appeal to superficial pity.

In one way, sentimentality and sympathy are widely different, for sentimentality means an exaggerated display of emotion over any person or any thing that makes a superficial appeal to the feelings, whilst sympathy means a suffering with those that suffer, a rejoicing with those that rejoice, and consequently a sharing and understanding of the lives of others. In another way, the two qualities are alike, for each demands a reciprocity in the subject which inspires the emotion—thus, it would be impossible to sentimentalise over, or sympathise with, a pig, an armadillo, or a porcupine. And yet there is an essential divergency in the nature of the reciprocity ; for sentimentality finds its reciprocity in a superficial prettiness such as that painted by Greuze, in superficial piety such as " The Maiden's Prayer," and in a superficial display of affection such as that depicted in " Mother First " ; * whilst sympathy finds its reciprocity in objects which are honestly worthy of sympathy.

To give two actual examples of objects which might

* It would be both dutiful and natural for a soldier returning from South Africa to kiss his " mother first," but it would be hateful if he performed the act with one eye on the onlookers and the other on the press artist ; consequently, the subject would not be a sympathetic one for painter or photographer.

excite sympathy or sentimentality. A certain financier, who died several years ago, ruined a number of persons, and did many things that neither society nor the laws of society could condone ; and yet this man is no unfitting case for sympathy, since, up to the last, he struggled to pull the fat out of the fire and do his best for the interests of his shareholders. Another man, a professing Christian, a preacher of the Gospel, persuaded members of his sect to invest their savings in a most risky building-society ; when the crash came, he laid his hands on all the money he could appropriate, and bolted to America, leaving the ministers and widows that he had entrapped to face the music. This latter man seems to be beyond the pale of sympathy, and yet, strange to say, he still appears to touch the sentimental feelings of some of his late co-religionists.

A few days ago I had a talk with the old man who goes round singing " Hearts of Oak." He is a fine old chap, but too old and stiff to work ; and when he is street-singing he does not turn round in search of alms like the ordinary beggar. " Wouldn't it pay you better to sing hymns ? " I suggested. " They do say," he answered with a chuckle, " that ' Rock of Ages ' alone is worth the price of a quartern of gin ; but I've not fallen as low as that, sir. Folks used to like my singing when I was younger, and if they like it well enough now to give me a few coppers, it's all I need." Which sentiment showed that he was an honest, self-respecting man, and a worthy object of sympathy.

On the other hand, the other beggar—the one who sings hymns—ought not to appeal to the sympathetic : his method of singing, which must have been learnt in the doss-house, and not at church or chapel, pro-

claims him a hypocrite ; the way in which he glances back at the houses he has just passed shows that he is a professional hypocrite ; his bloated face bears every sign of self-indulgence, and his dirty hands show no trace of honest work.

II. Sentimentality may be either the outward expression of the emotional side of some emotional theme, or it may be the cultivation of the inward feelings ; it may be exhibited in the writing of sentimental books, the making of sentimental pictures, or the indulgence of sentimental conversation, or it may be felt in interior thrills and throbs ; but whether it be a playing to a gallery, or a playing in a private theatre with only oneself in the stalls, sentimentality is to be abhorred by all wholesome and healthy persons.

I have written of sentimentality at some length, because I want it to stand out most clearly from sympathy, which is a natural and healthy sentiment ; and I instance Mr. Keighley's " Adieu " as an example of thoroughly wholesome sympathy. If a clerk's wife were to come to the garden gate each morning to kiss her husband good-bye before he went off to the City, one might feel that the display of affection was a trifle too public ; but if a wife were seeing her husband off to Australia, she would be a self-conscious fool if she were ashamed to kiss him publicly. It is the fact that the father is going off to the fishing-ground that makes his kissing his small daughter such a manly action ; the tense pose of the mother, as she prevents the child from overbalancing, gives a touch of robustness to the group ; the subject shows an artistic sympathy in the photographer, and the picture is both natural and bracing.

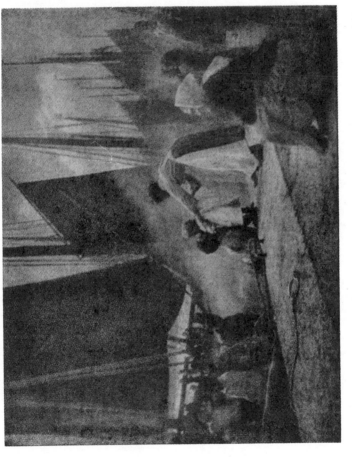

"ADIEU!"

By A. Keighley.

Thus we find all the elements of artistic sympathy in Mr. Keighley's " Adieu " :

(a) A subject worthy of sympathy; a subject that can be depicted without violating any of the canons of good taste, or trespassing on any one's privacy ;

(b) A treatment that shows the artist to have been in sympathy with his subject ;

(c) A choice and treatment of subject which shows that the artist has taken his public into his confidence, and both gives and expects sympathy.

III. This leads us to the inherent fault of the cultivated Englishman : he has learnt to abhor sentimentality, and having also learnt to keep a firm hand on any outward display of emotion—especially if he should happen to have been educated at one of the public schools—he is apt to be (or to appear to be) unsympathetic.

In all forms of artistic expression, music, literature, and painting, we meet with the same defect—either the artist does not feel his subject very strongly, or else he is too reserved to express himself freely to others. The English artist seldom " lets himself go," and consequently English art is usually cold and reserved. The baser artist may be shockingly sentimental, but the cultivated English artist is generally lacking in sympathy.

Of course, the above paragraph refers to the artist's work, and not to his private life ; for a man who is most sympathetic with his brush or pen may be a reserved and gloomy companion, and a painter who devotes himself to the description of town life may have an intense love for the country. What we really

mean by artistic sympathy is that the artist shall have a complete and interested understanding of his subject, combined with a desire to make others see through his eyes. Thus, if a writer should describe an avaricious character, he must not content himself with a dilation on the unpleasant side of the man's disposition, but he must go on to elaborate the thoughts and motives which formed the man's avarice and made his conduct seem right in his own eyes, and so create a character that is as convincing as it is detestable.

An artist must grasp his subject ; he must enter into the spirit of his subject ; he must be an insider, keen to describe something of which he has an intimate knowledge, and not an outsider who contents himself with a superficial description of some subject in which he merely takes an ethical or æsthetic interest. Herein lies the difference between painting and photography : the painter is forced to study his subject before he can trust himself to paint it ; he must understand anatomy before he begins to draw from the model, and he must know a good deal about shipping before he can draw the rigging of a boat correctly. The photographer, on the other hand, can erect his camera before any unfamiliar subject and trust his lens to do the drawing. Consequently, during the space of a fortnight's holiday, the photographer essays landscapes, seascapes, architecture, and figure-subjects, any one of which subjects would demand a lifelong study. A man born and bred in London takes several photographs whilst he is coaching across Dartmoor, and expects these snap-shots to be regarded seriously. How can he possibly understand his subject, much less sympathise with it ?

IV. The first essential in sympathetic photography

is the choice of a subject that inspires sympathy. This does not mean that the person or thing should be sympathetic in the ordinary sense of the word, but that he or it should have sufficient character to merit a close and intimate study. A woman, for example, must have individuality in order to be a fitting subject for sympathetic study. She may be beautiful, but her beauty should be the opposite of superficial prettiness ; she may be plain, but the plainness should be intellectual ; she may be ugly, but the ugliness must have strong individuality.

The second essential is a firm determination, on the part of the photographer, to study, understand, and depict the true character of the subject.

The third essential is the lack of self-consciousness which enables the photographer to express himself fully and freely to those who are capable of understanding, regardless of the opinion of critics and the sneers of cynics.

" Art has been maligned," says Whistler, in his " Ten o'clock " lecture. " She is a goddess of dainty thought, reticent of habit, abjuring all obtrusiveness." But this reticence must spring from the personal refinement of the artist, and not from a shrinking from hostile criticism nor from the fear of being misunderstood.

V. Probably the greatest secret of true Art lies in a sympathy between the artist and his subject. Given this sympathy, and the photographer must instinctively treat his subject sympathetically. He cannot treat it in an uninteresting manner, because it interests him ; he cannot treat it with gush or sentimentality, because he would be unwilling to make it appear effusive.

If a refined person were to describe some real friend, he would be keen to depict him as interesting; he would be unwilling to give any impression that his friend was a sentimentalist, and so his description would be both vivid and reticent : it should be exactly the same with the artist and his subject. Given this sympathy, and all forced or theatrical effects would become impossible : the photographer could not photograph the sun behind a cloud, and call his subject " Moonlight " ; he could not dress up a model in some stage costume, and call her " Vanity " ; nor could he clothe a man in a dressing-gown and photograph him as " A Monk."

Art is a goddess of dainty thought, reticent of habit, abjuring all obtrusiveness, and demanding sympathy. This is the reason why I urged the photographer, in my last chapter, to specialise in such subjects as attract his temperament and interest him naturally. If interest in a subject leads to sympathy with a subject, then sympathy leads to an intimate under-standing of the subject, and this understanding need not be the result of only laboured study. When Horsley Hinton photographed Niagara, he had just seen the Falls for the first time ; but Hinton delighted in atmosphere, light, and mist, and so he understood the beauty and individuality of the Falls with a full understanding.

VI. I spoke just now of beauty, plainness, and ugliness as being equally worthy of sympathy ; but I think that the natural man will have a natural sympathy towards beauty ; and such an instinct should not be despised.

Mere prettiness is, in itself, superficial ; and yet, the person who formulated the proverb that beauty is

only skin deep was himself absolutely superficial. The
face is the reflex of the mind ; and when a pretty sym-
pathy, a pretty imagination, and a pretty wit are
reflected in a pretty face, they become doubly attrac-
tive. Ugly features may become beautiful when they
are lit up by a sweet disposition ; hideous features
may become interesting when they are the reflex of
a strong character for either good or evil ; but the
present fashion of despising prettiness and decrying
beauty, irrespective of the underlying character, is the
result of confounding sentimentality with sympathy,
and avoiding both.

It is a strange cult—this contempt for beauty and
admiration of ugliness ; and, more, it is an unnatural
cult, for the natural man is attracted by beauty. With
the exception of the modern Germans, painters have
always sought beauty of features or beauty of form
or beauty of character in their models ; but many of
the progressive photographers seem to imagine that
they lose caste if their subjects are in themselves
beautiful.

Granted that mere prettiness be unworthy ; why
should mere ugliness be more worthy ? The natural
man feels that mere ugliness has even less merit than
mere prettiness, for it lacks even the superficial value
of the latter. And so, in the majority of cases, when
a photographer violates his natural instincts towards
beauty, Dame Nature pays him back and involves him
in the pursuit of the merely uninteresting. The cult
of ugliness almost invariably leads to the cult of
dullness.

VII. Now, the essence of art is expression—dainty
thought, expressed with reticence and unobtrusiveness ;
and the universal craving of the artistic temperament

is that its expression should appeal to the understanding of others. The poet may lock his study door, and repeat his verses aloud as he writes and polishes them ; the painter may work with his studio bolted, and examine his picture with appreciation as it nears completion ; but the moment that the creation is ended, the creator craves for the understanding and sympathy of others. The poet would rather read his verses to the housemaid, the painter show his picture to the gardener, than lack all sympathy.

I have heard it said that an artist should work to please himself. This idea is moonshine. An artist works to express himself to those who are capable of understanding, to express some new form of beauty to such as can sympathise.

Has any one ever heard of a painter hiding away his pictures, except in story-tales ? Has any one ever heard of a poet penning his verses in cypher, as Mr. Pepys penned his diary ? The very fact that a man shut himself off from the sympathy and appreciation of others would suggest incipient madness.

Marion Crawford points out that the chief peculiarity of an artist's temperament combines a diffidence concerning what he has done with an impatience of criticism and a strong desire to show his work to others as soon as it is presentable. The weakness of the artistic temperament lies in listening to the criticisms of those who are incapable of understanding, as well as to the criticisms of the sympathetic.

Of Art, Whistler writes : " . . . and in the book of her life the names inscribed are few—scant, indeed, the list of those who have helped to write her story of love and beauty." If this be true—and it is true—the list of those who have valued the story of love and beauty,

when fresh from the artist's hand, is also scant. The many will acknowledge Art, when it has been discovered by the Press and graduated in the auction rooms ; but only a very few will appreciate true Art on its intrinsic merit.

If only the misunderstood and unappreciated could realise that honest originality in Art is as caviare to the multitude, and that the sympathy of very few is worth coveting, their lives might be happier ; but such knowledge seems to be withheld from the artistic temperament.

CHAPTER XX

IMPRESSIONISM

I. REAL impressionism is an honest endeavour to get at the root of a matter, not by the publication of full details, but by drawing in the striking essentials with a bold, free hand.

A person may learn to focus his eyes on every object he looks at until he has accustomed himself to see almost microscopic detail ; or he may train himself to see form, colour, and values in each subject that interests him, until he has accustomed himself to perceive far more of these qualities than the ordinary man. The former would be a miniaturist, the latter (since he has accustomed himself to receive a general impression) an impressionist.

If I were to meet Monica in the village, I should recognise her long before I could see the details of her features. I should know her by the pose of her head, the tilt of her chin, the way in which she walks, and the way in which she carries her hands. She showed me half a dozen untouched proofs, taken by a Bond Street firm last week, and I should not have known her. Only the week before, Austin St. Just sketched her in a few strokes, and this picture is the living image of Miss Monica.

Rossetti and Burne Jones were the antithesis of the impressionist ; the former could seldom get away from

a certain drawing of the mouth and an extraordinary fullness of the throat ; the latter had a peculiar and inevitable pose of his seven-foot figures ; each became a slave to his own conventions : the impressionist, on the other hand, must treat every subject as if it were the only subject in the world. There is a family likeness between all Claude Lorrain's landscapes ; Le Sidaner painted a number of pictures of Hampton Court, each of which gives an entirely different impression of the Palace, and each of which is essentially Hampton Court. This, then, is the first principle of the impressionist : he must describe Nature as he sees it, not as he has been taught to see it, nor as other persons see it.

II. The next principle of the impressionist is that, since he sees things only by means of the light which they reflect, he must only depict this light that they reflect, and not the things themselves as he knows them to be. For example, he knows the features of his model by heart, he paints her as a figure in his landscape, at a distance of some thirty yards ; he could draw in her features accurately from memory, but he realises that at this distance her features would appear blended into an even mass of tone, so he draws her face in one even tone, without detail.

He knows that a distant hut is black, and that the horse grazing beside it is white. But there is so much luminous atmosphere between the hut and his eye that the hut appears far from black ; so he draws the hut, plus the atmosphere, and consequently draws it in some shade of grey. In the same way, the brilliant rays of light reflected from the white horse have to pass through the atmosphere, and lose so much of their brilliancy in transit that the horse appears a

somewhat light shade of grey. Again, an object in the distance may be either a horse or a cow—he is uncertain which, so our impressionist draws an animal that is strictly nondescript.

Many artists trust a great deal to memory when painting. The impressionist discards the treacherous memory, discards the treacherous imagination, and depicts things according to the value of the rays of light which are reflected from them. Consequently, the impressionist is more apt to draw a goat by means of a few broad brush-strokes of various values than to worry himself with such details as horns and hoofs. Again, if a brown horse were standing against a background of a similar tint, the impressionist would probably content himself with drawing the high lights and shadows on the quadruped, and ignore the outline.

The impressionist knows that the values in any subject are always changing, that the values in a landscape are entirely altered by a cloud passing across the sun or by a breeze springing up, and therefore he has no preconceived ideas, but paints his values as he finds them. Even in indoor portraiture there is no fixed scale : a white dress, a dark dress ; a large room, a small room ; a bright day, a dull day ; a thousand other things—they all affect the values of the tones.

So the impressionist is apt to depict any subject that strikes him forcibly, without bothering much about the more scholastic matters, such as composition and finish ; he tries to paint the reflected light as he sees it, trusting to a faithful rendering of values as a means of securing faithful form and faithful texture.

III. Therefore, a real impressionist of the camera learns to see things by their values—every one can learn

to see things in many different ways—rather than by their details ; for he realises that if he can get the values right, the general impression of his subject will be more vivid than if he were to secure only fullness of detail. And it will be found that if the onlooker stands some distance from an impressionist picture, he will receive a strong impression of reality.

And so, when an impressionist studies his subject, he usually partly closes his eyes, in order that he may be conscious only of the lights, half-lights, and shadows, and avoid the distraction of details. Then, lest he should be influenced by a memory or a preconceived idea of the subject, he bends his head on one side so that he may receive a fresh impression.

I have just flung my coat on one of my study chairs and put on an easy working jacket. I can see the pattern of the cloth, a tiny shininess at the elbow, but I hardly notice the high lights and shading. I close my eyes until the pattern is obscured, and the high lights and shadows attain sole importance. If I were to draw these reflected lights and shadows accurately, both in form and values, the drawing would give a far more vivid idea of a cloth coat lying on a chair than any elaboration of pattern and superficial texture could secure. Just as Sargent achieves his wonderful impressions of silk by painting the reflected lights and shades, so would I secure a true impression of the texture of cloth.

After all, the elaboration of detail is not very impressive. If I were to say that the population of the United Kingdom consumed 269,503,175 lb. of tea in 1906, my statement would not convey much meaning ; if I were to say that the United Kingdom consumed, each year, tea that weighed as much as the total

population of Manchester, Brighton, Birmingham, and Sheffield, I should give a much more under-standable impression.

IV. Impressionism is not waywardness ; it is not eccentricity ; and, above all, it is not a cloak to cover slipshod work.

The impressionist is essentially a scientist, who argues : " I cannot see objects without illuminating light ; I cannot see the objects themselves, but only the light which they reflect ; therefore, let me depict the form of the light which they reflect, in its varying strength, moderation, and weakness." And we notice this same scientific basis of impressionism in the work of the French impressionists ; for these men not only split up the rays of light into their primary colours, but also painted their subjects in their primary colours —thus, brush-strokes or dots of blue and yellow, placed side by side, were blended by the eye into a green that was more vivid and truthful than any mixture of colours could produce.

Applying the term " photographic " in its best sense, impressionism is photographic in character ; for both painters and photographers strive to capture a truthful rendering of light, shading, and shadow, and the only way that the photographer can ever hope to work in colour is by the same method as that which the impres-sionist adopts. If a little more attention were paid to the paintings of Monet and Le Sidaner, which are examples of science applied by artists to pictorial ends, colour photography might make some real progress.

V. Since the impressionist is aiming at the rendering of the intensities of reflected light, he is impatient of detail ; and, besides, the elaboration of detail defeats his object, which is to give a general impression of his

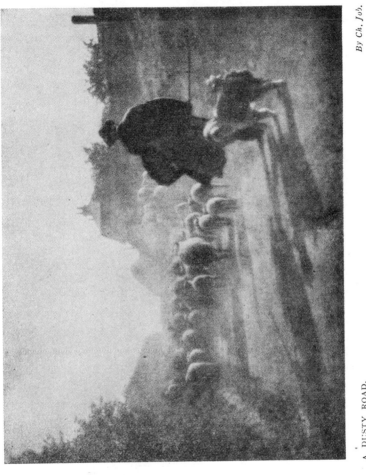

A DUSTY ROAD.

subject. A wood is a collection of trees, and each tree-trunk is a collection of bark details, and each branch is a collection of twigs and leaves : the impressionist does not aim at a catalogue of items, but at a wood massed into broad tones. A pocket handkerchief is a collection of woven linen threads, and each visible thread has its high lights, shading, and shadows ; but the impressionist avoids these finicking details, and strives to give the general tones of light reflected from linen.

In portraits, the impressionist aim is to synchronise tiny details and bring out the larger lights. A study of faces in an ordinary drawing-room, especially if the light be somewhat subdued, will show how little detail the human eye is usually conscious of. The clever hostess knows this, and subdues and softens her lighting, so as to soften the details of her guests' features ; and this is not only more becoming than a brilliant lighting with its hard shadows, but it also brings out the true character of the various expressions; for expression is shown by the contour of the muscles, each one of which is developed either by smiles or sulks, and by the modelling of the face, rather than by wrinkles, eyelashes, and other superficial trifles.

The Philistine is usually unobservant. When he lapses into attention, he strives to count the number of masts in a distant ship, or to tell the time by a distant clock, or to detect the mote in his neighbour's eye. Colour has but little charm for him, the play of light and shade is unnoticed, and tone is unthought of. Hence, the Philistine ridicules impressionism.

VI. Many of the earlier impressionists found a difficulty in capturing their values in colour-painting, and so they posed their models in a subdued light and

painted in a low key. Photographers seem to have caught this trick, without the same sufficient excuse.

When photographers come to working in colours—if they ever do—they will probably have to start in a subdued key; but, so long as they are confined to monochrome, there is no reason why they should not essay light and brilliancy. Low-tone prints are becoming monotonous, and light and open air are surely fitting themes for the "light-painters."

What may be technically termed "slight under-exposures" are sometimes necessary so as to accentuate high lights and shadows; but those obviously under-exposed prints, which are hung in the exhibitions under the guise of impressions, are doing much harm to the artistic status of photography; besides, they are generally wrong, quite wrong, essentially wrong. The genuine impressionist painter obtained his dark, empty shadows by subduing his light, and painting truthfully exactly what he saw; the photographer too often deliberately falsifies the values that are before his camera by intentional under-exposure—this is a brazen Wardour Street type of impressionism. When a man is working in tone, empty shadows are only right in such lighting as reflects no light into the shadows.*

Again, soft focus lenses seem to give very pleasant results, so long as the picture closes up and comes together, when viewed at a distance; out-of-focus effects sometimes blend details into masses in an agreeable manner; but when out-of-focus leaves and

* Of course, this does not refer to a print in a high key, in which the soft, indefinite shadows have been under-exposed in the negative, so as to bring out the full quality of the high lights.

branches seem to assume unusual shapes, when the light which shines through the branches is converted into round bull's-eyes, the work becomes contrary to the spirit of impressionism.

And lastly, vagueness is contrary to true impressionism ; for if a vague photograph really expresses the impression which the photographer received, then he must have received such a confused and muzzy impression that it was not worth recording. An uncertain impression is the mark of a lack of training. When the artist has studied impressionism, he learns to see and depict both form and values with great virility.

LEAF FROM MY NOTE-BOOK

Black

1906.—This year's *Windsor* contains an interesting story, in which a man discovers a dead black paint which reflects absolutely no light. The hero paints his body with this paint and, except that he casts a shadow, becomes invisible. When he passes before an object he blots it out, but the object only seems to vanish.

What an absurd idea ! How utterly unscientific ! The more perfect his black, the blacker and more noticeable would he appear ; unless, perchance, he happened to be standing immediately in front of some equally black surface.

Granted that this pure black paint, which reflected no light, were invented and applied, the details of the man would be invisible and he would become a silhouette ; but he would be a black and opaque silhouette, standing out against every background in the most noticeable way.

Then when he came out into the open—he was playing tennis in the story—his feet would be black silhouettes against the grass, his legs would appear silhouetted against the middle distance, and his body against the sky and distance. Theoretically he could not be seen, but practically he could be located as accurately as a telegraph post. Truly, a little science is dangerous to the story writer.

White is not called a colour, but it is the fullness of all colour, since it reflects all the colours of the spectrum. Black is the negation of all colour, because a pure, dead black would reflect no rays of light.

In practice, most blacks reflect a certain amount of light from the gloss of their surface ; and this is the same in quality as the light which is reflected from white, only, of course, far less in quantity.

If we would learn to see Nature accurately, and render the values of shadows naturally, we must learn to think of black—the black in our platinotype, for example—as the negation of light. By accustoming ourselves to calculate the amount of light that is reflected from shadows and dark objects, we learn to see, and render, shadows and dark objects truthfully.

The story writer's black paint and a single hole leading into a dark cavern would be equally black, since neither would reflect any light. The only pure blacks that I can recollect having seen in Nature are openings leading into caverns, wells, and mines.

CHAPTER XXI

SOME ESSENTIALS OF EXPRESSION

I. ON the hottest day of 1906 I met in Piccadilly two men I knew. The first man talked, for a full ten minutes, about the weather ; I know that he talked about the weather, because he is the sort of man who always talks about the weather ; I know that he talked for quite ten minutes, because I nearly got a sunstroke whilst listening to him ; but afterwards I could not recall a single word that he said. The second man stopped, looked at me pathetically, drooped like a parched sunflower, and walked on. Number One expressed nothing that could be remembered ; Number Two expressed himself vividly.

This is, I think, the first essential in all forms of artistic expression—the creation of an impression in the minds of others. For if a subject, or thought, or emotion be worth expressing, it is worth expressing well ; and if it be expressed well, it must create an impression.

This does not imply that the impression must be, so to speak, photographed on the mental retina. A melody may produce a very vivid impression at the time, and yet it need not run in one's head afterwards ; a picture may strike one as altogether good, and yet it may be difficult to recall to the memory ; a girl may appear adorable, and yet the recollection of her face may presently fade away and fail to materialise. But

if the melody, the picture, and the maid have created an impression, they will have established a desire for further acquaintance, and either will be recognised immediately.

What we term elusiveness is often a desirable quality in a work of fine art, for although it implies the inability to remember form and detail, it also implies an interest and a desire to remember. Things which fail to impress are forgotten entirely ; and so when Mr. E. F. Benson wishes to describe a thoroughly uninteresting man, he tells us that " his face was stamped with all the quality of obliviality ; to see him once was to insure forgetting him at least twice." In exactly the same manner, an uninteresting picture is forgotten so entirely that a second view only raises a memory that the onlooker may have seen a similar picture previously.

Therefore we may assume that the first essential of pictorial expression is the creation of a vivid— although, possibly, elusive—impression.

II. If virility be the first essential of expression, I think that individuality must be the second. Individuality need not show any great degree of originality ; the theme may have been treated before in much the same way, and yet the artist's rendering may express his personal view of the matter. Thus, Velasquez seems to have borrowed the idea of painting an undraped female figure, as Venus, from Titian ; and Steichen's " Little Round Mirror " was probably derived from the Spaniard's picture ; yet each of the three artists has worked out the theme into a personal expression of the idea, *Quot homines tot sententiæ*, which, being interpreted, means that each creative genius takes his own line.

The Artistic Side of Photography ♣

Actual imitation in art has never led to good work. Actual imitation can never lead to good work, because no two people can ever see the same thing with the same eyes. Individuality begins to creep into a photographer's work when he commences to think : " Doesn't this subject look jolly from here ? " and when, forgetting all about the text-books and the way so-and-so has photographed a similar subject, he chooses a station-point which appeals to him personally.

This individuality is a large subject, far too large to be treated of in a book on photography ; but one finds the same individuality in the boy of ten as one finds in the same individual at forty. As soon as his handwriting is formed it is formed for life ; as soon as he has learnt to express himself in a letter, his literary style is fixed ; and this individuality is the part of him which is eternal : he can train himself and refine himself, but he cannot destroy his individuality. When he tries to model himself on the same lines as some one else, he becomes artificial ; when he tries to develop and cultivate the better part of self, whilst he remains true to self, he becomes a power.

I do not mean for a moment that the photographer should not learn all he can from others or that he should not be influenced by others ; I do not mean that he should not acquire an increasing feeling after tone-values and the other refinements of expression ; but I do mean that he should be true to his own way of seeing, feeling, and expressing whatever he photographs. This individuality does not end with the choice of the subject and the selection of station-point ; it continues through the exposure, development, and printing, and assumes such a control over

240

the materials that the photographer can start with seeing the finished picture in his mind's eye, and work up to the desired effect without thought of failure.

Of course I am setting up a very high standard of technical skill—a skill which makes the original idea of the picture, seen by the artist's eye, with the colours translated into monochrome in the artist's brain, everything. I am crediting the artist with sufficient skill, in exposure and development, to make the coincidence of the mental picture with the finished print a practical certainty ; but then the photographer who falls short of this standard is no artist.

There is a nursery rhyme which exactly describes the ordinary amateur photographer :

> Little Jack Horner
> Sought his dark corner,
> With many a doubt and a sigh.
> When his plate came out right,
> He cried with delight,
> "Oh ! what a great artist am I ! "

Such a man may be delightful as a truthful irresponsible ; he may be interesting when he has the taste to retain his happy flukes and destroy his pile of failures ; but when he poses as an artist who records his personal impressions, he is the acme of fraud : he can never hope to achieve individuality.

I shall have something more to say presently to the person who is honestly aiming at the technical standard. In the meantime, I must repeat that the Japanese ideal of " truth to self," the French ideal of " personal interpretation," and the English ideal of " individuality," all mean seeing with one's own eyes and recording one's own impressions, and are essential to artistic expression.

241

The Artistic Side of Photography ❧

III. I do not know quite what to call the next quality that is essential to artistic expression, for one cannot take a word that is applied to the older forms of art and apply it haphazard to photography. Possibly " imagination " may meet the case.

By imagination, I do not mean fancy, or " sermons in stones," although these qualities may be woven into the quality of imagination ; I mean " the faculty of forming images, or pictures, in the mind "—real, true, vivid pictures—and of conveying these pictures to the onlooker.

The common formula amongst photographers, " That will make a picture," strikes me as absolutely heartless ; for how can an artist make others feel his subject unless he feels it strongly himself ? I have said this before under the headings of " Selection," of " An Essay on Nature," of " Sympathy," and now I wish to drive the fact home.

To load the dark slides, take down the camera, and go out with the intention of making a picture can never lead to work that is virile, individual, and convincing. The artist must feel some beauty or some quality of his subject very strongly, to start with ; and since an artist is one of those creative beings who crave to express themselves, he instinctively tries to translate his feelings into poetry, or paint, or photography, or whatever medium he favours. If this man be blessed with sympathy, he may succeed in making others feel something of what he feels.

Last summer I was staying in a country-house, and, as soon as the junketing of the day was over and dinner finished, I walked on the terrace with my hostess. After a time, our conversation lapsed into silence, and we instinctively leant over the balustrade

242

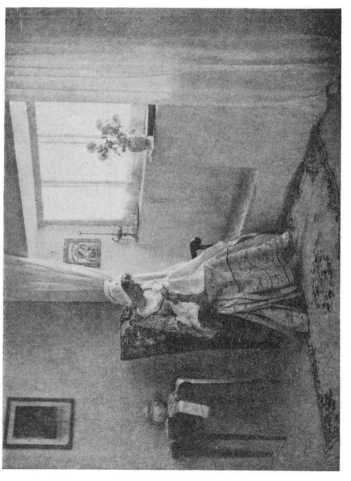

A QUIET CORNER.

By Guido Rey.

243

of the terrace. The valley was flooded with cool moonlight.

"I think," she said presently, "death must be like moonlight. All the silly vanities, all the impatiences, all the emotions will have been forgotten, and we shall look back calmly on the motives—I mean the great big motives—which have made us do things."

"Yes," I said softly.

"And I think God is like the moonlight," she continued—"calm and impassionate. I think He buries all our petty vanities, all our wretched little emotions in the shadows ; and looks down on the motives which make us do things."

She stood there in the moonlight, herself looking like the incarnation of her thoughts.

"And the sunshine ?" I asked.

"The sunshine is like life—it peers into all the shadows." She gave a shudder. "And it's like the world—it spies out all the dust."

I do not profess that I am religious. I do not pretend that I am sympathetic ; and yet the earnestness of my hostess has made me see something more in moonlight than I have ever seen before, or should ever have seen for myself.

I could not have sat down before my study-table and have evolved this quaint little moonlight sonata in order to add point to my argument. In this case, I am only the instrument which expresses the feelings of another, the camera which answers to the emotions of the photographer.

And this is, perhaps, the greatest secret of pictorial expression : the picture is formed in the artist's mind ; perhaps the subject is some conviction, some train of

thought, or some phase of emotion which finds an echo in Nature; perhaps it is some aspect of Nature which awakens a responsive chord in the artist's mind; anyhow, it is something that affects him strongly, and he manages to express his feelings in his picture so as to make others feel something of what he felt.

IV. But although the artist must feel strongly, he must also express himself with reserve; for if each one said all he thought or expressed all he felt, the world would fall to pieces.

First, there must be that personal restraint which avoids discursiveness, over-elaboration, over-expression, and over-emphasis; secondly, there must be that social restraint which avoids anything which will grate on others; lastly, there must be an artistic restraint which never oversteps the limitation of the medium.

The quality of personal restraint is not a matter that can be reduced to argument. A man will avoid plucky or contrasty negatives when he has acquired a feeling for tone; he will avoid theatrical schemes of lighting when he has learnt to admire refinement and simplicity. But restraint must be a matter of personal conviction; for a superficial veneer of refinement is only a poor garb at best, and a cheerful bounder is better than a self-conscious æsthete.

On the other hand, social restraint in photography is a matter which must be faced. Now, a painter probably paints from a model; but he adds and alters so much that his work gets clean away from the model: there is no mental association between the model and the figure in the finished picture. Unfortunately, the photographer cannot get away from his model, and the onlooker must always feel that the figure was placed

there, in front of the lens, when the photograph was taken.

This at once places such subjects as " Grief " or " Love-making " out of court. For a young widow to weep, or a young couple to kiss in front of the camera is not a nice idea ; for a photographer to snapshot such subjects, surreptitiously, is altogether nasty.

Then, as to the undraped figure. Artists, like Steichen, who are accustomed to paint from the model, can sometimes succeed in photographing the trained model without offence—in fact, I have specially included " The Little Round Mirror " as an example of absolutely good taste ; but such pictures are as rare as snow in summer. This is a pity, for the play of light on human flesh is a fine thing.*

In actual practice, the undraped female figure can hardly be photographed and exhibited without the taint of immodesty. The trained model will pose before a life-class of students with no more self-consciousness than a woman from Central Africa, but she would refuse to pose before a roomful of stockbrokers. In the same way, an undraped model would not object to be photographed as a study for an artist's picture, but she would object to have her photograph handed round amongst those who consider the female form in the concrete, and not in the abstract. After all, it is one thing for a model to pose for the drawing and flesh tints of " Venus " ; it is quite another thing for her to have her portrait taken in " the altogether."

* The play of light on flesh is indeed beautiful. By the time I have selected all the illustrations, I hope to have secured several examples. Mr. Coburn's " Water Carrier," for instance, perfect in composition, could only have been made by pure photography.

THE LITTLE ROUND MIRROR

By Eduard J. Steichen.

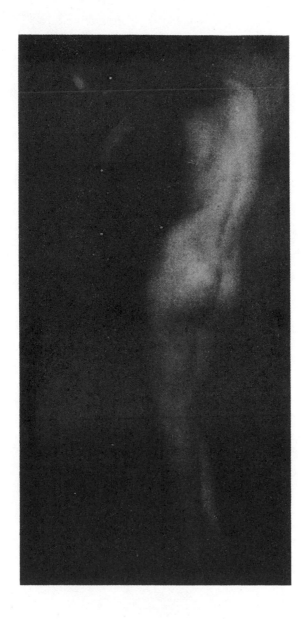

The same principle holds good with regard to religious, mythological, and historical pictures. In the painting of any character, from either sacred or profane history, we unconsciously assume that the artist tried to depict the traditional portrait, using the model as a basis for the lighting and anatomy—how much, or how little, the model may have been employed is no business of ours ; but in the photograph of a so-called historical character, we know that the model was actually posed and faithfully photographed. In straining our imagination beyond reasonable limits, the photographer is also straining his medium beyond credible limits ; in asking us to accept the photograph of his flesh-and-blood model as " St. Dorothy," he is asking us to join in a game of " Let's Pretend."

I do not think any one will deny that the great majority of photographs contain too much. This is probably due to the fact that the original subject was in colours, and the image on the focussing screen or view-finder was also in colours.

Colour performs a double function. First, it picks out and differentiates the different objects, by means of colour contrasts ; we can see this most clearly by realising that the charm of the spring woods lies in the contrast of the young beech and larch with the darkness of the pines. Secondly, colour simplifies the landscape by blending the different objects into chords of colour harmony ; and this quality can be noticed by comparing the restful chords of rich autumn tints in an oak wood with the insistent colour-repetition of the same wood in August.

When we once realise that monochrome may demand a greater simplicity of treatment than colour pictures, I think our conversion to simplicity in monochrome

will be both rapid and automatic. A photograph of one of the great pictures by Veronese or Rubens will be found to be dull food for the senses, whilst a simple subject like the " Norfolk Holbein," or Bellini's " Doge," will be satisfying ; a detailed etching of some oil-painting will prove cloying, whilst a simple etching or lithograph by Whistler will give stimulating pleasure; a portrait in mezzotint by one of the greater masters will convey a sense of perfect tone-work, whilst the multitude of tones in a mezzotint after Morland will be found to kill the purity of the individual tones. But I have said enough to set the log a-rolling.

V. In saying that personal restraint was not a matter that could be reduced to argument I may have erred ; possibly the quality may be suggested under the title of refinement.

In the revolt against " the perfect negative," which was often sparkling, plucky, and superlatively sharp, the fashion swung round to what may be termed " fuzziness " ; and this vice of fuzziness so repelled the ordinary man that the photographic world was split up into two contending factions. At the present time, the actual definition is regarded as a question of personal taste, and the clearness of an Albrecht Dürer or Memlinc is as much admired as the softness of a del Sarto or Whistler.

At the present time, clearness of definition and softness of definition are both admired, but sharpness of definition and fuzziness are no longer tolerated ; nor do I think that any one who had once grasped the difference between these qualities would suffer either sharpness or fuzziness. Let us distinguish the word " clear " from the word " sharp."

Sharp, having a thin cutting edge, affecting the

senses as if pointed or cutting, severe, keen, barely honest, shrill. Examples : a sharp wind, sharp words, sharp features, sharp practice, a sharp, shrill voice, sharp definition.

Clear, pure, bright, undimmed, without blemish, transparent. Examples : a clear day : clear-cut features, clear eyes, a clear voice, clear water, clear definition.

The examples I have included by Evans and Cadby are instances of a definition which is both clear and sympathetic ; a shorter exposure, a longer development, and a consequent hardening of contrasts, might have made the definition sharp. *Soft* means, not rough or hard, pleasing or soothing to the senses, sympathetic. Examples : a soft voice, soft water, a soft outline, soft definition. *Fuzzy* means covered with fluff or froth, lacking texture and coherency. *Muzzy* means dazed, bewildered, drunk.

In photography softness of definition must be backed up by the firmness and certainty of artistic knowledge —in other words, the artist must know exactly what he intends to express ; otherwise he is apt to fall into a fuzziness which suggests that form and features are modelled out of whipped cream, or a muzziness similar to that which is said to affect the human eyesight after too many whiskys-and-sodas.

Let us follow precedent and borrow a term from vocal phraseology : in artistic expression, our work should never be " shrill," nor, on the other hand, should we mumble.

VI. As we saw in the first chapter, the sixteenth-century Tuscans called Leonardo da Vinci's painting " mechanical," because it was " done with the hand." This accusation seems to have hurt the artist's feelings,

and yet it contained the germs of a great truth ; for what higher compliment can a painter receive than the statement that the manual part of his work—the actual execution—is mechanical ?

Now, this Messer da Vinci had the most inventive brain of any of the great Italians : from notes on aviation to the designing of fortifications, from the manufacture of original musical instruments to the painting of pictures, nothing was beyond his skill. He practically discovered aerial perspective ; he was the first to discover the laws of light and shade ; his scheme of portrait lighting is employed by the majority of photographers, and the instrument for copying clay models in marble, which he describes, is still used by every sculptor in Florence ; but his painting differed from that of the inferior artist insomuch as its execution was mechanical.

Where Messer Lucelli would ponder on the mingling of certain pigments so as to produce a desired colour, Leonardo would mix a more perfect shade, without contemplation ; where Messer Morelli would draw the outline of his model with much labour and many erasures, Leonardo would describe the same outline with rapidity, discoursing the while on science. In fact, Messer da Vinci had only to picture an image in his brain, and test the shadows and colours with his eye, whilst his hand automatically transferred the image to the surface of his panel.

Seriously, the highly trained artist converts his body into a machine, through which he may express what is in his mind. The voice which sings the song, the hand which guides the paint-brush, both act mechanically. It is only the raw amateur who has to feel after each high note or each difficult brush-stroke :

the trained artist would need a conscious effort to sing out of tune or draw inaccurately. When we speak of a mechanical picture, we mean that the brain, not the hand, acted mechanically—that the brain inspired the hand to copy the landscape without interpretation, or to set down some conventional subject without invention.

Of course it would be easy to argue, on these premises, that photography is a fine art ; but this is not my purpose. What I wish to impress is the fact that the technical part of the process should be mechanical, and that the hand should be the automatic servant of the brain. Just as the painter's drawing should be a kind of sixth sense, so should the management of the camera and exposure become a sixth sense, the development a seventh sense, and the making of the print an eighth sense—then the photographer's brain might have some chance to invent or interpret.

The camera is only a machine; but it is extraordinary how responsive machinery becomes to the will of a sympathetic mechanic. Blériot may sell sixty of his monoplanes ; but it is Blériot himself who flies across the Channel. Thousands of soldiers have equally good rifles, equally keen eyesight, equally steady nerves ; but it is probably one of these men who carries off the Queen's prize in several successive years.

This particular sympathy between a man and his machine, between an artist and his medium, can be acquired only by systematic practice, and it is systematic practice that gives a photographer complete, spontaneous control over his medium ; but the practice must be systematic.

The Artistic Side of Photography ♣

A beginner who exposes a dozen or more plates on one subject, until he has secured results that coincide with his memory of the subject, and only then passes on to a second subject, will learn more in a month than the ordinary photographer will learn in a lifetime.

LEAF FROM MY NOTE-BOOK

Interpretation of Nature

"How does one 'interpret Nature'?" asked Monica.

The day was intensely hot; and, as I was dozing in a hammock slung near the shady rectory pond, I was in no mood to be disturbed by questions that want some answering.

"How does one 'interpret Nature'?" repeated Monica.

My heart sank, but I still shammed sleep.

"How does one 'interpret Nature'?" insisted Monica.

"As feminine, singular, and decidedly vocative," I mumbled, and gave over all thoughts of rest.

The girl rose, and, going over to the garden table, fetched me a cigarette, lighting a match in a particularly feminine way that combined natural grace with an instinctive fear of fire. Then she smiled, and I capitulated.

"To *translate* implies no assumption of superiority," I began. "A translation—to translate colour into monochrome, for instance—must be pretty accurate, or else one will be found out. To *interpret* implies that one knows, or thinks one knows, the subject sufficiently well to render a free translation that will give the exact shade of meaning which the subject conveys. To 'interpret Nature' means that one must

257

weave her smile, or her frown, or her mood, into the language of expression. Is that clear ? "

Monica nodded.

" Now, Nature is a woman," I continued. " If one only wishes to make a superficial portrait of a woman, one sees that her figure is well posed, that her features are shown to the best advantage, and that the flesh tones are natural ; but if one wishes to interpret that woman, one tries to paint the portrait so that every one who sees it will understand something of her character. You understand ? "

" But we were talking about photography, not painting," suggested Monica.

" In photography, one would photograph the woman amongst characteristic surroundings, in a characteristic mood, with a characteristic expression. That is why I like Arbuthnot's portrait of Chodozko —he has caught the man's character, and interpreted it."

" In ' November Sunshine,' for instance, one would try to give an impression of coldness, brightness, and briskness. A frosty road, sufficient rime in the air to make the sunshine come down in beams of light, perhaps a brisk old woman trudging gaily down the hill, and the whole printed in clean, high-toned platinotype. One would wish to catch something of Anacreon's spirit :

> . . . the older I grow,
> 'Tis reason the more to be joyous and gay,
> As nearer I draw to my closing day."

Monica smiled in appreciation ; for, although she must have felt that Lord Derby's translation of Anacreon was not faultless, she must also have realised that it was something of an interpretation.

"Subject, *The Storm*," I continued : "An angry sea, thundering on the rocks, wreckage, and an angry sky. *Cranmere Pool*, Dartmoor. Desolate bogs, no sunshine, distant tors, a fog coming up in the distance ; and Heaven help the photographer to find his way out of it."

"And horse-flies, Mr. Anderson ? "

"Not horse-flies!" I protested, with a shudder. "Give me bogs, and fogs, and an adder or two ; but spare me the horse-flies."

"Then you don't consider gum, or oil-printing the way to interpret Nature ? "

"No! Emphatically No! Leave that class of interpreting to the painter ; he can do it far better than the photographer, just as the photographer can catch the delicacy of gradation better than the painter."

"And your verdict ? "

"That to interpret Nature by photography, one must love her, one must try to catch her in some descriptive mood that fits well with the scenery, and one must try to interpret this mood in one's photograph."

"Look ! " said Monica.

A shoal of carp were lying lazily near the surface of the pond, the midges were dancing in clouds, and the heat waves radiating from the distant lawn. In the shade of the beech-tree the rector was dozing over the contemplation of his evening sermon.

F. SOME PRACTICAL SUGGESTIONS ON PHOTOGRAPHY

CHAPTER XXII

THE RENDERING OF COLOUR INTO MONOCHROME

I. THE rendering of colours into exactly the right shades of monochrome—shades of tone that will, so to speak, suggest the original colours—is quite the most difficult problem that the pictorial photographer has to face.

If he had only to select a view and photograph it accurately, with every shade of gradation rendered to perfection, his task would be simple ; if he had only to make a faithful transcript of the tones of Nature, the panchromatic plate and colour screen would enable him to render his tones and colour-values faultlessly.

Of course the ordinary photographic plate renders the colours wrong—the blues come far too light in tint, and the greens and yellows far too dark. Of course a panchromatic plate, exposed behind a good strong colour-screen, will render every tint of the landscape, from the blue of the sky to the yellow of the St. John's-wort in the foreground, with almost fault-less truthfulness. We know that !

But given a first-class rapid plate, with an ample exposure, and a soft development that will prevent the

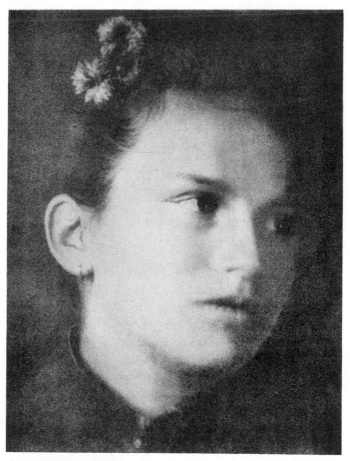

PORTRAIT TAKEN SOME
THIRTY-SEVEN YEARS AGO.

By W. Babcock.

Rendering of Colour into Monochrome

sky from becoming too dense in the negative—we may get false colour-values, but the sky will be simple, the distance will be simple, and the foreground will be simple ; whereas, with the most scientifically accurate panchromatic plate, exposed behind the perfectly determined colour-screen, every single tone in every single colour will be recorded, until we can get no rest by reason of the multitude of the tones.

With a first-class ordinary plate, we know that the sky and the brown bracken in the foreground will be almost devoid of detail and gradation, and that the wealth of tones will be found in the greys and bluish greens ; we also know that by varying the exposure and development we can either render the sky a light grey and the foreground a dark grey, or we can render the sky white, and the brown bracken black—in other words, that we can have any degree of contrast at will. On the other hand, with a colour-sensitive plate, properly exposed, all the gradations will be accurately recorded and all the contrasts will be accurately registered, and we must develop up the full strength of the tones, lest the result should be weak and anæmic.

I am strongly inclined to think that artistic expression, with fully corrected chromatic photography, begins and ends with the selection of the subject and station-point, and that the exposure should be determined by the darkening of the exposure meter, and the development timed by the dark-room clock ; whereas artistic expression, with ordinary photography, depends as much on the control of the exposure and development as on any other quality.

Half-measures are usually foolish, and the blind following of the *via media* is the mark of mediocrity ; but the thoughtful, rational use of just so much colour

correction as is needed for the special subject is surely the stamp of mature wisdom.

II. Let us begin at the beginning.

Just as there are sound-waves which the human ear fails to detect (few can hear the squeak of a bat, for instance), so there are light-waves which produce no sensation on the human retina. We can see colours up to a violet-blue, but beyond that the spectrum becomes invisible to human vision.

If we were to split a ray of white light into its component parts, and examine the resulting rays of light, we would find a regular scale of colours, beginning with a dark, throbbing red, passing through a bright red, orange, yellow, yellow-green, cool blue-green, blue, indigo, and ending with an almost invisible violet. For all practical photographic purposes, the scale begins with a deep red ; but, instead of ending with violet, it goes on to what is termed " ultra-violet " —rays which are invisible to the human eye, and yet visible to the sensitive plate.

I spoke of the red light-waves as " throbbing," because they vibrate slowly like the deep notes of an organ. As the light-waves become closer together they appear yellow ; when their frequency is half way between red and violet they appear a restful green ; when they are still closer they appear blue-green ; still closer, a blue ; yet closer, a violet ; and lastly these wave-crests come so close together that they produce no effect on the retina. The deep, throbbing tones of red affect the human eyesight strongly, but they affect the ordinary photographic plate not at all ; the shrill squeak of the ultra-violet is beyond the human faculties, but it agitates the silver particles of the sensitive film violently.

Rendering of Colour into Monochrome

If it were possible to illuminate a landscape with ultra-violet light, the subject would look as black as a coal pit, but the landscape could be photographed, shadows and all. If it were possible to flood the landscape with red or yellow light, the scene would appear brilliant, but it could not be photographed with an ordinary plate.

Now, as we realised towards the beginning of this book, we do not see objects themselves, but we see the light which they reflect. One object reflects all the various light-waves and we call it white ; another only reflects the red waves, whilst it absorbs the blue, green, and yellow waves, probably converting them into heat—we call this object red ; another object reflects only green, yellow, and red, producing an impression of yellow ; yet another object reflects no light at all, and this we call black.

But, my dear sir, this is theory, pure theory. An ordinary plate is blind to yellowish green, orange, and red, and if this theory were true it would be impossible for an ordinary plate to record grass or any flowers except those which were blue or white. As a matter of fact, practically all objects reflect more or less white light, as well as the predominant colour-wave. A scarlet tunic, for instance, reflects quite a quantity of white light; and when it is remembered that scarlet cloth has a comparatively mat surface, it will be realised what a quantity of white light must be reflected by leaves and other things which have comparatively shiny surfaces, and the immense amount of white light that must be reflected by wet objects or objects powdered with dew.

Again, although an object may appear bright red, this is no proof that it absorbs most of the violet and

ultra-violet light-waves. For the sum of one shilling one can buy a dark-room lamp which appears to give a modest light of the purest ruby, and yet such a lamp will pass enough of the white and chemical rays to fog a sensitive plate in next to no time.

Mr. C. E. Kenneth Mees has kindly allowed me to borrow some colour curves which he has planned, from his " Photography of Coloured Objects " ; so, save for a modicum of error which may have crept into my drawing, one may accept them as accurate. I have placed these curves side by side to facilitate comparison.

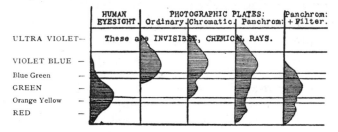

It will be seen from the first curve that the human eyesight begins somewhere about indigo, and is extremely sensitive to green, yellow, and red.

The second curve shows that the ordinary photographic plate is sensitive to the ultra-violet rays and is abnormally sensitive to the violet-blue ; but, with the exception of bluish-green, it is blind to the rest of the colours which affect the human eyesight. And here one meets with the contradiction of experience, for some of the best and truest renderings of grass have been taken on extra rapid ordinary plates, and these renderings must have resulted solely from reflected white light, which created no definite impression of white on the retina.

266

Rendering of Colour into Monochrome

The next diagram shows that the orthochromatic plate, which has been rendered sensitive to green by the admixture of some eosin or erythrosin dye with the emulsion, should be much more sensitive to green ; and yet any one who has used orthochromatic will know that there is practically no difference between these and ordinary plates, unless a colour screen be used with the former.

The panchromatic plate, which is an ordinary plate that has been bathed in isocyanin, is certainly more sensitive to green, yellow, and red ; but even here the violets and ultra-violet predominate ; and the panchromatic plate suffers from the great disadvantage that it is not easily developed by any dark-room light— in fact, it is best developed by time development.

Now, it will be noticed that, although the ortho-chromatic plate is rendered sensitive to green and the panchromatic plate to the whole of the spectrum, both these plates are overwhelmingly sensitive to those chemical rays which do not affect the human sight. This defect is remedied by placing a screen of bright transparent yellow close to the lens. The yellow screen allows the greens, yellows, and reds to pass through unchecked, whilst it stops the ultra-violet, and reduces the intensity of the blue and violet.

The following diagram shows the result of using the screen :

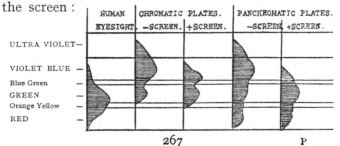

The Artistic Side of Photography ♣

It is evident from this diagram that an orthochromatic plate with a screen is sensitive to both green and yellow, whilst it is only a little too sensitive to blue—the red is not rendered. The panchromatic plate with the screen sees colours in much the same ratio as the human vision.

In other words, although the orthochromatic plate with a screen shows a nasty little gap in the bluish-green—somewhere about the colour of the pine-needles—when it is exposed behind a screen the plate is sensitive to the general colours of both landscape and seascape. Without a screen, the orthochromatic takes the place of the ordinary plate, and gives the same simplicity of tone rendering ; and since this plate is blind to red, it can safely be developed by a good red light.

The panchromatic plate is invaluable in any subject where red predominates ; it gives very delicate flesh tones in portraiture ; it is admirable when a truthful record and transcript of Nature is desired, and it is essential in scientific work. But since the panchromatic plate is sensitive to every coloured light, the dark-room lamp must be so subdued that it is exceedingly difficult to judge values and contrasts by inspection.

III. Assuming that the pictorialist wishes to exercise full control over his medium, I do not think he could do better than adopt some first-class rapid orthochromatic plate for general use, with hand as well as stand camera, and accustom himself to use his plates with or without a screen. I shall speak of panchromatic plates, for special occasions, presently.

Without a screen, the orthochromatic plate will do everything that the ordinary plate can accomplish.

Rendering of Colour into Monochrome

With a screen, which multiplies the exposure five or ten times, it is capable of much of a most desirable type of work that is quite beyond the possibilities of ordinary photography ; and with a graduated screen clouds and landscape may be finely rendered on the same plate. The ortho plate is perfectly easy to develop, and the adoption of one make of plate for all ordinary work will give the photographer a mastery over his medium that he could never acquire if he changed from one brand to another. As a wise pictorialist once remarked to me : " The successful photographer is he who finds a good plate, and sticks to it."

Now, if the photographer would learn to handle his orthochromatic plate in a rational manner, I am certain he ought to accustom himself to think of the whole spectrum, including the invisible ultra-violet ; for, although the human eye is insensible to some of the chemical rays, and the plate insensible to some of the visual rays, the whole spectrum reaches both the eye and the plate. Then, when he comes to the actual exposure, he can determine whether he shall depict the colour-values as experience has taught him that the unscreened plate will see them ; or whether he had better cut off a fraction of the chemical rays with a pale yellow screen ; or whether he should reduce the violence of the blue light from the sky with a graduated screen ; or whether he should cut off nearly the whole of the ultra-violet and reduce the violet with a ten times screen.

The diagram on the following page will explain matters.

It is obvious that the chief function of the screen is to cut down the ultra-violet—or, with the ten-times

screen, to eliminate it entirely—and to reduce the violence of the blue.

IV. Without a screen, the photographic plate can never record the visual rays accurately; but is Art always true to Nature? Without a screen, it can never translate the various colours into their relative values in monochrome; but are accurate translations always best?

The ordinary plate, and the ortho plate without a screen, do not work with the visual yellow rays of light

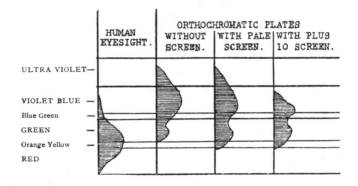

	HUMAN EYESIGHT.	ORTHOCHROMATIC PLATES		
		WITHOUT SCREEN.	WITH PALE SCREEN.	WITH PLUS 10 SCREEN.
ULTRA VIOLET—				
VIOLET BLUE —				
Blue Green —				
GREEN —				
Orange Yellow —				
RED				

—at least not chiefly. But if the photographer knows the exact effect that the chemical rays will have on his plate, and controls these rays so that they produce a picture which is pleasing, whilst it is not obviously untruthful, he has a right to do so.

But there are times when the violet and ultra-violet rays are too strong, or times when the delicate tints of the landscape are so beautiful that it would be a crime not to translate them as accurately as possible; and then the screen must be brought into play.

The usual idea amongst amateurs seems to be that orthochromatic photography is " advanced," and that

Rendering of Colour into Monochrome

the photographer who invariably uses a panchromatic plate and its regulation colour screen belongs to a higher order of beings than the ordinary run of the craft. This is hardly the case. The man who knows when to use a screen, and when to obtain certain desired results without a screen, is the skilled craftsman ; whilst the man who works by one fixed plan—whether that plan be chromatic or non-chromatic—is working mechanically. It needs a deal of experience to work with the chemical rays so as to secure an effect that is artistic whilst it does not appear untruthful.

And here I must insist on two things. First, the panchromatic plate, plus a screen, is so nearly true to human vision that he who talks about the screen " cutting out atmosphere " is talking balderdash. Secondly, when Nature is right (and, being right, delectable) he who tries to improve on the panchromatic plate, plus the screen, is a Philistine. But it will be urged that my artistic photographer has only orthochromatic plates with him. Well, unless the subject depends on the interest of red and yellow, an orthochromatic plate with a ten-times screen is true enough.

V. The qualities of the orthochromatic plate, without a screen, and the ortho and panchromatic plates, with a screen, may be summed up as follows :

(a) Without a screen, the orthochromatic plate is abnormally sensitive to the ultra-violet, violet, and blue ; and as the atmosphere seems to reflect and diffuse a quantity of these colours, the details of both sky and distance are apt to be buried up and lost in the development ; but with a comparatively short development, in a diluted developer, the sky and

distance are rendered in a very few simple tones of grey. There is but little atmosphere between the foreground and the lens, consequently the foreground is apt to be technically under-exposed, with but little detail. Most of the greens and all the yellows and reds are only depicted by the white light which they reflect, and consequently their gradations appear less complex than they would appear in a fully corrected plate. In short, the negative, if softly developed, lends itself admirably to the rendering of a subject in either a high or low key.

(b) The pale screen, shown in the foregoing diagram, increases the exposure between two and three times. It will be seen that this screen does not cut out the violet and ultra-violet, but restrains them slightly whilst the green and yellow are impressing themselves on the film. The correction of such a screen would only be slight, and the negative would not greatly differ from an unscreened negative. In fact, such an exposure might be regarded as a less violent edition of the unscreened exposure just mentioned.

But when the beauty of the scene lies in the delicate shades of mist or atmosphere, or when much depends on the soft contrasts of colour, or when the charm is in the cloud forms or distance, an orthochromatic or panchromatic plate, with an efficient colour screen, should be used.

(c) The ten-times screen, used on an orthochromatic plate, cuts out the ultra-violet altogether ; and although the plate still sees the blue more vividly than it is seen by the human eyesight, the green has full time to register itself. Such an exposure would give both clouds and landscape, whilst the distance would be defined much as the vision sees it.

Rendering of Colour into Monochrome

(*d*) The panchromatic plate, with a suitable screen, may be taken as giving correct visual values.

VI. There are times when brilliant reds and yellows can only be rendered justly by translating them into very light tints (as, for instance, a bunch of poppies or a wheat stack against a deep-blue sky), and in such cases a panchromatic plate should be over-corrected by the use of a strongly tinted screen ; but such cases are rare, for in over-correcting the reds and yellows, the photographer is also over-correcting those colours which Nature paints in greys and blues ; and in rendering foreground reds in a light tint, the photographer renders the distant blues so dark that he destroys all feeling of atmosphere.

VII. Such are the principles of colour rendering as I take them ; and if I have spoken rather too strongly in favour of the older method, it is because I can perceive a tendency to adopt orthochromatic methods, as a fashion, and not as the result of careful testing and sincere conviction. " It is the correct thing, therefore let us adopt a panchromatic plate and a colour screen," is surely a poor style of argument.

With a fully corrected plate we get a scale of gradations running right through the subject ; without a screen we can place the full detail of our gradations in the foreground, distance, or middle-distance, and develop the plate so as to secure tone and refinement.

All the same, orthochromatic photography places a wonderful power in our hands, especially when we have to deal with atmosphere and atmospheric effects ; for the colour screen does not cut out atmosphere, but renders it true to human vision.

A word to the wise. Any dealer can buy yellow glass, or stain gelatine, but it takes a highly trained

expert to make a screen that will cut out the correct proportion of violet rays, and allow the greens, yellows, and reds to pass. A wise man will obtain his screens from some firm that has specialised in the subject— Messrs. Wratten & Wainwright or Messrs. Sanger Shepherd, for instance.

CHAPTER XXIII

ADDITIONAL HINTS ON LANDSCAPE WORK

I. THIS book has been, so to speak, a book on landscape work; consequently there is but little more to be said on the subject, with the exception of some hints on the choice of a lens and camera, and the matter of relief.

The focal length of the lens has already been discussed under the heading of Perspective, and the nature of the lens must now be determined. The first thing to be considered is the question of reflecting surfaces.

Now, we have only to stand before a house, with the setting sun behind us, to realise how brilliantly the surface of glass reflects the light ; and the finely polished surface of a lens reflects far more light than the common surface of window-glass. The outer surface of a lens

reflects the rays of light away from the plate, and although a small portion of the light is lost, this loss is of no practical importance. But when we have a doublet, the inner lens of the doublet reflects some light outward, part of which is reflected back towards the plate by the surface of the outer lens ; under certain conditions this tends to fog the plate. Considering that some of the modern lenses are composed of five separate lenses, each separated from the other by an air-space, the risk of lens-fog is a real danger, especially when photographing against the light. A safe rule is the avoidance of all lenses that are formed of more than two separate combinations.

The single corrected landscape lens, formed of two or three lenses cemented into one, is a delightful instrument to use with a stand camera, but it is some-what slow in action, seldom working at a larger aper-ture than f/11. The rapid rectilinear—or R.R. lens—is composed of two landscape lenses mounted in a lens tube, and works at about f/8. The symmetrical anastigmat is composed of two very highly corrected landscape lenses, works at a large aperture, and is excellent in every way. The single combinations of either R.R. or symmetrical anastigmat may be used as single landscape lenses of about double the focal length of the doublet ; the single combination of a R.R. usually requires considerable stopping down, but the single combination of the anastigmat makes an excellent landscape lens. The original Aldis lens is an anastigmat of different construction to the symmetrical, and the combinations cannot be used separately, but it is an excellent little lens and wonderfully cheap : it has practically superseded the R.R. Since speed is some-times essential, even in landscape work, if I were

buying a new lens I should select a symmetrical anastigmat by one of the first-class makers, or, if expense were an object, I should buy an Aldis.

Reflections from the inner surface of the camera must also be guarded against, and since the most brilliant light comes from the sky, a lens screen will remove this danger. The lens screen is usually in the form of a small awning placed above the lens, and it may be made of black cardboard. It should be arranged to cut off all the light from the sky except that which is focussed on the sensitive plate ; but care must be taken lest it be placed too low, and thus cut off part of the image.

II. The camera for serious landscape work may be either a reflex, a hand camera that opens out into what is practically a stand camera, such as the Sanderson, or a stand camera. Since portability is a great advantage, and nearly all workers enlarge their negatives, and since such hand cameras as the Sanderson, Sinclair's "Una," Thornton-Pickard's "Folding-Ruby " fulfil all the functions of a stand camera, the stand camera need hardly be considered.

The reflex camera is fitted with an interior mirror, which reflects the image on to a focussing screen at the top of the camera, and consequently the subject can be focussed and arranged until the moment of exposure. At the exposure the mirror is automatically removed and a focal plane shutter is released. The double advantage of being able to focus until the moment of exposure, and of seeing the image right way up on the focussing screen, cannot be over-estimated ; and a good reflex camera is a very fine instrument. But some of the cheaper reflex cameras close the mirror with a bang which destroys definition

at the slower speeds, and none of the cheaper reflexes should be bought unless they are first tested at, say, one-twentieth of a second, and the developed plate

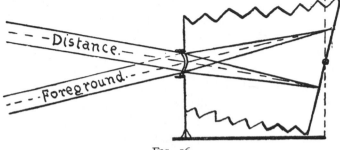

FIG. 16.

shows no blurr. The faults of the reflex are, first, its bulk ; secondly, its lack of much rise of front ; and thirdly, in the cheaper models, the lack of swing back

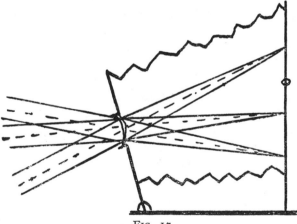

FIG. 17.

or its equivalent—the swing front. The photographer can easily accustom himself to the weight and bulk of a reflex ; the want of swing front is not very serious ;

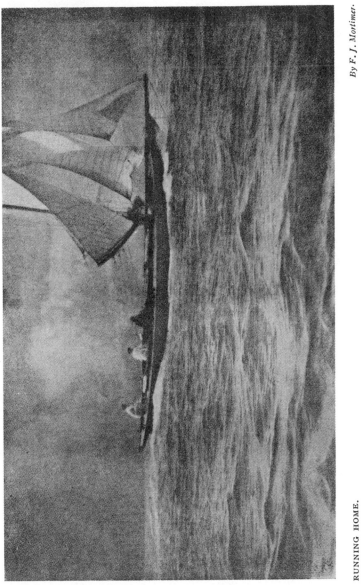

RUNNING HOME.

By F. J. Mortimer.

but the deficiency in rising and falling front is a decided drawback.

In figs. 16, 17, the swing back and front are depicted. The foreground in a landscape requires a longer camera extension, in order to bring the foreground objects into focus, than does the middle-distance ; consequently, when the foreground is brought into reasonably clear focus, the middle-distance is apt to be much out of focus, and *vice versâ*. By swinging back the focussing screen, this fault is remedied. It

FIG. 18.

will be seen that the swing front performs a similar function, and if the lens has a fairly large field, the swing front is excellent. This swing is almost essential in cameras for marine work, as it allows the photographer to make his station-point close to the surface of the water, after the manner of the sea-painter.

Fig. 18 shows the action of the rising front. When the camera is levelled, the horizon is opposite the lens ; and, since the image is upside-down on the focussing screen, a rise of front will bring the horizon closer to the bottom of the picture. Painters are

very fond of a low station-point in landscape work, and if a low station-point be employed, a rising front is essential ; the rising front is also necessary in architectural photography. The falling front is useful with a high station-point, especially when it is desired to bring the horizon close to the top of the picture, as in the photograph of a peacock at the beginning of this chapter.

III. Many years ago I lost the sight of one eye for some months, consequently I have a more practical knowledge of the advantage of double vision than most. With one eye it is impossible to judge the distance of a lawn-tennis ball or of a flying partridge, and the branches and leaves of the trees look as flat as fretwork. I can remember the first day that I was allowed to use both eyes, and the glorious way in which everything sprang into relief. The camera has only one eye, and, consequently, although it does not see things quite as flatly as a man with only one eye, it sees things very flatly.

The lens does not see things stereoscopically like human vision, and therefore it only depicts distance and relief by means of perspective, or atmosphere, or shading. Fig. 19 illustrates this.

Fig. 19 depicts two pillars. In A parts of them are shown without either perspective or shading, and they look dead flat. In B they are drawn with some perspective at the base, which gives a certain feeling of relief. In C parts are again drawn, but this time with shading, and the sense of relief is considerable.

Thus, in the photograph of a wood, the trees acquire solidity and relief, partly by the perspective of their bases, and partly by the shading. This perspective is rendered partly by showing the bases higher up in

the picture as they recede from the camera, and partly by the shadows which the trees cast in sunshine. A somewhat high station-point helps on the perspective drawing.

When working in the open, sunlight coming from one side gives relief, and the long shadows towards evening are a great assistance. Atmosphere, although it does not give relief, conveys a sense of distance ; for, as objects recede from the camera, the moist

FIG. 19.

atmosphere paints each more distant object a lighter tint and with a less clear definition. When the atmosphere paints London

> A fretwork
> Of bluish grey
> Against grey sky,

London is at its best, and the sense of distance is most real.

In landscape work the height of the station-point of the lens from the ground is a most important

matter, and one which can be learnt only from prac-
tical experience. A series of studies taken with the
camera at different heights is invaluable, and the
subject selected might well be a pathway.

IV. A landscape painter usually divides the planes
of his picture into three divisions, the foreground,
the middle-distance, and the distance. The interest
and beauty of his subject may lie in any one of these
divisions, or it may be evenly distributed amongst
the three ; but the foreground and distance should
harmonise together, so as to make the picture one
harmonious whole.

Now, supposing there was an interesting foreground
containing some children picking flowers ; the function
of the middle-distance and distance would be to give
an open-air feeling to the scene. The foreground
would naturally be sharply focussed, and the other
distances might well be softened into masses of various
tones ; but the tend of the lines and masses in the
distance should lie so that they counteract and balance
the tend of the foreground. Supposing, for instance,
that the foreground, distances, and cloud-forms all
sloped from left to right, the result would give a very
ill-balanced composition ; but if the tend of the
landscape were countered by cloud-forms sloping the
opposite way, the picture would appear well balanced.

Again, suppose the interest of the subject lay in
the middle-distance, the foreground might well be
kept so simple in form and definition as to be reduced
to mere masses of darker tones : so long as it balanced
the tend of the middle-distance, it would perform the
double function of balancing the composition and
throwing the distances back into their proper planes.

LEAF FROM MY NOTE-BOOK

The Pinhole

April 25, 1910.—" Mr. Coburn says," burst out
Monica excitedly—" I met him photographing some-
thing at Hammersmith—that you're spoiling your
book by leaving out all about pinhole photography
—it's most artistic."

I sighed, partly because the photography book was
finished and I was deep in something else, partly
because the little pinhole is a big subject and I had
purposely avoided it. " Coburn's like the rest," I
said ; " he takes one or two pinhole photographs, finds
the definition delicious, swears by the pinhole, then
gives it up because he finds it slow and impracticable."

" But he says——"

" He says," I grumbled, " that his photograph of
the Tower of Babel shows what the pinhole can do.
But then he only pinholed the Tower of Babel because
his lens wouldn't bring the different languages to a
focus on the same plane."

" He says," persisted Monica, " that what you have
written about pinhole enlargement is all very well,
but that a negative which has been softened in the
enlargement is not the same as one that has been
taken soft."

I fetched an old album, dated 1901, and, opening
it, handed it to the girl. " These two photographs
were taken with the same pinhole, the same camera-

extension, and under the same conditions ; one was given an exposure of three minutes, the other an exposure of one second—there is the same difference in exposure as there would be between one of three seconds and one of one-sixtieth of a second with a lens ; here is another of fishing-boats, taken in half a second—it ought to have had one minute's exposure. Both must have been frightfully under-exposed, but they do not look like normal under-exposures. Do you understand ? "

" I think so," said Monica.

" If one treats the pinhole as though it were a lens aperture (a hole of $\frac{1}{100}$ inch, with a ten-inch camera extension, as f/1000) the pinhole gives a most artistic rendering of architectural exteriors ; but one knows but little about the possibilities of pinhole photography in landscape work, only that the smaller the hole the clearer the definition. It is a subject that needs to be investigated from the beginning, free from all thoughts of lens-photography."

CHAPTER XXIV

SOME ELEMENTS OF PORTRAIT WORK

I. THE landscape photographer has to face many difficulties and exercise infinite patience : his subject is a " set piece," and therefore his composition is confined to the choice of a station-point, whilst he has to wait for the lighting and atmosphere until they chance to combine happily. But the portrait photographer has no such limitations, for the arrangement and lighting of his subject are in his own hands, and the rendering of character is a pursuit that ought to excite his artistic faculties and stimulate his technical skill. Hence portrait work offers such a field for personality, individuality, and insight that the scarcity of really artistic portraiture is a marvel.

If one were to tick off Baron de Meyer, Frederick Hollyr, Holland Day, Alvin Coburn, Mrs. Kasebier, Furley Lewis, Frederick Evans, and some eight others, the list of persons who can be trusted to take fine portraits would be exhausted. The shortness of this list seems to be due to the commercial greed of the professional and the idiotic conventionality of the amateur.

Let me picture a typical West-End photographic establishment—it is necessary to do so, as the professional has exercised, and still exercises, an overwhelming influence on the popular ideas of portraiture. There is an expensive and elegantly furnished shop,.

with a gentlemanly proprietor, who talks glibly of dukes and duchesses and has his name engraved on the photographic mounts ; there is a charming receptionist, who books the appointments. The actual work is done by an operator whose salary may be equal to the price of a dozen platinotypes, whose fixed idea is centred on a lighting and pose like those of Reynolds or Romney, and who snaps off his sitters without thought or knowledge of character rendering. Then, lest some shred of truth should creep into the portrait, the negative is retouched by a girl who has seen nothing of her victims, who knows nothing of modelling, and who touches out character lines with the same facility as she removes wrinkles. Of course there are some professionals who themselves operate, and love their work ; but even in such cases the retoucher usually destroys the likeness.

The ordinary amateur devotes far too much attention to text-books, and becomes wrapped up in schemes of composition, schemes of posing, and schemes of lighting, until he forgets all about the character rendering, which is the heart and soul of portrait work.

If a man wishes to take, or even to appreciate good portraits, he must forget nearly all he has been taught about composition, and begin by learning to realise that the likeness is everything ; that the pose of the figure is not an essay in composition, but part of the likeness ; that the lighting is planned to throw up the particular features and bring out the particular modelling of one particular face ; and that even the placing of the hands is a portion of the character rendering.

Velasquez's half-length portrait of Philip of Spain is perhaps the finest portrait in the world ; yet, what

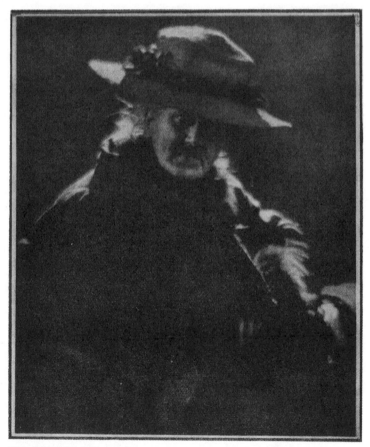

MRS. WIGGINS OF
BELGRAVE SQUARE.

By Baron A. de Meyer.

professional or what ordinary amateur would dream of posing his sitter in such a simple manner? As a matter of fact, the composition in most of the great portraits is exceedingly simple, and we can only assume that the less the artist has worried himself about his composition the more has he been able to devote his attention to the interpretation of character and the surrounding of his sitter with a typical atmosphere.

II. In photography the drawing is performed automatically; but it depends on the station-point of the lens whether the drawing appears natural or unnatural, the perspective pleasing or exaggerated, and the foreshortening true or false.

If we realise that in portrait work the station-point of the lens is everything, and the focal length of the lens only affects the size of the image, we shall save ourselves trouble and confusion. Given a station-point about 8½ feet from the sitter—and this is the closest station-point that will give an agreeable perspective—an eighteen-inch lens will draw the face about an inch and a half long, whereas a six-inch lens will only draw it about half an inch long; but the drawing of the proportions and perspective of the face will be identical. Those who wish to do large heads must have long focus lenses, but those who are content to work small may employ lenses of short focal length.

In selecting the station-point there are two things to consider : the distance of the lens from the sitter, and the height of the lens from the ground.

(a) *The distance* of the station-point from the face is best considered by means of a diagram. This diagram is quite simple, and will repay a few moments' careful study.

Fig. 20 shows a life-size head photographed by a modern wide-angle anastigmat, with the station-point, L, quite close to the face. The eye having been focussed, the nose, B, will be depicted somewhat larger than life-

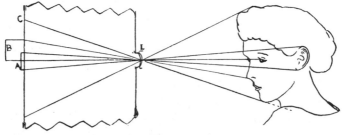

FIG. 20.

size, and the ear, A, will be depicted much smaller than life-size. In the same way, the width of the face near the cheek bones will be life-size, whilst the width of the face near the ear will be narrower than life-size. It is also evident, from the line C, that the chin will hide

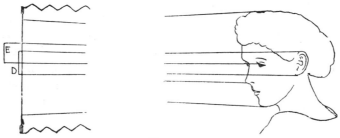

FIG. 21.

the neck. Thus, a perfectly formed face would be depicted with a huge nose, tiny ears, wide cheek bones, narrow jaws, and no neck : all roundness and symmetry would be lost.

In Fig. 21 the station-point of the lens is 8½ feet from

the face—this is the closest station-point that will give satisfactory drawing for a large head and shoulders —and the perspective is widely different from that in fig. 20. Space necessitates the omission of the central portion of the diagram, but it will be seen that the nose, D, and the ear, E, are drawn almost the same size, and that the chin does not hide the neck.

This, then, may be regarded as the first technical principle in the portrayal of a head and shoulders : the lens should be at least 8½ feet distant from the

<div align="center">
FIG. 22. FIG. 23.
</div>

sitter's face ; if the lens can be placed somewhat farther off, so much the better. But if a full-length portrait be required, the station-point should be still farther distant from the sitter, and 17 feet would be none too far. Figs. 22, 23 show the perspective with a full-length figure.

In fig. 22, which assumes a station-point 8½ feet from the sitter, the upper part of the figure is satisfactory, but the perspective of the lower part is too steep. In fig. 23, which is taken at a distance of 17 feet, the perspective is quite satisfactory.

Accepting the principle that the station-point of the

lens should be 8½ feet from the sitter when photographing head and shoulders, and 17 feet distance when photographing whole-length figures, lenses of the following focal lengths will give the following size portraits :

Focal Length.			Head and Shoulders.			Full Length.		
6 inch lens	½ in. heads			about 1½ inch.		
12 ,, ,,	1	,,	,,	,,	3	,,
17 or 18 in. lens	1½	,,	,,	,,	4½	,,
20 to 24 ,, ,,	2	,,	,,	,,	6	,,

These are the largest figures that should be attempted with the respective lenses ; but, provided there be a sufficient length of studio, an eighteen-inch lens would draw a half-inch head in satisfactory perspective.

Of course, all this only refers to the taking of the original negatives, and if larger portraits be required, the image may be subsequently enlarged without altering the perspective ; as I shall presently show, a one-inch head may be enlarged to life-size without straining the qualities of the medium.

(b) The height of the station-point next needs consideration.

In fig. 24 the lens is placed on a level with the eyes ; in fig. 25 it is placed somewhat higher. It will be easily seen that the higher station-point renders the shoulders on a level with the chin, producing a hunched-up appearance ; also the higher station-point shows too much of the top of the head. As a general rule, the lens should be placed level with the sitter's eyes, and exceptions from this rule should only be made with a definite purpose. In some few cases the higher station-point will be found to give a more pleasant rendering of the features ; and if the person be photo-

graphed as seated, reading or sewing for choice, the picture will appear natural. In other cases a slightly lower station-point will make a saucy face appear delightfully piquant.

If the head be placed high up in the picture, an impression of height and importance is given to the figure ; if the head be placed low down, the sitter appears short. Since the lens is on a level with the sitter's eye, a considerable fall of camera front is

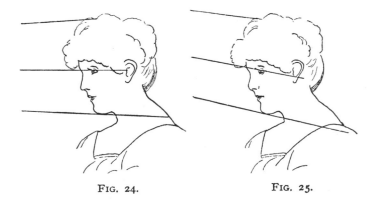

FIG. 24. FIG. 25.

necessary, so that the head may be placed high enough in the picture. My own practice is to use a whole-plate for a half-plate portrait, to lower the lens panel before starting work, and to arrange the exact position of the portrait in the picture space afterwards. This practice avoids keeping the sitter waiting whilst one is arranging the image so that it comes exactly right in the picture : incidentally, the cost of the plates discourages one from making exposures on the chance of a fluke, and encourages one to work with care and conviction.

III. The aim in lighting should be to bring out the

THE SILVER SKIRT

By Baron A. de Meyer

modelling and individuality of the sitter's features. The draftsman can suggest relief by the skilful drawing of lines, but the photographer—as we saw in the last

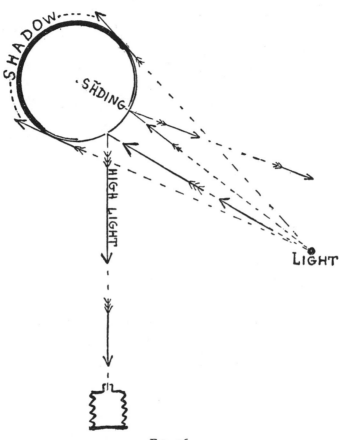

FIG. 26.

chapter—depends on shading for the relief and modelling of a face.

It is quite true that different faces demand different

299

lighting, and that each face photographs best in the lighting which becomes it best ; but the unsophisticated man is apt to be content with a generally becoming lighting, and to see part of the modelling by means of the stereoscopic nature of the human vision ; whereas in photography this sense of stereoscopic relief is lost, and all relief depends on the shading. Therefore the photographer must learn to see relief in his model's face solely by the shading and shadows, and this can hardly be learnt without a firm grasp of the principles of the light-shading.

In fig. 26 we have a stone ball, illuminated by one small, intense light—we must assume that the ball is photographed in a room draped with black velvet, floor and all, so that there is no reflected light—and this is what happens. The light strikes one small portion of the ball and is reflected straight towards the camera : this is the high light. The light strikes other portions of the ball and is reflected away from the camera, but a certain amount of the light is diffused and reflected towards the lens by the rough surface of the stone : this forms the shading. No light reaches the shadow, which is invisible to both eye and sensitive plate. But notice this : the portions of the ball that are near the high light reflect more diffused light towards the lens than those portions which are close to the shadows, consequently there is a graduated shading. Again, if the room were small and painted a light colour, the shadows would be relieved by reflected light, and the shadow portion of the ball would be visible.

Thus, in a face lit in the ordinary manner we find a high light reflected by the ridge of the nose ; and since the skin of the nose is close in texture and somewhat

tightly drawn, this high light is strong. There is another light reflected from the dome of the forehead ; another from the curve of the chin, and a fourth from the cheek bone : brilliant little lights are also reflected from the eyes. Then there is shading on all the parts of the face that recede from the camera, except, of course, in the shadows ; this shading is prevented from becoming too dark by the light which is diffused from the texture of the skin, and at the side of the nose it

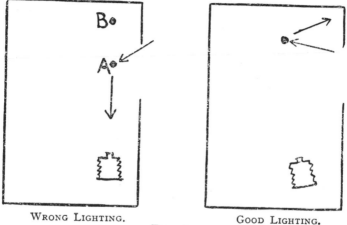

WRONG LIGHTING. GOOD LIGHTING.

FIG. 27.

is also lit by the light which ricochets from the cheek. The shadows are relieved by reflected light, either from the side of the room and furniture or from the dress : when the sitter wears a white dress the shadow under the chin is very slight. Bearing all this in mind, fig. 27 becomes illuminative.

In the position marked A the light ricochets off the side of the face, especially off the jaw close to the ear, and destroys the shading. In the position marked B the shading becomes too strong. The position in

the second diagram gives very good modelling, and if a studio of this size were papered with fairly light paper the shadows on the face would be nice and soft.

IV. Leonardo da Vinci has recorded in his note-books that a figure should cast a shadow of the same length as the figure itself—and such an illumination gives very satisfactory shadows beneath the chin, nose, and eyebrows ; if the light be more slanting than this, the shadows under the eyebrows are apt to be unsatisfactory. Consequently, when taking a portrait in an ordinary room, it is wise to block up the lower sash of the window.

If the sitter be placed close to a small window the lighting will be very strong and the shadows severe ; if the sitter be placed at some distance from a large window the lighting will be softer and the shadows relieved by reflections from the opposite wall. A screen of butter muslin placed between the model and the window softens the light ; but it must always be remembered that in this case the muslin practically becomes the source of illumination.

A small room, like that suggested in fig. 27, will make a perfect studio ; but if the room in which it is proposed to take the portrait be large, it may be reduced to the size of the smaller room by means of a screen covered with a medium light paper. The white light-reflector, so dear to the heart of most professionals, is an abomination ; for who has seen a friend's face with the shadows lit by white reflections, except in a whitewashed passage ? The chalky shadows, which disfigure most professional portraits, are anathema.

Take a room as large as a cavern, with no windows on the far side, and the shadows on a face will be inky

black. Place a screen (covered with light sage paper, for choice) at a couple of yards from the sitter and parallel with the window, and the shadows will be lit as though the screen were an ordinary wall. By such means, almost any room can be made into an excellent studio.

V. In actual practice it is often necessary to strengthen the high lights on the negative, so as to impart vivacity to the face, or to soften wrinkles, from motives of charity : this is best done by retouching. I have never come across a professional retoucher who failed to ruin the modelling of the face or the texture of the skin ; and as the amount of retouching that is necessary is easily learnt, the photographer should do it himself. Imagine Sargent sending his portraits to be "finished," and allowing a professional finisher who had never seen the sitter to put the last important touches to the picture !

A retouching desk, good H and HB pencils sharpened on sandpaper until they have points like darning needles, and a bottle of retouching medium are all that is needed. A very little of the medium is rubbed on the place to be retouched, care being taken to leave no hard outline of the medium ; as soon as it is dry the high lights are strengthened and the wrinkles softened with very light, gentle strokes, just as though a very delicate drawing were being finished : this is much better than any method of "stippling" or "cross-hatching," and any one with a delicate touch can manage it.

Wrinkles, especially those beside the mouth and beneath the eyes, which betoken past troubles, those on the forehead, which denote thought, and those at the corners of the eyes, which were made by keen

glances, should only be softened, and not removed. All these were formed in the formation of the character, and so they are part of the character of the face.

In the same way, great care should be taken to retain the texture of the skin when retouching the high lights. A smooth skin will give stronger high lights than one which has the bloom of a peach, for the smooth skin will reflect the light brilliantly, whereas the soft skin will diffuse much of the light. The same holds good with regard to the various features. The skin of the nose is usually closer in texture and more tightly drawn than the skin of the other features, and consequently the high light along the ridge of the nose is usually the strongest high light—but this is not the invariable rule ; the high light on the forehead of a scientist, or the high light on the clean-shaven chin of a soldier, might well prove the highest light in a picture.

Many of the imperfections and exaggerations in a portrait negative are due to the tiny, and almost invisible, blood vessels in the skin : these affect the ordinary sensitive film strongly. The use of a panchromatic plate with a moderate colour screen will improve these matters wonderfully, without unduly prolonging the exposure.

LEAF FROM MY NOTE-BOOK

Amateur Portraiture

September 1908.—It is difficult to understand why so few amateurs take up miniature work. A large portrait, from half-plate upwards, is very difficult to handle, and the apparatus is costly. And what could be more desirable than a delicate miniature, printed on thick, smooth platinotype, with clean margins and a line drawn round the picture ?

A strong, long-extension camera, with carriers to take quarter-plates, can be picked up for a song, and a fine old 10-in. Petzval portrait lens would almost be given away.

A quite small miniature, printed on a piece of platinotype the size of a man's visiting-card, would require but little technical skill, whilst the lighting and artistry might be perfect.

The ordinary amateur large portrait is a terrible thing ; it is far too large for the lens usually employed, and too difficult for any one without artistic education to handle. Why not try miniatures ?

CHAPTER XXV

ARTISTIC PORTRAIT WORK

I. WHEN Valasquez set himself to paint a portrait he set himself the task of painting a likeness and not a "composition": he does not appear to have worried much about the posing or lighting, but he seems to have devoted his whole energy to the interpretation of character and the portrayal of likeness.

I still cling to the belief that the portrait of Admiral Pulido-Pareja was painted by Velasquez, and not by his son-in-law, del Mazo; but whether it was painted by the former or the latter, it will serve to compare with the portrait of Prince Carlos in illustration of my point. The pose of the two figures is almost identical; but there the similarity ends : the portrait of Prince Carlos shows all the dignity and ease which distinguished a prince of the Royal House of Spain ; the Admiral is essentially a bold, vigorous sailor ; every line of the face, every line of the figure marks this difference. The painting of Æsop, on the other hand, is the picture of a clever, yet careless, literary man, who was essentially the writer or editor of a collection of fables.

Mr. Bernard Shaw may have gone a trifle too far when he insisted that if photography had been invented in the seventeenth century Velasquez would have used the lens instead of the paint-brush ; but the

Spaniard certainly forms an ideal guide to the photographer. The pose of his figures always appears natural, and we are almost tempted to believe that he allowed his subjects to pose themselves : at any rate, his portraits are always characteristic, from the carriage of the head to the carriage of the hands, and from the expression of the features to the position of the feet. In artistic portraiture, naturalness, truthfulness, and individuality are everything ; and the planning of Rembrandtesque effects of lighting or Reynoldesque effects of posing is to fling away the substance for the shadow.

II. Now, if one wishes a sitter to be easy and natural, one must be particularly careful to pose him entirely by the previous arrangement of his chair, and by mental suggestion ; he must not be conscious of being posed, and must imagine that he is posing himself. Half the usual camera-shyness is due to the fact that the sitter is afraid of being placed in an unaccustomed attitude ; the remaining half combines a fear of moving during the exposure, with the awful uncertainty of being taken at any moment. If a portrait is to be a success, these fears must be removed.

Assuming that the photograph is to be taken in a studio, all possible arrangements, such as the placing of seat, background, and camera, rough focussing, and the elementary part of the lighting, should be made before the sitter's arrival—a surgeon should not display his knives before an operation—and the sitter should be treated as a welcome guest.

The photographer has not got to make " a picture," he has to catch a characteristic expression of his subject, which is a far more difficult matter. For a seated figure, I consider a most comfortable easy-chair an

essential—I mean the kind of chair that will tempt the sitter into a natural attitude, and beguile him into sitting still and remaining in focus. If this chair be placed exactly right, the sitter should automatically pose his face in a good lighting ; and if he be taken looking at the camera, just as the three reproduced Velasquezes are looking at the artist, the desired lighting will be a certainty.

Velasquez is a very good guide as to the rendering of hands : there is always a tremendous amount of character in his drawing of hands. First it will be noticed that he gives his sitters something to hold, in the second place he allows them to arrange their hands for themselves. The easy pose of Prince Carlos's hands, the Admiral's firm grip, and the attitude and employment of Æsop's two hands tell quite as much about their respective characters as their features and expression.

A standing figure should have a mantlepiece or some other solid object to lean against—a door-handle is not half a bad support, and the reflections from the door may provide a pleasant change from the usual lighting.

Speaking of lighting, the light reflected from a newspaper, from a white dress, or from a First Communion veil, may often be employed with advantage ; but the source of the reflected light should be shown, so as to make the lighting appear natural.

I have a great belief in a silent studio shutter fixed inside the camera. If a long length of tubing be used, and the release bulb be held in the pocket, a happy expression can often be caught unawares whilst the sitter is interested in the photographer's conversation. As to the lens : my own inclination tends towards

ADMIRAL PULIDO-PAREJA.

ÆSOP.

PRINCE CARLOS.

The three photographs by Anderson, Rome.

either Dallmeyer's Bergheim lens or the Petzval portrait lens. The Bergheim lens gives a soft focus, not by confusing the rays of light like defective human eyesight, but by bringing the different colours of the spectrum to focus at different distances from the lens. Thus, when the blues and violets are clearly focussed, the reds and yellows are much out of focus. Take the case of a blond with freckles ; the eyes would be clearly defined, the hair massed together, and the freckles softened ; the red of the lips would be thrown out of focus, and the tiny cracks and wrinkles on the lips, which are so troublesome, softened.

A Petzval portrait lens, working at f/4, gives a brilliant definition in the centre of the field, with the definition towards the edges of the field somewhat confused. The sharpness of definition will be softened by the breathing and unconscious movement of the sitter during an ample exposure.

With the soft lighting that is desirable in portrait work there is little fear of over-exposure. A long exposure simply means that the image is stamped firmly on the film, and that the negative will take a little longer than usual in the printing. On the other hand, most artists find that a long exposure gives a softness to the definition, and that slight change of expression which prevents it from appearing too set and fixed. In the case of somewhat strong lighting, it is usually better to stop down the lens, and trust to the movement of the subject for the necessary softness, than to give an exposure of only a second's duration. If the sitter knows that the exposure will be from a quarter to half a minute, and that he need not keep stony still, he will prefer it to the awful waiting for an " instantaneous exposure."

III. So far, I have assumed a studio, or a room fitted up as a studio ; but every part of each room and passage in the house is a potential studio, and every part of the garden will lend itself to portrait work at some time in the day. I have seen delightful portraits of a business man taken at his office desk, of women in their drawing-rooms, and of children grubbing in their gardens. As soon as the photographer has learnt to see modelling by means of its high lights, shadings, and shadows, and not by his stereoscopic vision, he will find that all the world's a studio, and all the men and women merely sitters. So soon as he has learnt to see in this manner, he may be certain that when a person looks well he will photograph well.

But the photographer should never forget that when the sight is fixed on the sitter's face the background is apt to be overlooked. The retina may be as sensitive to spots of light in a background as is the photographic plate ; the retina may even telegraph these spots of light to the brain ; but if the brain is concentrated on the sitter's expression it does not heed such telegrams. It is true that the lens will throw the details of the background out of focus, but an out-of-focus spot of light in a background is quite as obtrusive as one that is clearly defined.

To write of open-air photography would need, not a paragraph, nor even a chapter, but a whole book ; and yet I cannot let the subject pass without reminding my reader that open-air portraiture needs a thorough grasp of the principles of lighting and plenty of common sense. It is obvious that a portrait taken in the open country will show but little shading, therefore it is desirable to include sufficient of the landscape to establish the truthfulness of the lighting. If the

portrait be taken against an open distance, the light will glance off the cheeks and destroy the shading. A house or wood behind the camera will cast faint shadows beneath the features, and help the modelling. Shrubs make an exceedingly spotty background. Portraits in sunshine are too much neglected ; the plates should have an ample exposure and be developed in a weak developer : the sun begins to become useful as soon as a five-foot object casts a five-foot shadow.

IV. All indoor portraiture requires a very careful study of the values of shadows, especially the shadows on the sitter's face, so that development may be stopped as soon as there is sufficient contrast between the shadows and high lights ; but of all schemes of lighting, the values in a portrait taken against the light demand the keenest study. Such portraits are often very charming ; and since the modern woman has a habit of seating herself on a window seat with her back to the light, photographs taken against the light come well within the scope of modern portraiture.

As an aid to the study of values in 'gainst-light subjects, I should suggest the following experiments. Stand about four yards from a window and place a model so that she rests against one side of the window frame. Then, as she turns, first her full face, and then her side face, notice the elusive quality of the shadow details : they are neither distinct nor indistinct, and they are lit up here and there by light reflected from the dress and shoulders. Next ask your model to read a newspaper, with her back turned three-quarters towards the window, and notice the attractive lighting of her features by light reflected from the paper. Then remove the paper, and light the shadows by means of the conventional reflector—a sheet on a

towel-horse will serve—and notice how chalky and unnatural her face becomes. The white light reflected from the newspaper looks natural, because the source of the reflection is seen ; but the light from the invisible reflector appears palpably false.

The exposure with such a subject must be very long, so as to stamp the details of the features firmly on the film—thirty seconds at f/7 will be none too long—consequently an ordinary development will make the high lights round the face far too strong and dense before the features are developed. But if the film be filled, and the high lights smothered with a powerful restrainer before development, the desired strength of contrast can be secured. Mr. Winthorpe Somerville has devised exactly the right restrainer for the purpose :

Copper sulphate	10 grs.
Potassium persulphate	20 grs.
Nitric acid	50 mms.
Water	40 oz.

Soak the exposed plate in the above solution for thirty seconds. Rinse under the tap, and develop in a fairly strong pyro-soda. The surface of the film will develop quickly, and as development continues the restrainer will wash out of the film and the developer take its place and develop the high lights. Development will probably be completed in from 3½ to 4 minutes : if the development be continued longer the high lights will attain great density. When the plate is placed in the developer, after its rinsing, a pad of cotton-wool must be passed over the film to remove air bubbles. Of course, in this method of development the high lights will lack delicate gradation ; but since the interest lies in the shadows, and the high lights can

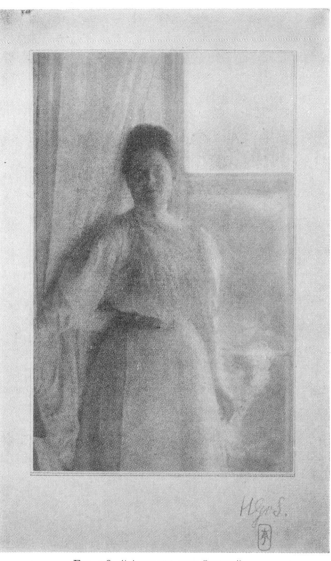

FIG. 28. " AGAINST THE LIGHT."

be brought into value with the shadows, this does not matter.

With the exception of portraits taken with the sitter standing or seated by the window, strong contrasts of lighting seldom appear natural ; for one is not accustomed to see one's friends in a large room lit by one small window.

V. Strong lighting, however, is sometimes necessary in order to bring out the character of a strong face. This is noticeable in the portrait of Admiral Pulido. On the other hand, the character of a sweet face is brought out by soft lighting.

Definition has also something to do with character rendering ; and the haphazard manner in which most amateurs employ either soft or clear definition is to be lamented. A child's face, a face with soft modelling, and especially a face in which the eyes have a line round the iris, like one of Botticelli's Madonnas, usually call for clear definition. Careworn faces, rugged faces, and strong faces will generally stand soft definition without losing their strength and character : to synchronise wrinkles does not take away their character.

Now, in every person there are two parts : there is the natural disposition, which is expressed in the features, and the character, which is shown in the expression : the disposition and features are born with an individual, the character and expression are formed through yielding to evil impulses or by striving after good. A child born with a gentle disposition may grow into a weak and amiable character, or it may grow into one who is steadfastly sweet. A child born with a strong disposition may develop into either a firm character or into a domineering tyrant. Muscles develop with constant use : one smile, one frown,

317

leaves no trace ; but the constant habit of smiling or frowning alters the modelling of the facial muscles. Every habit of character leaves some trace in the face, and although a repentent sinner may be every whit as good as an habitual saint, the character expressed in the face of a Saint Augustine will be absolutely different from the character expressed in the face of a Saint John.

The eyes, mouth, and the lines near the eyes, nose, and mouth express formed character, as distinct from natural disposition ; but the muscles and modelling of the face have more to do with the expression of character than the ordinary person has any idea of. This is why I commenced by advocating a plan of lighting that is best calculated to throw the facial muscles into relief, and bring out the character.

Although persons may not be conscious of their besetting faults and habitual failings—in fact they seldom are—they detest these faults in the abstract and loathe them in others ; consequently, when a weak man is posing before the camera he will always try to look stern, and an ill-tempered person will contort his features into a smile. The photographer must be on his guard, and if he would depict character, he must wait until the mental posing of his sitter is over before he sets himself to conquer the likeness. Each photographer will have his own method of starting work, so if I venture to describe my method, I am not stating it as an admirable example, but only as a possible way.

If I am photographing a man I always ask him to smoke : this not only breaks the ice, but it also gives him something to hold. If my sitter be a woman, I ask leave to smoke, because tobacco destroys the

professional atmosphere of the operating-room and takes the edge off the operation. Then, because the sitter will be thinking of the portrait, I talk about photography, and from that try to turn the conversation towards some topic in which the sitter is particularly interested. All this time I busy myself with imaginary work about the camera, so that when I make the first exposure it will not suggest some obvious change of occupation. The preliminary exposures are seldom successful; but it is not safe to make these exposures with empty slides, as some sitters throw themselves into the operation at once, and the best chance of the sitting may be lost.

If one can once get the sitter interested in some subject of conversation, the matter of obtaining a natural and characteristic likeness is only a question of patience ; but allow the victim to become nervous and self-conscious, and the task is hopeless. My experience has fixed two elementary facts in my mind : one is the wisdom of asking some one to read aloud " The Jungle Book " or " The Just-So Stories," when photographing children ; the other is, that women can sometimes pose empty hands gracefully, men seldom, girls never.

The gift of character-reading is essential in the portrait photographer ; and once the sitter's character is discovered, it is no bad plan to try and photograph some predominant quality in the abstract—I mean some such quality as gracefulness, cleverness, knowledge, firmness, virtue, or wit.

LEAF FROM MY NOTE-BOOK

Character in Photography and Painting

" Easterbrook says," remarked Monica, " that the difference between photography and painting is that the photographer can only catch one passing expression, whilst the painter paints the general likeness and character of his sitter."

" Easterbrook is an honest man," I answered ; " and he is certainly the strongest R.A. after Sargent. But that does not prevent him from being self-deceived."

" Please explain, Mr. Anderson."

" Sitting for a portrait is very tedious work, and the expression of the sitter—I wish some one would invent a pleasanter word than ' sitter '—the expression of the sitter changes continually. The artist catches his subject in a self-descriptive mood and paints as much as he can before that mood alters, then he has to finish the expression from memory. I have no doubt that Easterbrook was perfectly honest when he wrote about blending several expressions into one and getting a general likeness, but I am equally certain that he really worked from the sub-conscious memory of one descriptive expression."

" But—— " began Monica.

" But me no ' buts ' ! " interrupted I. " If one wants a sort of general expression, nothing could be simpler than to wedge one's sitter into the corner of

a very comfortable chair, interest him in his pet topic, and take half a dozen negatives. A composite print from these negatives would secure a general expression that would beat Easterbrook's idea : or why not employ a cinematograph ? "

" And yet there are some persons whose likeness depends on change and vivacity ? "

" How can a painter depict a changing expression ? " I inquired.

Monica shook her head.

" A photographer can make three consecutive exposures," I suggested, " and mount three prints as a triptych."

I could see Monica gathering herself together for one last protest, just as a horse gathers itself together before a water-jump. " But does not the painter's individuality count for something ? "

" Can't you, even you, my dear Monica, tell a Coburn from a de Meyer, or an Evans from a Cadby ? Are not the great photographic portraits simply reeking with individuality ? "

" Yes," owned Monica.

" A painter's individuality embraces the state of his liver, the state of his eyesight, and the state of the weather. It also includes, most emphatically, the strength of his like or dislike of the sitter. S—— can become pictorially abusive, even to the verge of brutality, if he dislikes his sitter. There is apt to be too much ' individuality ' in a painter's portrait."

Monica asked for my verdict on the case : she always ends a discussion like that. I think she does it to please me.

" Leave the ordinary professional work on one side —it is taken by Philistines, and retouched by strangers

—and compare a dozen portraits from the leading photographic exhibitions with a dozen portraits from the Royal Academy ; you will find more truthful character rendering in the photographs than in the paintings. The most hopeful future of artistic photography lies in portrait work.''

CHAPTER XXVI

FLOWER PHOTOGRAPHY

I. I ALWAYS think that flower photography bears the same relation to landscape work that a lyric bears to prose ; and just because it is a lighter and more delicate branch of camera work, people seem apt to regard it as of secondary importance.

Now, the photography of flowers appears simple and easy—the photographer has only to place them in a vase and photograph them ; but it is in reality a branch of photography that demands the highest exercise of artistic talent, for it is a bold act to take objects whose beauties depend almost entirely on colour, and attempt to suggest similar sensations of pleasure by a photograph in monochrome. It will be found that when Nature falls back on monochromes in brown and like colours, she bestows much grace of form, as in leafless trees and various kinds of grasses ; but she has not dared to venture on drab roses or brown lilac, and her elementary attempts which resulted in green flowers are far from satisfactory. Yet the photographer must take the rose and the lilac, and picture them in browns or greys so that they convey a sensation as pleasurable as that of colour. It may be argued that there are such objects as white flowers ; but is not white the fullness of all colours, showing the most delicate colour sensations in every shading ; and has not the white flower its complement of green leaves ? Try whitewashing the foliage of a white blossom, and note the result.

II. I understand that the Japanese have a strong feeling that it is immoral to place flowers of a different species together, or to arrange flowers and foliage of different families in the same vase : for example, it would be immoral to arrange lotus blossoms and roses together, or to place plum and pine branches side by side. However fanciful such ethics may appear to the Western mind, the underlying principle is sound enough. This was brought home to me when a friend of mine brought home a bunch of fresh spring foliage and arranged oak leaves and lilac leaves in the same vase : the tints of these different kinds of foliage harmonised, and yet the effect suggested discord, for oak and lilac do not grow side by side, and the union of the two in one vase appeared unnatural.

Hothouse flowers and garden flowers do not grow together, nor do moorland flowers and water plants, and so the union of ox-eye daisies and maidenhair or of heather and forget-me-nots appears incongruous and contrary to Nature. On the other hand, an arrangement of ox-eyes and the long fronds of meadow grass, or of hothouse blossoms with maidenhair are harmonious.

III. The arrangement of flowers should be both natural and simple. Thus, the conventional arrangement of a vase of flowers, with a couple of blossoms lying on the table beside it, may help on the academic " composition," but, since one is not accustomed to see flowers placed to fade on the table, the arrangement seems artificial. If the subject had been " Arranging Flowers," with more blossoms, a pair of garden scissors, and perhaps an extra unfilled vase, the composition would be apt and natural. The same fault of artificiality may be found with baskets of flowers,

all neat and tidily arranged, fit for a bridesmaid, but totally unlike a basket of flowers just brought in from the field or garden. Most flowers in their natural state require plenty of light and air, and so flowers are seldom found growing closely together. The same feeling should actuate the photographer in his arrangement of flowers, for when blossoms are bunched together, the grace and delicacy of each flower is lost, and the individual perfection of the blossoms is merged into a clumsy whole. The fewer flowers that are included in a picture the better, so long as the picture-space is not left ostensibly empty; and it is wonderful how few flowers will serve to fill a picture : probably nine out of every ten flower-pictures are ruined through overcrowding.

IV. On Wimbledon Common, close to Roehampton, some vandals have erected a huge flagstaff, and there it stands, stayed with wire ropes, 153 feet of rigid, useless nakedness, a blot on the landscape and an example of the handiwork of man. Close by there are some poplar trees ; Nature has built these supple, and they yield to every breeze, and curve into exceedingly graceful curves. This is the hand of Nature, who delights in curves. So with flowers, the stems and leaves delight to curve.

Now, two things must be noticed about these curves : in the first place, they are always graceful, free-hand curves, and never formal curves like those drawn with a pair of compasses ; and in the second place, when the plant is healthy they are always supple curves. When plants begin to droop, or the flowers that have been gathered are allowed to flag for want of water, the curves lose their elasticity, and with their elasticity their gracefulness ; therefore, if

flower-pictures are to show the beauty of Nature, the flowers must be freshly gathered and placed in water to recover themselves before they are photographed.

When photographing rushes, daffodil leaves, and other straight-growing plants, photographers have an unhappy habit of breaking some of the leaves, so that they hang down. This is an artistic error, for although a curve may be countered by an opposite curve, a broken curve is a broken line of beauty; besides, a broken stem is the natural token of sadness, and Art has always chosen it as the emblem of sadness, and when we see a tree which appears to break the curve of each branch, letting the end droop straight down, we call it the "weeping willow." But, on the other hand, when a stem has been broken, and the plant has picked up fresh life, such a stem will often form a new and beautiful curve as the blossoms raise their heads towards the light.

Nature's principle of curvature requires careful study; for although she delights in repeating curves so as to give a swing and ryhthm to her foliage, no two curves are exactly identical. As a rule, the central leaves of such plants as the iris and narcissus will be found to curve fairly high up, and as the leaves grow farther from the central stem, the curves will commence lower down; and then, lest the curves should become monotonous, Nature will bring a stray leaf curving across the rest. This countering of curves is most graceful, and in some of the finest flower-subjects, it will be found that perhaps two flowers curve in the same direction, whilst the third curves across them.

V. The arrangement in Nature is nearly always good; but Nature very seldom arranges her flowers

ready for the camera. In looking at blossoms as they grow—say, in looking at a rose-bush—the eye is focussed on one brilliant or noticeable blossom; and although other roses within the range of vision may be equally conspicuous, the narrow-view angle, and the imperfections of human vision, vignette off the other roses, and make the rose which is admired predominant: if this bush were photographed, the various blossoms would stand out equally distinct. For various reasons, such as the lack of colour in the photograph, and the flat surface of the print, the eye would not single out one rose in the picture, as it singled out one rose in Nature; but the sight would wander from one blossom to another without repose, and, if a noticeable flower were situated close to the edge of the picture, the eye would wander on, to be brought sharply and violently against the boundary of the picture-frame.

Sprays and branches of blossoms are exceedingly difficult subjects for the pictorial photographer to handle, and as a rule two or three flowers make a more artistic picture; but a spray of yellow roses will certainly make a very sumptuous composition if it be handled with artifice. Experience has taught us that if we can arrange the lighting so that a chief high light is reflected from an important blossom that is at some distance from the edge of the picture, possibly also strengthening some shadow beside the flower, a feeling of unity will be established. The lighting in such a subject should be arranged to give relief and modelling: panchromatic plates and colour screens are essential in the rendering of what may be termed " sumptuous flower pictures," so as to secure the full rendering of delicate gradations.

CHAPTER XXVII

SOME SUGGESTIONS ON ARCHITECTURE

I. LONG ago, when photography first caught my fancy, I used to regard architectural photographs as records. Then I came across some photographs by Frederick Evans.

Now, architecture, especially interior architecture, is the creation of the architect ; and the photograph of a new interior is only, at the best, a fine technical record in monochrome. But time adds a certain atmosphere to the architect's creation, and later generations leave their trace on the building—now by the placing of a Perpendicular window where there had been one in Early English, now by some addition to the structure—until the building becomes the handiwork of man, instead of the creation of an individual.

It is when the photographer catches the spirit and atmosphere of what has been, and carries our imagination back into the past, that his architectural work becomes a Fine Art ; and it is this literary and imaginative quality in Mr. Evans's photography that makes his work different from either a history or a record. Such is the quality in " Height and Light in Bourges Cathedral " ; for Evans carries us back, until we almost expect a procession of monks to appear from around the distant pillars, or some gallant to come

HEIGHT AND LIGHT IN
BOURGES CATHEDRAL.

By F. H. Evans.

round the corner, dust the pavement with his mouchoir, and lout on one knee. How Mr. Evans gets his effects is a marvel; it is certainly neither by theatrical lighting, gush, nor sentimentality .

There is one essential in architectural work, and that quality is the rendering of texture. Stone must look like stone. Under-exposure, especially when followed by over-development, covers the texture of the high lights with a layer of unprintable density as surely as the Goth would cover the surface of the stone with coats of whitewash. So, in all architectural photography the exposures must be generous and the development cautious.

II. If any branch of pictorial photography has a limitation in the size of the prints, that branch is architecture ; for, in the first place, the nature of the subject requires a stopping down of the lens and the rendering of clear detail ; and, in the second place, a direct print that is not larger than ten by eight suggests, whilst a large enlargement challenges, attention.

Since the definition in architectural work is fine and an inspection at close quarters is invited, the view-angle may be wider than in any other branch of photography ; but a narrow view-angle will give a more pleasant perspective than a wide one, and if the focal length of the lens be less than the length of the plate, the perspective will become violent.

The most important act in photographing an interior is the choice of a station-point that will show the perspective of the pillars, or the arrangement of the building, to the best advantage. Then, and only then, comes the choice of a lens that will fit the subject on the plate. It is far better to be content with a small picture taken on a portion of the plate than to

alter the station-point to one that is even slightly inferior.

In order to fit the subject on the plate, a battery of several different lenses is desirable, and a set of convertible anastigmats is the counsel of luxurious perfection ; for although quite good work may be done with one doublet, the choice of subject is thereby limited.

III. The architectural camera may be either a stand camera or one of the hand-stand type ; but a considerable rise of front and depth of bellows towards the lens panel are essential. The spirit level should be of the T type, and is best carried loose in the pocket : it can then be held at the side of the camera, or placed on either the camera back or base-board, as convenience suggests. A large adjustable lens shade should be attached to the camera front : the cutting off of the light from some window, just above the subject, will often save the plate from much light-fog. The focussing screen should be of the finest acid-etched glass, and if part of the screen be rubbed with vaseline, the focussing in a dark church will be all the easier.

The tripod must be rigid ; it must have sliding legs, easily clamped, so that a high or low station point may be secured at will ; the points of the tripod must be fitted with removable rubber shoes, so that they will not scratch the church pavement. The tripod legs are best prevented from slipping by the attachment of adjustable stays, running from leg to leg. Nothing breaks the photographer's heart so effectually as the slipping of one of the tripod feet after three-quarters of a long exposure.

A very low station point is usually best : a high

station point is apt to make the pavement appear to slope upward.

IV. Personally, I have found the Barnet ortho-chromatic plates excellent for interior work; the dye in the film seems to check halation, and when the plates are backed they are wonderfully free from all trace of halation. I have never tried the Cristoid films, but Mr. Evans swears by them for interiors; two of the finest landscape photographers use them for all their most delicate work; and I hear them spoken of with unstinted praise for the making of enlarged negatives.

The glass of the photographic plate is very apt to reflect back the rays of the high lights, which spread in the gelatine and fog portions of the image. Even though they be backed, plates are apt to suffer from halation; but films, whether the emulsion be coated on celluloid or gelatine, are free from this defect. The Cristoid is formed of a film of slow emulsion coated with a rapid emulsion. Those who have used them tell me that these films give a great latitude in exposure, and so long as the exposure is ample there is but little risk of over-exposure. Theoretically, unlike plates or celluloid films, the Cristoid must allow the developer to penetrate through the back of the film and reach the delicate gradations of the high lights. This gives considerable food for contemplation. As I say, I have never tried the Cristoid films; and as a proper test of any new material takes considerable time, I cannot test them at the present moment; but, in theory, they seem near perfection.

CHAPTER XXVIII

TECHNICAL HINTS

HERE " The Artistic Side of Photography " ought to
end, and I ought to be able to refer my reader to some
text-book on the technical side of photography for
practical details ; but, unfortunately, I know of no
book that will entirely answer the purpose. One
book gives directions which would lead to unduly
contrasty negatives ; another makes platinotype an
exceedingly difficult process ; few contain satisfactory
directions for making enlarged negatives ; all re-
commend lenses of far too short a focal length for
satisfactory pictorial work.

And, since I may have persuaded some Person of
Taste to take up pictorial photography, I am morally
bound to enable him, at the least, to start in the right
way. After that he will be able to learn all he needs
from practical experience and " The Dictionary of
Photography," " The Figures, Facts, and Formulæ
of Photography," and " The British Journal Almanac."

Assuming that the Person of Taste knows how to
load his slides and put together his camera—any
dealer will show him—the first question is the exposure ;
and here I can recommend a most excellent little
hand-book, " Welcome's Exposure Record," and I
have nothing to add to Mr. Welcome's advice, except

an exhortation to use the first column in the list of plate speeds for normal exposure. So I will commence with a hint on dusting the plate.

HINTS ON DEVELOPMENT

I. DUSTING THE PLATE, so as to remove any particles of dust before exposure. If the plate be dusted in the ordinary way, the dusting-brush will deposit as much dust as it removes. After filling the dark slides, open each shutter in turn and, holding the slide so that the plate is *film downward*, dust the surface of the film gently. Dust falls down, not up, and all the dust will fall off the plate, whilst none of the dust that may happen to be in the brush will fall upwards and attach itself to the film. This sounds obvious, but I have never seen the practice recommended in print.

II. DEVELOPER.—The essentials in a developer are that it should be reliable, that it should give an image in which even the most delicate gradations print out, that the image should not lose density in the fixing, and that the developer should stain neither film nor hand. The following formula possesses all these qualities ; it keeps well, and if the skin be wetted *before* the fingers are placed in the developer, and washed after development, there is no danger of pyrostain.

In solution No. 1 the pyro (or pyrogallol) is the actual developing agent ; the function of the metabisulphite of potassium is simply to preserve the pyro. In solution No. 2 the carbonate of soda is the accelerator, which sets the pyro working; sulphite of soda is added to keep the developer from staining both film and fingers. The formula was planned by the

335

German chemist, Herr Zähr, and is as perfect as any developer can be. The stock solutions are :

<div align="center">SOLUTION NO. 1</div>

Metabisulphite of potassium	½ oz.
Pyrogallol	1 ,,
Water, to make	27 ,,

<div align="center">SOLUTION NO. 2</div>

Sulphite of soda	6 oz.
Carbonate of soda	4 ,,
Water, to make	27 ,,

Mix in the above order. The metabisulphite may be dissolved in warm water, not too hot, and the pyro added when the water is cold. The chemicals in No. 2 may be dissolved in hot water.

Bromide of potassium destroys the delicacy of gradation in the earlier stages of development ; and although the addition of bromide is recommended by many plate-makers, it is required by no modern plate.

III. THE NEGATIVE to aim at in pictorial work, especially if enlargement be intended, is much thinner than the so-called technical negative. If the negative is once over-developed, reduction is a risky and uncertain process ; but, as will be shown, a new and perfect negative can be made from the very ghost of an original negative. My own practice has always been to develop the original small negative very softly, with a view to subsequent enlargement, and to make a new negative for direct printing, if required. It is difficult to reduce the scale of gradations and make a plucky negative into a soft one, but it is very easy to make a new negative, with any desired degree of contrast, from one that is exceedingly thin. But

<div align="center">336</div>

I will give two methods of development, one for a negative that will be suitable for enlargement, the other for a negative suitable for direct printing on platinotype.

IV. DEVELOPMENT.—I think that the beginner should first aim at developing a good ordinary negative, from an exposure on a normal kind of subject, and this by mechanical means. When he has learnt this he can next learn to judge density and contrast during the development by the light of his dark-room lamp ; and finally, he can bring his reason into play, and learn to develop by the logical system suggested in the chapter on development.

Now, different makes of plates take different times to develop, and both the nature and warmth of the developer make a difference in the time of development ; but Mr. Watkins discovered a key that will solve the difficulty. Take a certain fixed developer warmed to between 60 and 70 degrees Fahrenheit, and place therein two plates of different makes ; notice the time which each image takes to make its first appearance ; multiply each time of first appearance by the same factor, and the resulting negatives will be similar. (By the way, since my reader may be a very cultivated lady who hates arithmetic, I had better explain that the " factor " is just the number by which she must multiply.)

Thus, the factor for a good negative to be used in platinotype printing—with a one-grain pyro-soda—is 12. Take one of Messrs. Bedstead's excellent " Lucifer " plates, expose it, and place it in the developer ; the image will begin to appear (the appearance will be first seen where the rebate of the dark slide has covered the plate) in thirty seconds. Thirty seconds multiplied by twelve makes six minutes :

development will be finished in six minutes. Or take one of Mr. Ashtray's delightful " Vesta " plates, and treat it in the same manner ; the image begins to appear in one minute (1 multiplied by 12 makes 12) : development will be finished in twelve minutes. Perhaps the " Vesta " may have developed more slowly than the " Lucifer " plate because the developer was not quite so warm ; perhaps the nature of the plates may have been different, but the two negatives will print similar results.

It is troublesome to keep on altering the factor (besides the difficulty of multiplying by a factor that is higher than 12—and how would the cultivated lady like to multiply a first appearance of 23 seconds by a factor of 18, for instance ?) ; so we will take a constant factor of 12 and alter the character of the negative by altering the quantity of pyro in the developer. One grain of pyro to the fluid ounce, with a factor of 12, will make a soft negative ; two grains of pyro, with the same factor, will secure a negative calculated to print a platinotype having fairly soft gradations. To make the one grain and the half-grain pyro developers, take the afore-mentioned solutions—the pyro is No. 1, and the soda is No. 2 :

NEGATIVES FOR ENLARGING.

Stock solution No. 1 $\frac{1}{4}$ oz.
Stock solution No. 2 1 ,,
Water, to make 8 ,,

This developer gives about half a grain of pyro to the fluid oz.

NEGATIVES FOR PLATINOTYPE

Stock solution No. 1 $\frac{1}{2}$ oz.
Stock solution No. 2 2 ,,
Water, to make 8 ,,

This developer gives about one grain of pyro to the fluid oz.

338

In each case the period of the first appearance of the image must be noted (that is, the number of seconds that elapse between the pouring on of the developer and the appearance of the image), and this number of seconds must be multiplied by 12.

Of course some may like stronger contrasts, and these must multiply by a higher factor, or use more of No. 1 solution ; others may like still softer contrasts in their negatives, and these must employ a factor of 8 or 10 : each to his taste.

This sounds a very simple method of development, and the technical photographer will call it " machine-made " ; but it will give exactly the type of negatives that the technical worker desires. Try it ! Just try an experiment on Mr. Technicalis, and see for yourself. Expose a plate on the village pump, timing the exposure by Welcome's pocket-book ; develop in the following developer (the rascal loveth a plucky negative, so mix a developer to please him) ; take 1 oz. of No. 1, 2 oz. of No. 2, adding 4 grains of bromide, and sufficient water to make 8 fluid ounces ; develop with the factor of 5. Believe me, when you show the negative (Technicalis careth not for such vanities as prints, and doubtless never maketh them—he loveth only negatives) the villain will embrace you as a brother expert, and a maker of the Perfect Negative.

When the pictorial photographer attains sufficient skill to develop by the use of reason, he will judge development by the density of his negatives ; but even then he might well employ the factorial system when he is aiming at normal results.

V. THE DARK-ROOM LAMP.—The quality of the light matters far more than the quantity ; and a large lamp, fitted with a large sheet of ruby glass, will

give quite a quantity of light without fogging the plate. But the ruby glass must be bought from some first-class dealer who tests all his glass with the spectroscope. This is essential.

However safe the light may be, it is wise to cover up the developing-dish, especially during the first part of the development. A little experience of a plate will show how long it may be covered before the image is expected to appear.

VI. THE FIXING BATH.—Always be liberal with the hyposulphite—it only costs about a shilling per 7 lb. —and to spare the hypo is to spoil the plate; also, a jar to hold the hypo does not cost much. To be exact, the best fixing bath is :

Hyposulphite of soda	4 oz.
Metabisulphite of potassium	$\frac{1}{2}$,,
Water, to make	20 ,,

But the photographer will save himself a deal of trouble if he keeps a cup that will hold about 4 oz. in his hypo-jar, and a pint jug hard by. Shovel a cupful of hypo into the jug; fill with hot water; when the water has somewhat cooled, add about $\frac{1}{2}$ or $\frac{3}{4}$ oz. of metabisulphite. *The* important thing is to place the plate in a perfectly clean bath of the hypo solution after it has been fixed—give the plate a double fixing.

VII. WASHING.—Hypo clings in the film. Hypo sinks in water. Any method of washing that ignores these two qualities is useless. Thus, if the photographer placed his negative in a very deep dish, and allowed a gentle dribble of water to run into the dish, and out over the edge, his washing would be ineffectual; if he filled a large bath (I mean a bathroom

bath) with water ; washed the back of his negatives under the dark-room tap, and fixed them on a board with drawing-pins, and floated the board in the bath, so that the negatives were floated film downward, the hypo would fall out of the gelatine and sink to the bottom of the bath. Probably, if a negative were placed in a running stream and its edges supported on a couple of shelving rocks, so that the film was downward, it would be washed in half an hour ; but under ordinary circumstances a couple of hours is none too long. Beware of cheap washing-tanks with inefficient syphons.

VIII. DRYING.—Always remember that dust falls down, not up. If a negative be dried face up, it will be covered with fine dust, which will ruin it for enlargement. Plates can be dried very rapidly out-of-doors, and provided they are supported face downward they will dry free from dust.

IX. SPOTTING.—If the pinholes in a negative are due to air-bubbles forming on the film during development, they may often be touched out with retouching medium and pencil ; if they are due to defects in the film itself, they are best spotted out with a fine sable brush, moist light-red, and a steady hand.

These are the most obvious hints, and my only excuse for giving them is that they are not to be found in many of the ordinary text-books.

ACTUAL DEVELOPMENT

In normal development it takes about two grains of pyro to develop a quarter-plate, and consequently the ordinary photographer who uses a strong developer containing two grains of pyro to the fluid

ounce finds a single ounce of developer sufficient to develop a quarter-plate ; but when the pictorial worker comes to use his weaker solutions, it requires four ounces of his half-grain and two ounces of his one-grain developers to hold the necessary amount of the pyro for a quarter-plate. A half-plate needs twice this amount, and so on.

The reason why the pictorial photographer works with weaker developers than the technical man is simple. The half-grain developer acts much more slowly than the stronger solution ; and since the pictorial photographer requires a thin negative, the weaker solution gives the pyro plenty of time to circulate through and develop the film. The high lights in a thin negative developed with a strong solution are flat and improperly developed.

Now, nearly all artistic people are frightfully untidy, but the difference between a workman and an amateur is that the true workman can always lay his hands on what he wants. The workman may leave his dishes in the sink, but his dishes have been washed out and left full of water ; the workman may seem to keep his chemicals in confusion, but the chemicals in constant use are always in the same place ; his dark room may be untidy, but he keeps the door closed for half an hour before he puts his negatives to dry, so that the dust will have settled.

In actual development, prepare the developer ; have the slides handy with the dusting-brush resting hard by ; place the watch or dark-room clock well in the red light ; turn out the gas, and do not hurry : hurrying does not really save any time, and it is the fruitful cause of mistakes.

Take out the exposed plate leisurely ; dust it,

holding the film downwards, leisurely ; place it in the dish and pour on the developer leisurely, and glancing at the watch, rub the fingers over the film so as to remove air-bubbles, and cover up the dish until the time has come to look for the first appearance of the image. As soon as the image has begun to appear cover up the dish, calculate the time of the development, and light a cigarette. There are two other points to consider : in pouring on the developer, hold the dish by the nearest left-hand corner, and, commencing at the opposite corner, pour on the solution with a quiet, even sweep ; secondly, keep the dish rocking pretty constantly so as to have a constant flow of the solution over the film—or, still better, don't worry ! buy a " plate-rocker." As to rubbing off air-bubbles with the fingers. Have you ever met an artist who could keep his fingers away from the paint or ink ? So long as the fingers are always rinsed, before, as well as after, placing them in the pyro, our solution will not stain—at least not very badly.

As soon as the plate is developed rinse it under the tap and place it in the hypo : the backing may be sponged off after the plate has been fixed.

The real workman learns to do most of his dark-room work by touch. He learns to load and empty his slides by touch, to dust his plates by touch ; and the true workman keeps his exposed plates away from the direct rays of the red light as much as possible.

MAKING A TRANSPARENCY

In order to make either a new or enlarged negative, it is necessary to make a transparency. A trans-

parency is simply a print that is made on a sensitive plate instead of on platinotype or other printing-paper.

When making a new negative, a transparency is first printed by gaslight in the printing-frame, and developed just as though the sensitive plate were a sheet of bromide paper. So soon as the transparency is dry, the process is reversed and the new negative is printed in the printing-frame and developed.

Assuming that the transparency is exactly like the negative reversed, with all the qualities of the original —so like, that when the negative and transparency are placed film to film and held up to the light, the picture is lost in one even tone of dense drab : assuming that the new negative has a similar quality, then the new negative must be exactly like the original.

When making an enlarged negative, the transparency is placed in the enlarger instead of a negative ; a large sensitive plate is substituted for the usual sheet of bromide, and an enlargement is made and developed.

With one exception—and that simply because a sensitive plate is more sensitive to light than bromide —the whole process is as easy to work as bromide, more certain in the manipulation, and better under control.

I. NATURE OF THE TRANSPARENCY.—The lantern slide is a flashy type of transparency that is specially made so that it may be thrown across a large room and enlarged twenty or forty times ; the transparency that we need should have a density similar to that of a somewhat thin negative, and must have tone rather than brilliancy : in fact, a good transparency must have the qualities of a good negative, and not those of a lantern slide.

Now, special plates are made to give special results —a lantern plate is made to give brilliancy, a slow landscape plate to give pluck, and a rapid ortho plate to give tone—and consequently we will find the quality of the plate that we use brought out in the transparency. A lantern plate will give a flashy, useless transparency ; a landscape plate will give a plucky transparency ; a rapid orthochromatic plate will reproduce the tone qualities of a good negative : therefore reason tells us to use a rapid ortho for general purposes ; and reason also suggests that if the original negative should happen to be too flat, the use of a slow landscape plate will give the desired strengthening of contrasts.

If one finds that a photographic journal recommends the use of lantern plates in the making of transparencies for enlargement, one invariably finds the editor lamenting that an enlarged negative will never reproduce anything of the quality of the original.

In judging the effect of a transparency, a large sheet of white paper should be placed on a table in the window, and the transparency held between the eye and the paper so that the reflected light passes through the image ; the plate should not be held up between the eye and a gas-jet for inspection. The qualities to be desired are tone and refinement ; there should be no clear glass high lights, or dense shadows.

II. MAKING A TRANSPARENCY.—I have tried many different plates for transparency work, and have selected two plates for my own use (I do not say that these are the best plates, only the best that I have tried), the Barnet rapid ortho, and the Imperial fine-grain ordinary : both plates must be backed. With a good negative of either the " enlarging " or " platino-

type " variety, the ortho plate should be used ; when the original negative is either flat or excessively thin, the Imperial plate should be employed.

(*a*) *With a good negative.*—The best developer in making a transparency is amidol.

> In 6 oz. of hot boiled water
> Dissolve ½ oz. of sulphite of soda,
> Add 6 grains bromide of potassium
> And 26 grains of amidol.

In ordinary cases, dilute this solution with an equal bulk of water.

Of course it is impossible to determine the exposure without seeing both negative and gas-jet ; but the procedure will be as follows. Take the original negative, clean the back and, after dusting both back and film, place it in the printing-frame. Light the dark-room lamp, turn down the gas-jet until the flame is a mere speck ; place a backed ortho plate (after dusting) on the negative, film to film, and close the printing-frame. Place the printing-frame 8½ feet from the gas-jet, turn up the gas for, say, six or nine seconds. Turn out the gas and develop the transparency. Development will take about four minutes, and the plate is then fixed and washed.

With an ordinary gas-jet, at 8½ feet from the jet, the exposure behind a negative made for enlargement would probably be about six or eight seconds ; the exposure behind a negative made for platinotype printing would probably take from twelve to eighteen seconds. Plates are cheap, transparency-making is quick, and it is always wise to make several transparencies, giving different exposures, and select the best. The pictorial quality of a transparency is far easier to judge than the pictorial possibilities of a negative.

(*b*) *With a thin or flat negative.*—Follow the same procedure, but substitute a fine-grain Imperial for the ortho. The exposure, at 8½ feet from the gas, will be from six to twelve seconds with the mere ghost of a negative, and longer with one that is only flat. In extreme cases, a strong rodinal or pyro-soda, re-strained with plenty of bromide, may be employed.

(*c*) *With a dense negative.*—So long as the exposure has been fairly correct, and the density obtained by over-development, the printing-frame should be placed close to the gas.

(*d*) *In a high key.*—The scale of gradations can be condensed, and transparency made in a high key, with soft, delicate high lights, and cool grey shadows, by a full exposure and rapid development. The exposure must be full, so as to impress the gradations of the high lights on the film ; the development must be rapid, so as to prevent the developer from pene-trating the film of the transparency and developing the shadows too densely. The best developer is a strong rodinal, 1 in 15, with a few drops of bromide, and warmed to about 75 degrees.

(*e*) *In a low key.*—The exposure should be just sufficient to stamp a suggestion of shadow details on the transparency : a development in a 1-in-80 rodinal will develop the shadow details. The trans-parency and resulting negative should be rather thin. The low-toned effect is obtained by printing the platinotype somewhat deeply.

III. MAKING A NEW NEGATIVE.—The only differ-ence between making a contact negative and a contact transparency is that the negative should be developed in the same pyro-soda that we formulated in making a negative for platinotype printing.

The Artistic Side of Photography ♣

People are so much accustomed to regard the making of an enlarged negative as a kind of conjuring trick, and they are so wont to discuss the different methods of enlarging from irrational standpoints, that I must ask my reader to use his common sense. An enlarged negative is nothing more or less than a large-scale photograph of the transparency illuminated by transmitted light ; that is to say, it is a large-scale photograph of the transparency illuminated by the light which shines through it. If the transparency be held between the eye and the gas flame, the flame will be seen through it and it will not look well ; if the transparency be placed between the lens and the gas flame, the flame will be photographed through it, or, at any rate, the illumination will be very uneven. As the transparency appears to the eye, so will it photograph.

I. ILLUMINANT.—When the enlargement is made by artificial light, a condenser has to be placed between the light and the transparency. This condenser is, in reality, a large double lens that diffuses the light through the transparency, and it is formed so that it bends the rays of light towards the enlarging lens. The fault of this method is that the rays of light which shine through the clearer portions of the transparency (the high lights) shine on with but little let or hindrance, whilst the rays that ought to shine straight through the transparency-shadows, and straight on towards the lens, get broken and diffused by the density of the shadows ; consequently, in an enlargement by artificial light the shadows in the negative are apt to be under-exposed, and the contrasts too contrasty. In order to minimise this failing, it is wise

to place a sheet of ground glass between the condenser and the transparency, so as to diffuse the light.

It is difficult to make this quite plain ; but, roughly speaking, when rays of light shine through the film the dense part breaks them up far more than do the clear parts ; when there is diffused light behind the film the transparency itself looks and photographs as though it were luminous.

Consequently, when a transparency is illuminated by the diffused light from the northern sky, or from a white reflector, the illumination is at its best.

Fortunately, the text-books explain the different enlargers pretty thoroughly, and there is no need to enter into the matter here ; but a few hints may not come amiss.

(a) The best possible illuminant is daylight ; and the best form of daylight is obtained from a white reflector placed at an angle of 45° in front of the transparency.

(b) Diffused light from the northern sky is nearly as good.

(c) Electric light and spirit vapour are far better than gas light.

(d) The portrait lens sold with most enlargers has seldom a flat field ; an anastigmat is far better. As long as the lens covers the transparency, the focal length of the lens does not matter, nor does it affect the perspective.

(e) A pinhole substituted for the lens will give a delightfully soft definition, and if the hole be fairly small the definition will not be woolly.

(f) A backed orthochromatic plate makes an excellent enlarged negative ; and I hear the Cristoid films spoken of very highly.

(g) An enlarged negative looks very different from the original, and is best judged by its printing capacity.

II. ENLARGEMENT EXPOSURE.—It is difficult to give any data for a daylight exposure, and impossible to give data for one made by artificial light ; but the following may be of some use.

Assuming that a Barnet rapid ortho plate is used, and the lens is stopped down to f/11, and that the exposure is made by daylight from a northern sky, Welcome's table of exposures may be employed as follows :

Scale of the Enlargement.	When the light by Welcome is				
	$\frac{1}{8}$	$\frac{1}{6}$	$\frac{1}{4}$	$\frac{1}{3}$	$\frac{1}{2}$
	expose for	expose for	expose for	expose for	expose for
2 diameters	1 sec.	$1\frac{1}{2}$ sec.	2 sec.	3 sec.	4 sec.
3 ,,	$1\frac{3}{4}$,,	$2\frac{1}{2}$,,	$3\frac{1}{2}$,,	$5\frac{1}{4}$,,	7 ,,
4 ,,	$2\frac{3}{4}$,,	4 ,,	$5\frac{1}{2}$,,	$8\frac{1}{4}$,,	11 ,,
5 ,,	4 ,,	6 ,,	8 ,,	12 ,,	16 ,,
6 ,,	$5\frac{1}{2}$,,	$8\frac{1}{4}$,,	11 ,,	$16\frac{1}{2}$,,	22 ,,

This table is for a transparency of moderate density.

III. PINHOLE ENLARGEMENT.—Details that appear soft and pleasant in a small direct print in platinotype are apt to become coarse and obtrusive in an enlargement. One remedy for this is to throw the enlargement slightly out of focus ; but a far more artistic effect can be obtained by enlarging through a pinhole. I believe the idea of using the pinhole in enlargement is original (a small thing, all mine own), but the effect is altogether good ; the definition is soft, without being fuzzy.

A very small pinhole must be employed, and the edges must be both sharp and cleanly cut. A No. 12 needle makes a hole measuring $\frac{1}{75}$ inch in diameter,

a No. 11 needle, one of $\frac{1}{80}$ inch. Take a very thin sheet of copper or brass, and laying it on a piece of soft wood make a dent with a somewhat blunt needle, without piercing the metal. Then turn the metal over and rub with a very fine whetstone the bulge made by the needle. As soon as a very tiny hole is rubbed through, gauge it with the No. 12 needle, and when the hole admits the needle it is $\frac{1}{75}$ inch in diameter. Then black the edges of the hole with the smoke from wax matches, or by chemicals.

The pinhole is substituted for the lens, and the best position for the pinhole is to place it the same distance from the transparency that the transparency measures from corner to corner. Thus, if the transparency measures 4 by 3, the pinhole should be 5 inches from the transparency. If the sensitive plate be placed ten inches from the hole, the negative will, obviously, receive an enlargement of two diameters, and make a 6-by-8 picture. The exposure must be calculated by the distance of the sensitive plate from the pinhole ; and, since the pinhole enlargement must be made by daylight, an exposure with a $\frac{1}{75}$ in. pinhole, on a rapid ortho, would work out as follows :

Distance of pinhole from plate.	When the light by Welcome is				
	$\frac{1}{8}$ expose for	$\frac{1}{6}$ expose for	$\frac{1}{4}$ expose for	$\frac{1}{3}$ expose for	$\frac{1}{2}$ expose for
10 inches	7 min.	10 min.	14 min.	21 min.	28 min.
15 ,,	16 ,,	24 ,,	32 ,,	48 ,,	64 ,,
20 ,,	28 ,,	42 ,,	56 ,,	84 ,,	
25 ,,	37 ,,	55 ,,	74 ,,		
30 ,,	64 ,,	96 ,,			

When the $\frac{1}{80}$ in. pinhole is used, the exposure should be rather less than half the above periods.

When the enlargement is made in an enlarging camera, several minutes should be allowed to elapse between the placing of the camera and the exposure—this will allow any dust to settle ; also the shutter of the dark slide should be drawn gently. The period of exposure in pinhole work seems lengthy, but the camera is quite able to look after itself. Personally, I always used to make my exposures during lunch time.

IV. DEVELOPMENT.—The high lights and shadows are so far apart in a large negative that one who is used to dealing only with small plates is apt to judge that both contrast and density are less than they are in reality, and consequently to over-develop. A weak pyro-soda should be used, or a weak rodinal.

If the negative should prove too dense, or the contrasts too strong, reduce the enlarged negative in a quarter of an ounce of ammonium persulphate dissolved in ten ounces of water. This reducer takes several minutes to commence action. The moment the solution becomes cloudy, reduction has commenced, and it proceeds with great rapidity. If only a slight reduction be desired, stop the moment that the solution begins to cloud. In order to stop the action of the reducer, plunge the plate into a solution of sulphite of soda—half an ounce of the sulphite to ten ounces of water, which has been prepared beforehand. Leave the negative in the soda for five minutes, and wash for half an hour.

LOCAL REDUCTION

Only a purist would insist that a negative should remain absolutely untouched. A landscape, for in-

stance, may lend itself to the making of a picture up to a certain point ; and at that point there will be some intense shadow or violent high light—perhaps close to the edge of the picture surface—that destroys both the composition and general tone of the picture. Again, when the photographer converts a small portion of a landscape into a picture that should be complete in itself, it is sometimes necessary to strengthen one high light or deepen one shadow in order to secure principality. So long as the general tone and the delicate gradations of the light-drawing are not injured, only an unreasonable purist would object to some slight alteration.

The retouching knife scrapes away gradations ; the retouching pencil, unless it be employed very carefully and sparingly, buries gradations ; but these objections do not apply to chemical reduction, for potassium ferricyanide, applied locally to either the transparency or the enlarged negative, will reduce the general density of a patch, without interfering greatly with its gradations.

Take the following :

Hyposulphite of soda	¼	oz.	
Water 2	,,

When dissolved, add sufficient 10-per-cent. solution of ferricyanide of potassium to colour the water a medium yellow.

Soak the plate ; blot off the water with photographic blotting-paper ; apply the reducer with a paint-brush. After reduction, place the plate in clean hypo (the ordinary fixing bath) for five minutes, and wash thoroughly.

Reduction is only desirable when it improves, rather than degrades, the tone of the picture.

PRINTING

(a) P.O.P. is useful for unfixed proofs. Platinotype is more easy to use, and permanent. An unfixed print in P.O.P. has very beautiful gradations, but these are lost in the toning and fixing.

(b) Those who like bromide can find full directions in any photographic manual. Carbon-velox gives strong contrasts, and is consequently useful for taking proofs from very thin negatives that have been developed for the purpose of enlargement. Each packet contains full directions.

(c) Carbon is a fine medium ; but to describe carbon printing would demand a couple of chapters, and most manuals contain full instructions.

(d) Platinotype is the favourite medium among the school of pure photography, and the process is far more simple than is usually made out. So long as the paper is stored in a calcium tube, and the printing is not done in a damp room, there is no danger from moisture. If the photographer should find any difficulty in floating the print on the surface of the developer, the print may be placed in a dry dish and flooded with the developer. The image should be printed until the details are just visible in all save the whitest high lights, and the correct depth of printing is easily learnt.

The print is best developed in the D. salts supplied by the Platinotype Company, and cleared in three baths of diluted hydrochloric acid (1 part acid to 75 parts water) ; starting with a bath that may have

been used before, and ending with one that is fresh, the print is left in each bath for five minutes, and finally washed in running water for fifteen minutes.

The developing bath should be just tepid for cold tones, and the warmer the bath, the warmer the colour of the print.

END OF MY NOTE-BOOK

A Retrospect

And so, my dear Monica, our work is finished. I call it " our work " ; since in the writing of a book, as in the creation of a picture, there must be two engaged : there must be one who expresses, and one to whom expression is made. And I think that this is true. No sensible man can express himself to the General Public, for the General Public is very vague and very far off, and the General Public includes MY LORD JOHN HEAD-IN-THE-AIR and little *johnnie nose-in-gutter* as well as Jack See-Straight. In writing for Monica Clear-Eyes, I may reach Jack See-Straight.

There is much in our book that is debatable, and some that may prove wrong ; but I think that this, at least, is right—the failure of pictorial photography has been due to the blending of light-drawing with hand-work. For who can excel in a medium unless he adhere to that medium ? (Who, for instance, can hope to master mezzotint by falling back on crayon whenever he meets with a difficulty, working partly in mezzotint and partly in charcoal ?) And I think that the future of the movement lies with those who work as Hill worked, as Coburn and de Meyer work, as Evans and Cadby work, and as the Photo Secession is working.

The chief need at the present is a book on the technical side of pure photography. Who will write it ?

356

INDEX

357

Index

Index

Printed by Hazell, Watson & Viney, Ld., London and Aylesbury.

THE LITERATURE OF PHOTOGRAPHY
AN ARNO PRESS COLLECTION

Anderson, A. J. **The Artistic Side of Photography in Theory and Practice.** London, 1910

Anderson, Paul L. **The Fine Art of Photography.** Philadelphia and London, 1919

Beck, Otto Walter. **Art Principles in Portrait Photography.** New York, 1907

Bingham, Robert J. **Photogenic Manipulation.** Part I, 9th edition; Part II, 5th edition. London, 1852

Bisbee, A. **The History and Practice of Daguerreotype.** Dayton, Ohio, 1853

Boord, W. Arthur, editor. **Sun Artists** (Original Series). Nos. I-VIII. London, 1891

Burbank, W. H. **Photographic Printing Methods.** 3rd edition. New York, 1891

Burgess, N. G. **The Photograph Manual.** 8th edition. New York, 1863

Coates, James. **Photographing the Invisible.** Chicago and London, 1911

The Collodion Process and the Ferrotype: Three Accounts, 1854-1872. New York, 1973

Croucher, J. H. and Gustave Le Gray. **Plain Directions for Obtaining Photographic Pictures.** Parts I, II, & III. Philadelphia, 1853

The Daguerreotype Process: Three Treatises, 1840-1849. New York, 1973

Delamotte, Philip H. **The Practice of Photography.** 2nd edition. London, 1855

Draper, John William. **Scientific Memoirs.** London, 1878

Emerson, Peter Henry. **Naturalistic Photography for Students of the Art.** 1st edition. London, 1889

*Emerson, Peter Henry. **Naturalistic Photography for Students of the Art.** 3rd edition. *Including* The Death of Naturalistic Photography, London, 1891. New York, 1899

Fenton, Roger. **Roger Fenton, Photographer of the Crimean War.** With an Essay on his Life and Work by Helmut and Alison Gernsheim. London, 1954

Fouque, Victor. **The Truth Concerning the Invention of Photography:** Nicéphore Niépce—His Life, Letters and Works. Translated by Edward Epstean from the original French edition, Paris, 1867. New York, 1935

Fraprie, Frank R. and Walter E. Woodbury. **Photographic Amusements Including Tricks and Unusual or Novel Effects Obtainable with the Camera.** 10th edition. Boston, 1931

Gillies, John Wallace. **Principles of Pictorial Photography.** New York, 1923

Gower, H. D., L. Stanley Jast, & W. W. Topley. **The Camera As Historian.** London, 1916

Guest, Antony. **Art and the Camera.** London, 1907

Harrison, W. Jerome. **A History of Photography Written As a Practical Guide and an Introduction to Its Latest Developments.** New York, 1887

Hartmann, Sadakichi (Sidney Allan). **Composition in Portraiture.** New York, 1909

Hartmann, Sadakichi (Sidney Allan). **Landscape and Figure Composition.** New York, 1910

Hepworth, T. C. **Evening Work for Amateur Photographers.** London, 1890

*Hicks, Wilson. **Words and Pictures.** New York, 1952

Hill, Levi L. and W. McCartey, Jr. **A Treatise on Daguerreotype.** Parts I, II, III, & IV. Lexington, N.Y., 1850

Humphrey, S. D. **American Hand Book of the Daguerreotype.** 5th edition. New York, 1858

Hunt, Robert. **A Manual of Photography.** 3rd edition. London, 1853

Hunt, Robert. **Researches on Light.** London, 1844

Jones, Bernard E., editor. **Cassell's Cyclopaedia of Photography.**
London, 1911

Lerebours, N. P. **A Treatise on Photography.** London, 1843

Litchfield, R. B. **Tom Wedgwood, The First Photographer.**
London, 1903

Maclean, Hector. **Photography for Artists.** London, 1896

Martin, Paul. **Victorian Snapshots.** London, 1939

Mortensen, William. **Monsters and Madonnas.**
San Francisco, 1936

*Nonsilver Printing Processes: Four Selections, 1886-1927.**
New York, 1973

Ourdan, J. P. **The Art of Retouching by Burrows & Colton.**
Revised by the author. 1st American edition. New York, 1880

Potonniée, Georges. **The History of the Discovery of
Photography.** New York, 1936

Price, [William] Lake. **A Manual of Photographic Manipulation.**
2nd edition. London, 1868

Pritchard, H. Baden. **About Photography and Photographers.**
New York, 1883

Pritchard, H. Baden. **The Photographic Studios of Europe.**
London, 1882

Robinson, H[enry] P[each] and Capt. [W. de W.] Abney.
The Art and Practice of Silver Printing. The American edition.
New York, 1881

Robinson, H[enry] P[each]. **The Elements of a Pictorial
Photograph.** Bradford, 1898

Robinson, H[enry] P[each]. **Letters on Landscape Photography.**
New York, 1888

Robinson, H[enry] P[each]. **Picture-Making by Photography.**
5th edition. London, 1897

Robinson, H[enry] P[each]. **The Studio, and What to Do in It.**
London, 1891

Rodgers, H. J. **Twenty-three Years under a Sky-light,** or Life and
Experiences of a Photographer. Hartford, Conn., 1872

Roh, Franz and Jan Tschichold, editors. **Foto-auge, Oeil et
Photo, Photo-eye.** 76 Photos of the Period. Stuttgart, Ger.,
1929

Ryder, James F. **Voigtländer and I:** In Pursuit of Shadow Catching. Cleveland, 1902

Society for Promoting Christian Knowledge. **The Wonders of Light and Shadow.** London, 1851

Sparling, W. **Theory and Practice of the Photographic Art.** London, 1856

Tissandier, Gaston. **A History and Handbook of Photography.** Edited by J. Thomson. 2nd edition. London, 1878

University of Pennsylvania. **Animal Locomotion. The Muybridge Work at the University of Pennsylvania.** Philadelphia, 1888

Vitray, Laura, John Mills, Jr., and Roscoe Ellard. **Pictorial Journalism.** New York and London, 1939

Vogel, Hermann. **The Chemistry of Light and Photography.** New York, 1875

Wall, A. H. **Artistic Landscape Photography.** London, [1896]

Wall, Alfred H. **A Manual of Artistic Colouring, As Applied to Photographs.** London, 1861

Werge, John. **The Evolution of Photography.** London, 1890

Wilson, Edward L. **The American Carbon Manual.** New York, 1868

Wilson, Edward L. **Wilson's Photographics.** New York, 1881

All of the books in the collection are clothbound. An asterisk indicates that the book is also available paperbound.